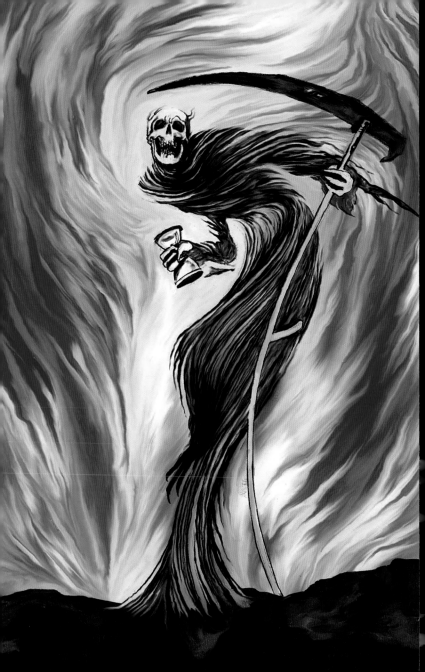

FANTASY ARTIST'S
POCKET REFERENCE
íncredíble
characters

FINLAY COWAN

with BOB HOBBS, JEFFREY CATHERINE JONES AND SAYA URABE

IMPACT

This book is dedicated to
Tyler Swift-Cowan

A DAVID & CHARLES BOOK
Copyright © David & Charles Limited 2007

David & Charles is an F+W Publications Inc. company
4700 East Galbraith Road
Cincinnati, OH 45236

First published in the UK in 2007

ISBN-13: 978-1-60061-011-0 hardback
ISBN-10: 1-60061-011-0 hardback

Printed in Singapore by KHL Printing
for David & Charles
Brunel House Newton Abbot Devon

Commissioning Editor Freya Dangerfield
Assistant Editor Emily Rae
Art Editor Sarah Underhill
Production Controller Kelly Smith

Visit our website at www.davidandcharles.co.uk

David & Charles books are available from all good bookshops; alternatively you can
contact our Orderline on 0870 9908222 or write to us at FREEPOST EX2 110, D&C
Direct, Newton Abbot, TQ12 4ZZ (no stamp required UK only); US customers call
800-289-0963 and Canadian customers call 800-840-5220.

Contents

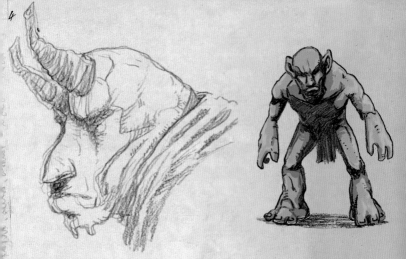

Introduction

The colourful and exciting characters that inhabit the fantasy worlds created by a number of artists and authors all have their roots in the wider world of myth and legend. Folktales from the world over since time immemorial have given modern artists a range of mythic archetypes on which to base their characters. This book provides an introductory guide to these 'classic' archetypes and gives both aspiring and established creators a core selection of the fundamental icons from which all fantasy characters have evolved. This book aims to both inspire and educate artists in the difficult task of unleashing your imaginations and help kick-start the process of creating your own fantasy worlds.

Numerous are the books and websites on myths where you will find endless documents about the most wonderful and fascinating folktales and characters from around the world. But, eventually, the text becomes as dry as the parchment it was first written on and even the most exciting story becomes monotonous without the flair and drama of the artist or storyteller to bring it life and excite and enthrall the audience. That's the secret – we can all find the story, but can we tell it? That's where this book comes in.

This book takes a diverse collection of classic character types from a variety of cultures around the world, and looks at all the different ways in which it is possible to bring them to life – to breathe life into those ideas and turn them into figures that inspire us... to make the fantastic believable.

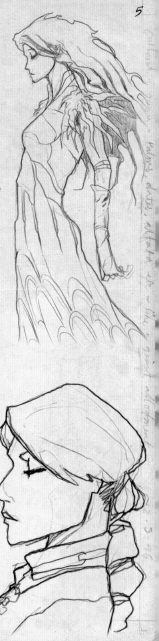

The book is arranged according to generic types: heroes, heroines, villains and half-humans and also looks at all the supporting characters that you might find in any fantasy epic, such as merchants, soldiers and mad scientists.

Each spread includes a short description of the origins of the fantasy character followed by some basic tips on how the artwork was produced. Then you will find some advice and ideas on how to develop your own character, usually with a few examples of characters from myths and folktales from around the world. You will also find many suggestions and ideas for story development that will help you understand how to enhance dramatic situations for your characters. Finally, you will find a few keywords to help you carry out your own research.

Aims

When I was growing up people use to say, 'Use your imagination'. I used to hate hearing this because it sounded so simple but the truth was – I didn't know *how* to use my imagination. The thing is, you have to *feed* your imagination; when you are trying to think of a hairstyle for your drawing of a faery you need to have 20 ideas for hairstyles in your head just to get one good one down on paper. And that's what this book is about, its main aim is to feed your imagination so when you think 'warrior' you don't just think 'furry boots' and 'loincloth'. We will look at the classic archetypes, and how they are normally portrayed, then suggest a few variants that will hopefully inspire you to seek out new possibilities for the stereotypes we all know and love. This book will help you to look at the typical formulas, then show you how to come up with a new angle or a modern spin on them. Using your imagination isn't easy – you have to feed your head!

My aim with this book is to ignite the spark that will turn you from the story reader into the storyteller... this book should act as the bridge between finding the character and bringing it to life. How is it done? Turn the page for a few basic points to consider...

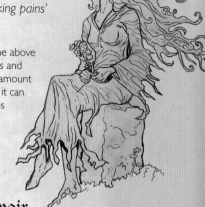

Put the hours in

'Genius is an infinite capacity for taking pains'
Thomas Carlyle

When the Scottish philosopher made the above comment he was saying that great artists and thinkers will always go to an enormous amount of effort to make their work as good as it can be. He was suggesting that being a genius isn't something you are born with… it is something you achieve by just putting the hours in. It would be a pleasure to have all the time in the world but the pressure of a deadline can be good too.

Fill the reservoir

The creation of a believable fantasy world involves an inverse pyramid of research, text and imagery. You always start off with far more information and imagery than you need. For example, there was far more research, notes and drawings left out of this book than actually ended up in it. This is a natural process of refining and defining your ideas… you need to put a lot of material into your reservoir.

Use personal experience

You can fall in love with a place. You can fall in love with every tiny detail of it – every leaf, every flower, the scents, the sights, the smells. Let your heart lead you to the places that you love. Then, whenever you turn a page, you will find yourself returning to that place in your mind; you will remember the slant of sunlight on the grass, you will remember the shape of a flower or leaf. The love you have for a place or memory will inform your art and you will return to that special place in your heart again and again throughout your artistic career. That special moment in your life will become one of your themes.

The same can be said for people; the ones you love will haunt your work forever and you will always be trying to capture their hair or their smile. They will mark you for life and you will return to them again and again. It doesn't matter what happens in the real world – they will always re-appear in your work and their presence in your life will help define your look and style as an artist.

You can't put something of yourself into every single drawing or story you create but it's good to always try and put something emotional into your work. If your work has personal aspect to it then

it will have more depth and there will be a good chance that the emotional charge of the work will transfer to the viewer or reader. It is this emotional involvement that will give a work meaning and, hopefully, it will stand out from work that is sterile and soulless.

Look in the right places

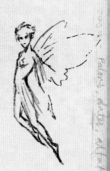

Don't ever use other fantasy art as a reference point – use it for inspiration but you have thousands of years of art and history to find details and ideas. Don't get stuck on the latest Hollywood film. One of the hardest things with carrying out research is knowing where to begin, so at the bottom of each page in this book you will find a list of ideas for further study, that you can use to find imagery and information. You can use these as keywords on the Internet or at your local library to find amazing visual examples of everything you need to inspire you and flesh out your designs, For example, typing in the words 'Orientalist painters' will lead you to an enormous list of the artists who travelled in the Middle East during the 18th and 19th centuries. You will find a wealth of details in their work that you can then copy into yours; you will find shoes, weapons and costume details that you could never get from looking at fantasy paintings and films, and this will help you bring new ideas and skills into your work, which will, in turn, help you in your career as you build up your own reference library of historical imagery.

Draw every day

One thought struck me hard during the production of this book: You have to draw every day. Fact. I was producing artworks here and there in between other jobs… and they were OK… but the whole process wasn't really clicking for me. Then I got a month of free space and worked on the book all day every day. In the first ten days that I sat down to do this I produced a lot of bad work. There were a few good ones here and there but for ten long, lonely days I was just not in my rhythm. Then, on the eleventh day I hit my stride, I was 'in the zone' so to speak and in one weekend I churned out 90 drawings, all of which were pretty good (well, I was satisfied with them anyway).

The point here is that you have to be prepared to produce a few bad drawings every single day in order to be able to produce a good one every now and again. This thought should give you some comfort when you are, indeed, producing nothing but a load of rubbish. Don't let those bad drawings and those bad ideas get you down. You have to churn out some dross to get to the good stuff.

Equipment

Many of the artworks in this book have been produced using computers and software such as Photoshop but this doesn't mean it's essential to have a computer, scanner and graphics tablet. This book's aim is to show you how to use your imagination, not how to use a computer.

Pencils, paper and ink

The majority of artworks in this book are produced with nothing more than pencil and paper and could be coloured just as effectively with crayons, felt-tip markers or coloured pencils, which is great because a pencil and paper is the cheapest tool you can buy in any business. I didn't start using computers to colour my work until I had been working for 14 years! Up until then I had relied on pencil, paper and ink. People hired me because of my imagination… and my skills at drafting. So, don't be put off by having a lack of equipment – it can be an advantage.

Brushes and paints

Brushes and paints have been around since the beginning and they are still the number one tools of choice for any artist. This may have something to do with the fact that they are very responsive to the hand and allow the artist a great deal of expression. You can use watercolours for working quickly and creating great colour blends and effects; oils and acrylics require more technique but allow you more freedom and potential than watercolour. Use coloured inks for creating areas of flat colour. As for brushes, the simple truth is you get what you pay for – the best approach is to start out with a bunch of cheap brushes and one or two expensive ones.

Computers

If you decide you can't live without the opportunities offered by digital art and you decide to buy a computer, make sure it's the best you can afford… and that means cancelling that holiday or resisting the temptation to buy the *The Lord of the Rings* boxed set, no matter how essential it may seem for 'research' purposes. Do your research on the Internet or public library. A computer can be a

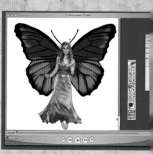

huge advantage to producing, reproducing and disseminating your work. The cybersphere may be confounding at first but be patient and enjoy the journey – if you find that it's not for you, then that's fine, the traditional mediums of drawing and painting are still valid.

Other materials

As an aspiring artist the first thing you should do before you do anything else is go out and buy a human skull – it's absolutely essential. Some people may say this is ghoulish, they may even say it's sick… and they'd be right.

A word of encouragement

Most of you who know my work know this: I'm great with a pencil and not bad with ink. But, a) I'm lousy with a brush, and b) I can't paint to save my life. I can handle Photoshop to a reasonable degree but I don't know where to begin when it comes to all those wonderful 3D packages everyone's using these days.

So how does this help you? Well, I'm not saying you should be lazy, but ask yourself – 'can I really be absolutely the best at *everything*?' Maybe it's a matter of being brilliant at one thing and merely 'good enough' at everything else. In my case I compensate for being bad at painting by being able to touch up my paintwork in Photoshop. So it's a matter of trying a bit of everything to begin with, then focusing your energy on an area that really suits you and, more importantly, finding the area that you are prepared to go the distance with.

Finlay uses:

- 0.9mm propelling pencil with B leads
- Any paper he can get his hands on
- Lightbox made for him by his Dad
- Muji propelling erasers
- Adobe Photoshop
- Faber Castell Pitt Artists black ink pens
- Schminke watercolours
- Macintosh G4 Powerbook laptop, DVD superdrive with a 17in screen
- About 1 terrabyte of external hard drives for backing up

Saya Urabe uses:

- Macintosh eMac and iBook
- Adobe Photoshop
- Corel Painter
- Adobe Dreamweaver
- Adobe Fireworks
- Zebra round pen, school pen and G pen
- Kaimei inks

Bob Hobbs uses:

- Autodesk 3D Studio MAX
- Curious Labs / e-Frontier Poser
- Eon Software Vue d'Esprit
- Adobe Photoshop

Jeff Jones uses:

- Oil
- Canvas
- Acrylic
- Pencil
- Pen
- Ink

Sources of fantasy characters

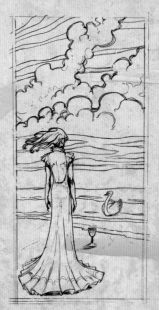

Before we look at specific sources for your artwork, it is first necessary to answer a few frequently asked questions…

What is the difference between mythology and folklore?

Myth and folklore have been the subject of serious academic study and can't easily be summarized but, in short, a myth is part of a structure of ideas and practises used by a form of priesthood as a means of organizing and educating a society through a series of rituals and laws. Folklore is a more organic process, a series of ideas and stories passed on orally. Both systems are similar; they are used to inform and educate, and sometimes control a society. The main difference between the two seems to be that myths are used by a priesthood to get a population to behave and folktales are used by parents to get their kids to behave.

What is the social function of myth and folklore?

Myths and folktales are said to have a 'social function'. For example, the abundance of creatures in Northern European folklore that kidnap children is a clear attempt to warn children of the dangers of strangers. It is worth studying the work of mythographers as it can help in the process of placing your fantasy characters in a social context that's relevant to the world we live in today.

Do you believe in faeries and elves?

When asked this, my answer is 'no' but I do believe in the social function of myth, and for me this is much more important than believing in whether these creatures exist or not. The fact that myths and folktales, both ancient and modern, have a social function makes them relevant and gives them a purpose in our lives.

For centuries artists and writers have redefined ancient characters for new audiences. Sometimes the modern writer will drain the original myth of all its power and mystery but a good artist will breath new integrity and heroism into them to inspire and guide a new generation of readers.

Principal sources

Fantasy art and fiction owes its existence to a multitude of historical sources of which the main sources are the following:

Nordic

NORSE MYTHOLOGY This is the pre-Christian religion of the Scandinavian countries and bears many similarities to the older Germanic mythology, which had evolved from Indo-European mythology.

THE EDDAS This collection of poetic verses existed in oral traditions and are a part of Norse mythology. The Norse Sagas are historical stories ranging from early Viking explorations to tales of kings and ordinary people. Their inclusion of supernatural subjects and a heavy belief in fate has made them important sources for fantasy artists and writers.

THE NIBELUNGEN This is the name given to a dynasty of kings whose exploits appear in Old Norse manuscripts and the Eddas. They were a huge influence on Wagner and Tolkien.

European

THE MABIGNION This is a collection of stories told in verse form. They date from the Middle Ages but it is believed that many of the stories are older.

ARTHURIAN LEGEND The stories of King Arthur and his Knights were first written down by Sir Thomas Mallory in 'Le Morte D'Arthur'. The precise origins of King Arthur are uncertain but the stories of Excalibur, The Lady in the Lake and Merlin have inspired artists and writers for centuries.

THE BROTHERS GRIMM These brothers travelled around Germany collecting folk stories and eventually published them in 1812. It is believed that many of the stories were written down as they had been spoken and are considered to be a pure resource of folklore.

ANDERSEN Hans Christian Andersen was a collector of folk stories who re-wrote them for publication.

Modern influences

Machines, imagery, costumes and storylines from the Victorian period have become popular in fantasy fiction in recent years. This mix of modern and ancient imagery has led to many interesting 'hybrid' realities, which continue to refresh the genre. It is possible to create a mix of historical periods to create an interesting fantasy world.

Other sources

The religions of ancient empires have proved to be a rich source of material for fantasy art and fiction. Ancient Egypt, Rome and Greece are principal sources and there is an endless supply of heroes and monsters in the mythologies of Persia, Sumeria and Mesopotamia.

It is also worth studying the mythologies of Asia, India, Eastern Europe and Russia, The Far East, Africa, the Americas, Australasia and Oceania.

Definition of folk characters

Fantasy is a general term that includes faerytales and folklore, myths, legends, sword and sorcery and even elements of modernism and surrealism. The world of myth is peopled by a diverse range of fascinating species whose identities often get mixed up and it is probably unnecessary to try and be pragmatic about folk characters whose origins are shrouded and whose function varies from place to place.

Folktales were passed from person to person and evolved from town to town as they were carried by merchants and minstrels. The beauty of this gradual evolution is that stories changed to fit specific locations but similar characteristics can be found right across Europe and even throughout the world. Dwarves and gnomes have clear definitions in most cultures whereas goblins and brownies are very generic terms, which are harder to pin down.

Faeries and elves

These are two of the major species of the fantasy genre and can be traced to similar origins. Faeries have their roots in an ancient race of immortals called the Tuatha Dé Danaan who lived in Ireland, while elves have their roots in early Scandinavian myth. Both species were tall, beautiful, fair haired and dressed predominantly in white. Over time they were reduced in size and became the 'little people' of popular belief and splintered into a variety of 'shadow tribes' which included everything from leprechauns to pixies.

One thing we can be certain of is that, after much comparative study, there is no such thing as a small elf in a pointy hat who is said to be Santa's helper – these characters are undoubtedly gnomes…

Geographical location

When we entertain ourselves with the creations of fantasy, we usually see in our mind's eye another age, inhabited by people in various costumes from human history – from the finery of Egypt to the chivalric dress of medieval Europe. But folklore and fable are a living, breathing thing and the creation of fantasy stories is a necessary part of modern life. These visions enable us to escape, to imagine, and most importantly they act as metaphors that tell us how to live, how to behave and how to achieve. All you have to do is a visit a place with a knowledge of local folklore and you begin to see it all around you… go to Australia with a knowledge of dreamtime or the forests of Northern Europe with the traditions of faery folk in your mind's eye and you will see its relevance and meaning. The natural world resonates constantly with stories from myth – you'll see trolls in every gnarled tree stump, faeries in every strand of floating gossamer and elves in every ring of mushrooms… Every time you read a story and pass it on, you will find yourself confronted with new stories and new connections.

Synthesis of folklores

Another natural development in the evolution of folklore is the tendency for myths to merge together and this has been lamented in recent years. On the one hand it is quite natural for the various species of the shadow tribes to intermingle with one another as their stories are told and re-told. On the other, it can lead to a loss of the power and diversity of ideas. This is most obvious in modern films where the difference between good and evil is more distinct than it was in days gone by.

Modern fantasy filmmakers have admirably succeeded in refining storylines and giving audiences what they want, but they are often missing out on one fundamental aspect of storytelling – the unexpected. This view of big business can be reflected in our own personal struggle to be creative as individuals. Ultimately, it is a matter of finding the balance between producing something familiar and allowing ourselves the freedom to unleash the deep subconscious visions that we are all capable of producing. If you go too far in either direction, you end up with something that makes no sense and fails in its primary objective: to inspire, entertain, enchant and enthral… to make sense of your life and the world and offer your tiny but significant contribution to the evolution of the human race and the creation of a better world.

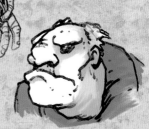

ART BY BOB HOBBS

BARBARIAN

THE BARBARIAN IS SEEN AS THE ARCHETYPAL WARRIOR WHO USES BRUTE STRENGTH AND RAW FURY TO EXCEL IN COMBAT. THE WORD COMES FROM THE ANCIENT GREEK WORD *BARABROS*, WHICH BASICALLY MEANT ANYONE WHO WASN'T GREEK. THE ROMAN TERM 'BARBARA' REFERRED TO THE GERMANIC TRIBES - AND IT IS PROBABLY FROM THESE TRIBES THAT WE HAVE THE IMAGE OF THE LONG-HAIRED, AXE-WIELDING WARRIOR THAT WE ASSOCIATE WITH THE ARCHETYPAL BARBARIAN.

THE ROMANS DESCRIBED ALL THE VARIOUS GERMANIC TRIBES, THE GAULS AND THE HUNS AS BARBARIANS, LUMPING THEM TOGETHER AS ONE UNPLEASANT THORN IN THEIR SIDE.

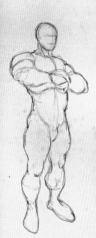

Development

• The archetypal barbarian shown here is a staple of the 'sword and sorcery' genre of fantasy fiction.
• Add a spin on this popular look by experimenting with tattoos, hair braiding and varieties of ponytails and other hair accessories.
• Consider the practical elements of how this character might dress in different environments: in a mountainous region he might carry ropes and interesting hooks and grapples; in a desert he would carry a heavy water skin and wear a turban to protect him from the sun.

Media and Execution

• Poser 3D software and Photoshop.
• A pencil sketch was recreated in 3D in the Poser program, using the Freak model, available from DAZ software.
• The texture maps for each element were in one file to be opened and altered in Photoshop (above right).
• Once rendered out, the image was exported to Photoshop and worked on there, the most important thing being the hair.
• The hair was created using a fine Airbrush tool and a Wacom graphics tablet and pen (above centre).

FURTHER STUDY: Conan, Kull, *Dungeons and Dragons*, Warhammer

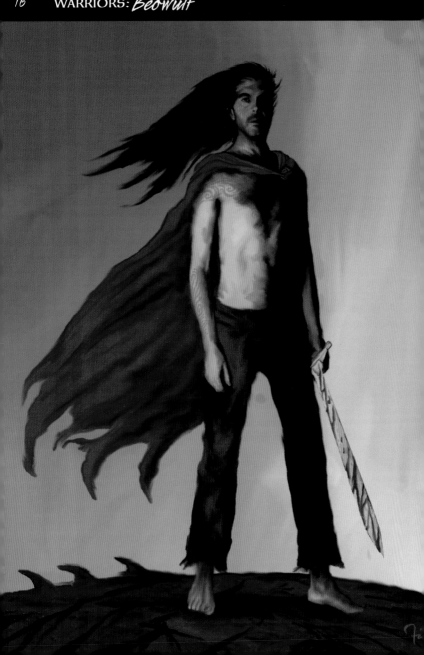

Beowulf

THE EPIC POEM 'BEOWULF' WAS WRITTEN IN OLD ENGLISH. THE ORIGINAL MANUSCRIPT WAS WRITTEN IN THE 11TH CENTURY AND IS HISTORICALLY IMPORTANT BECAUSE IT IS THE BEST OF VERY FEW EXAMPLES OF THIS ANCIENT LANGUAGE. THE POEM IS PART HISTORY AND PART MYTH, AND BEARS ALL THE HALLMARKS OF THE CLASSIC FANTASY STORIES WE KNOW TODAY. IT TELLS OF A SWEDISH HERO, BEOWULF, WHO SLAYS A MONSTER, GRENDEL, AND EVENTUALLY KILLS A DRAGON TOO, BUT DIES OF WOUNDS RECEIVED IN THE BATTLE.

TOLKIEN WAS AN EXPERT IN OLD ENGLISH, AND THIS POEM WAS A MAJOR INFLUENCE ON THE STYLE AND MYTHOLOGY OF THE LORD OF THE RINGS. WITH ITS CLASSIC ELEMENTS OF HEROISM AND VANQUISHING MONSTERS, BEOWULF IS THE ARCHETYPAL FANTASY HERO.

ART BY FINLAY
MODEL LOU SMITH

Development

• Extreme facial tattooing or makeup (far right) can give your hero a fearsome appearance.
• Real Vikings (top centre) wore loose linen trousers and a simple cloak, but are usually depicted with horned helmets and furry loincloths.
• Most warriors would receive numerous wounds and scars during a lifetime of combat.

Media and Execution

• Fine pencil and Photoshop.
• The figure in the basic photo required significant changes to hair and posture. Shadow areas were manipulated a great deal.
• Background, clothes and sword were hand-drawn, and facial tattoos drawn on a separate layer in Photoshop. Opacity was reduced to make them faint.

FURTHER STUDY: Electronic *Beowulf* (British Library), sagas, epics

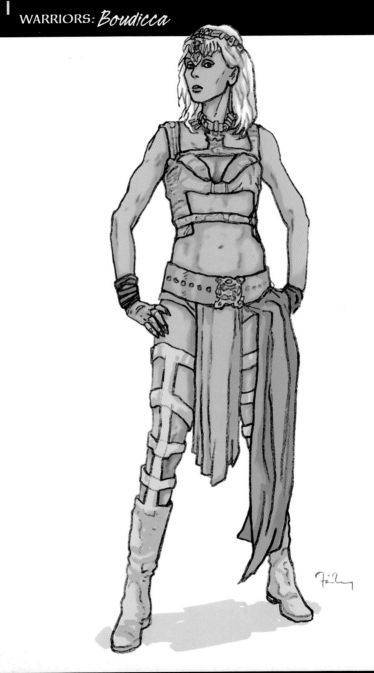

Boudicca

BOUDICCA WAS A CLASSIC WARRIOR QUEEN WHO RULED THE BRYTHONIC CELTIC ICENI TRIBE OF EASTERN BRITAIN AROUND 60 AD. SHE BECAME A POPULAR FIGURE BY LEADING A REVOLT AGAINST THE ROMANS, WHO OCCUPIED BRITAIN AT THAT TIME, AND WAS FAMOUS FOR BEING AT THE FOREFRONT OF THE BATTLE, FIGHTING AT THE HEAD OF HER ARMY.

IN THE EARLY STAGES OF THE REBELLION HER ARMY SEIZED AND DESTROYED THREE ROMAN CITIES, INCLUDING LONDON, BUT ROMAN TECHNOLOGY AND DISCIPLINE EVENTUALLY PREVAILED. LEGEND SAYS THAT BOUDICCA POISONED HERSELF TO AVOID BEING CAUGHT.

Media and Execution
• Fine pencil and Photoshop.
• The warrior queen was based on a photograph which was traced over with a hard line pencil on the lightbox.
• The proportions were adjusted to make the figure taller and more muscular.
• Adjustments were made to hair and clothes before scanning the pencil drawing and colouring it in Photoshop.

Development
• Boudicca was tall (above) with long red hair. The dreadlocks and hair jewellery shown above are not necessarily true for this period, but may have existed.
• She was famous for her piercing stare (right), to make herself appear more fearsome to her enemies.
• The main picture shows an entirely fanciful interpretation of a warrior queen, using the styling and clothing of modern fantasy characters.
• The average soldier wore simple clothes from rough materials in earthy colours (far right). Basic check patterns existed, and the wicker shield is typical of the period. Hammers were often used as weapons.

FURTHER STUDY: Queen Cordelia, Queen Gwendolen ART BY FINLAY, MODEL JANETTE SWIFT

Female hero

FEMALE HEROES HAVE PLAYED A SIGNIFICANT ROLE IN MYTH AND FICTION SINCE THE DAWN OF TIME, AND FROM THE AMAZONS OF DAHOMEY TO BLENDSA OF SWEDEN, STRONG FEMALE FIGHTERS HAVE FORMED AN ESSENTIAL PART OF MOST ADVENTURE STORIES. ROBERT E. HOWARD HELPED DEFINE THE IMAGE OF THE SWORD-WIELDING FEMALE WITH HIS CHARACTER RED SONJA AND INCREASINGLY BOOKS, FILMS AND COMPUTER GAMES HAVE FEATURED FEMALE HEROES. THESE HEROES ARE OFTEN BASED ON HISTORIC FIGURES SUCH AS TOMOE GOZEN, ONE OF A VERY RARE BREED OF FEMALE SAMURAI WARRIORS (AROUND 1180).

Development

• Research figures from history, such as the warrior queens of Mesopotamia (top), who can provide inspiration and storylines for your fantasy heroines.
• The Far East is a good source of ideas for strong fantasy characters: modern Manga comics and computer games draw their influences from this rich vein (centre).
• The Amazons of Dahomey (below) were an all-female regiment of the Fon tribe in West Africa, which continued up until the late 19th century. They were said to be extremely cruel to their captives and were accorded a sacred status, detached from normal life.

Media and Execution

• Oils and acrylics can take a lifetime to master, but can result in a depth of form and colour that can't be achieved with any other medium.

FURTHER STUDY:
Blendsa, Amazons, Liath Luachra, Kaipkire, Tomoe Gozen, Chelidonis, Kunoichi, Mai Sukhan, Boudicca

MAIN PAGE ART BY JEFF JONES, OTHER ART BY FINLAY

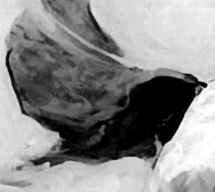

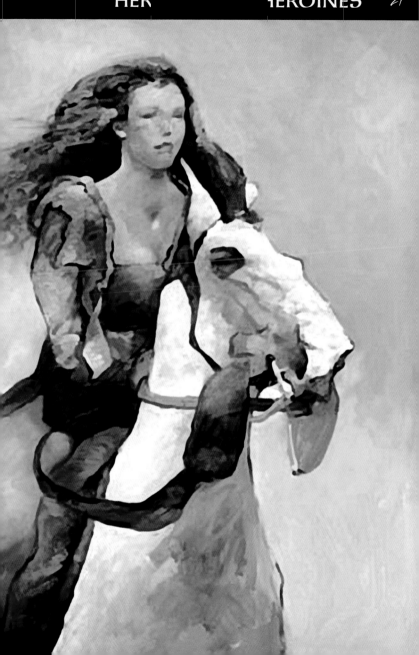

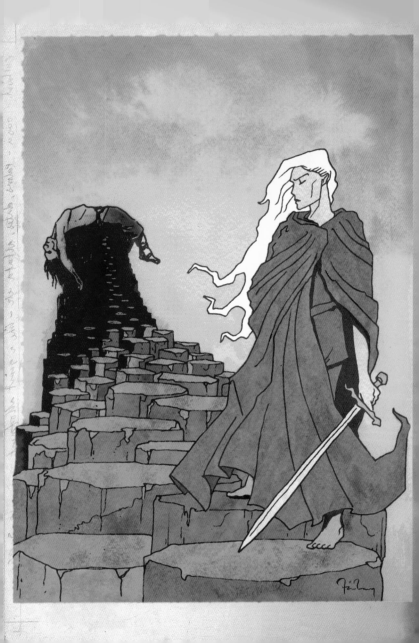

Finn mac cool

FINN MAC COOL/ OR FIONN MAC CUMHAIL/ WAS A POET/ WARRIOR AND MAGICIAN FAMOUS IN IRISH AND SCOTTISH MYTHOLOGY IN A SERIES OF STORIES KNOWN AS THE FENIAN CYCLE. FINN WAS THE SON OF THE LEADER OF A TRIBE CALLED THE FIANNA/ BUT HIS FATHER WAS KILLED AND FINN GREW UP IN HIDING/ VOWING TO AVENGE HIS FATHER'S DEATH. HE WAS TAUGHT HIS SKILLS AS A WARRIOR AND HUNTER BY A WISE WOMAN NAMED LIATH LUACHRA.

A STORY TELLS HOW HE BUILT THE FAMOUS GIANT'S CAUSEWAY IN IRELAND TO AVOID GETTING HIS FEET WET. I CHOSE THIS STORY TO PICTURE HERE AND CROSSED IT WITH HIS FAME AS THE 'GIANT KILLER'. IT IS SAID THAT FINN STILL LIVES/ SLEEPING IN A CAVE UNDER DUBLIN/ READY TO RISE AGAIN AND FIGHT FOR IRELAND IN A TIME OF NEED.

Media and Execution
• Watercolour and ink pen.
• The original pencil drawing was traced off on to watercolour paper.
• The watercolours were limited to just two or three complementary colours; water was added to 'erase' or lighten areas.
• The ink line was added when the colour had dried.
• The colours were adjusted in Photoshop, and the ink layer was used to select colour areas, which were then adjusted using the Hue/Saturation dialog box.

Development
• My name, Finlay, is derived from Finn and means 'white warrior', which gave me the idea for his white hair. Look into the history of your name and see what ideas it gives you.
• Consider using secondary characters such as Liath Luachra as the basis for your characters.
• The colours reflect the famous hexagonal basalt columns in Ireland.
• Finding your character can be a matter of trying variations of facial style and hair. In this drawing (far right) I tried to make Finn more of a tough-looking warrior but kept his signature fair hair.

FURTHER STUDY: Fenian Cycle, Beowulf, Gilgamesh, Ulysses

ART BY FINLAY

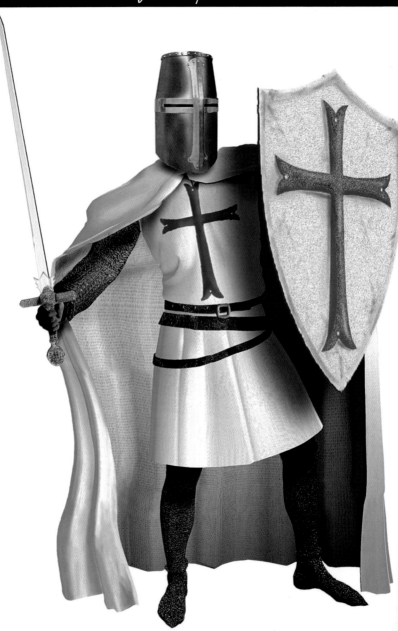

Knight templar

THE WORD KNIGHT DERIVES FROM OLD ENGLISH CNIHT, MEANING A KIND OF PAGE BOY OR SERVANT. THEY WERE THE LOWEST FORM OF ARISTOCRACY, BUT THIS WAS A LOT BETTER THAN BEING A PEASANT; THEY WERE GIVEN LAND AND TREASURE AS REWARDS FOR THEIR ALLEGIANCE AND, IN RETURN, THEY WOULD FIGHT FOR THE KING WHENEVER CALLED UPON.

THE ORDER WAS CREATED AFTER THE FIRST CRUSADE OF 1096 TO PROTECT EUROPEAN PILGRIMS TRAVELLING TO JERUSALEM FOLLOWING THE CHRISTIAN CONQUEST. THEY PERFORMED THIS SOCIAL DUTY FOR ABOUT TWO CENTURIES BEFORE THEY WERE ALLEGEDLY ROUNDED UP AND MURDERED BY THE CHURCH AND MONARCHY FOR BEING TOO RICH, TOO INFLUENTIAL AND FOR STEALING THE HOLY GRAIL.

Media and Execution

• Poser 3D software and Photoshop.
• The figure was created in Poser complete with most of the basic uniform available from the software.
• Appropriate texture maps were added to the basic model elements, such as the white linen fabric for the tunic and cape, worn leather for the belts and a texture for chain mail.
• The shield, sword and helmet were created in Photoshop based on photos found online.
• The red cross was painted on the tunic and duplicated on the shield in Photoshop.

Development

• When working in a fantasy context, you don't have to be historically accurate – mix clothes and armour from different periods to create new types of character.
• Add Viking ornament or the braids of Russian Cossacks to your medieval knight.
• What would Knights Templar wear if they were in a cold climate instead of the hot climates normally associated with them?

FURTHER STUDY: Knights Templar, Arthurian legends, Holy Grail, Medieval warfare

ART BY BOB HOBBS

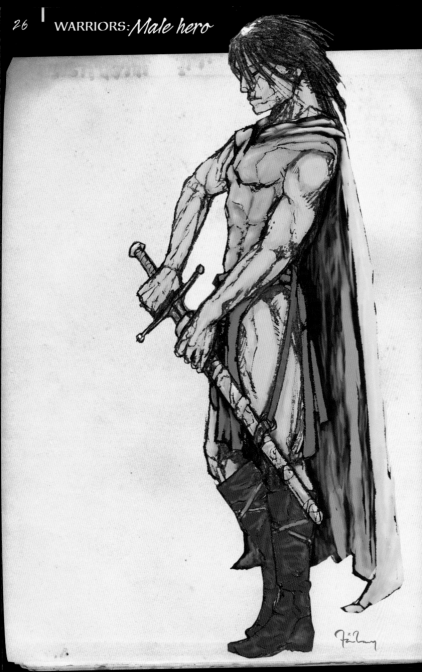

Male hero

THE WARRIOR IS A DOMINANT FIGURE IN FANTASY ART AND FICTION. GENERALLY SPEAKING, A WARRIOR IS A PERSON WHO DEVOTES ALL THEIR TIME TO THE ART OF WAR AND IS THEREFORE HIGHLY SKILLED IN MANY WARLIKE ACTIVITIES, FROM ARCHERY AND SWORDFIGHTING TO MARTIAL ARTS AND EVEN MAGIC.

IN HISTORY, ENTIRE SOCIETIES OR TRIBES WOULD BE CLASSED AS WARRIORS, WHILE IN OTHER CULTURES WARRIORS WOULD FORM THEIR OWN CLASS, WHICH ADHERED TO A STRICT SET OF PRINCIPLES OR CODES OF CONDUCT. MANY WARRIORS WERE TRAINED TO FIGHT FROM BIRTH AND SCHOOLED IN VARIOUS PHILOSOPHICAL TEACHINGS, INCLUDING CONCEPTS OF 'HONOUR' AND 'CHIVALRY'.

Development

- Warriors are likely to have highly developed musculature, so pay attention to good muscle tone and definition.
- Typical postures are likely to be dynamic or steadfast, and the character should reflect these mental qualities (far right).
- Experiment with different braidings for beards, different methods of shaving heads and piercings (right and below).

Media and Execution

- Fine pencil and Photoshop.
- A loose pencil drawing was put through the Watercolor filter in Photoshop to make it look more like ink.
- Colours were added on several opaque layers before being merged on to one layer.
- Shadows were added using the Dodge and Burn tools.

FURTHER STUDY: Hero, Paladin, chivalry, Bushido, Samurai, Kshatriya

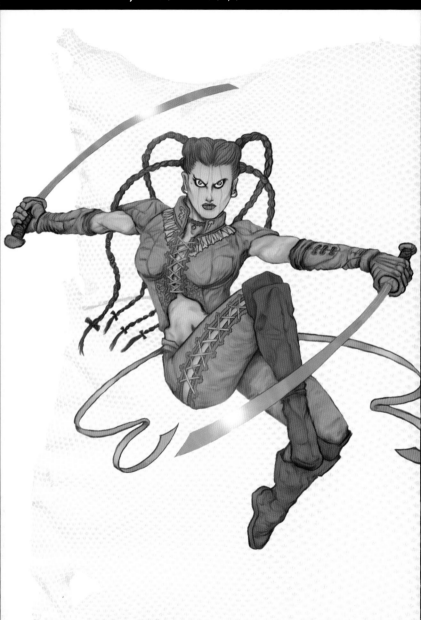

MARTIAL ARTIST

THE TERM 'MARTIAL ARTS' APPLIES TO A WIDE RANGE OF COMBAT SKILLS, MOST BASED ON FAR EASTERN TRADITIONS, SUCH AS JUDO, KARATE AND KUNG FU. TRADITIONALLY, A MARTIAL ART IS A HIGHLY ORGANIZED SYSTEM OF TRAINING WITH AN EMPHASIS ON DISCIPLINE, SELF-DEFENSE AND SELF-DEVELOPMENT PRACTICES, SUCH AS MEDITATION AND PHILOSOPHY. THESE TRADITIONS HAVE MADE PRACTITIONERS OF MARTIAL ARTS A POPULAR FOCUS FOR CHARACTERS IN FANTASY AND SCIENCE FICTION GENRES.

MARTIAL ARTISTS MAKE APPEALING CHARACTERS BECAUSE THEY CAN COME WITH VALUES, SKILLS AND WEAPONS THAT DEFINE THEIR CHARACTER, GIVING THEM A UNIQUE IDENTITY.

Development

- Look at images and films of martial arts to provide an excellent starting point for your creations.
- I experimented with a character look and clothing style that was more Indian than Far Eastern, creating an elaborate mix of styles that bears little resemblance to an existing martial art form.
- Your characters do not have to be historically or anatomically accurate: use references as a springboard to develop your own ideas.

Media and Execution

- Fine pencil and Photoshop.
- The original drawing was produced with a mixture of soft and hard pencil lines.
- Colours were added in Photoshop on several layers.
- These were then merged together and painstakingly blended to produce a painterly effect.
- The highlights were added last.

FURTHER STUDY: Samurai, Ronin, Savate, Kung Fu, Karate, Bushido, Judo, Capoiera

ART BY FINLAY

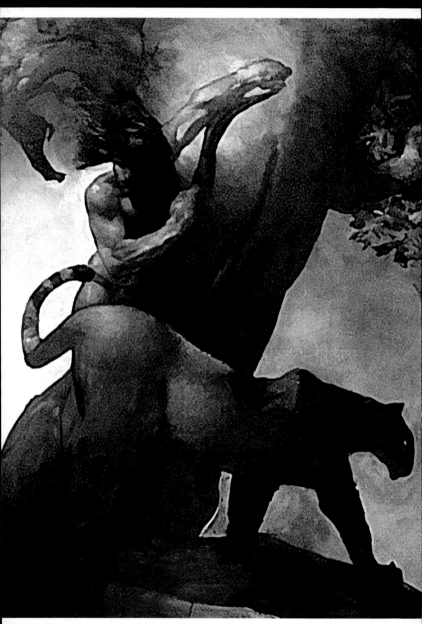

MAIN PAGE ART BY JEFF JONES, OTHER ART BY FINLAY

PRIMITIVE HERO

WHERE THE CHARACTER OF BEOWULF PROVIDES THE TEMPLATE FOR THE ARCHETYPAL FANTASY HERO, THE PRIMITIVE HERO IS, PERHAPS, THE ORIGINAL HERO. HE EXISTS OUTSIDE OF CIVILIZATION OR EVEN BEFORE CIVILIZATION HAS EMERGED, AND THIS IS PART OF HIS APPEAL - HE REPRESENTS THE MOST BASIC NEEDS AND DRIVES OF MANKIND. HE HAS NO LOFTY AMBITIONS OTHER THAN TO SURVIVE AND AVOID BEING EATEN, AND IS OFTEN ABLE TO COMMUNICATE WITH ANIMALS AND IS CLOSE TO NATURE.

ARTIST JEFF JONES HAS LONG BEEN FASCINATED BY SUCH 'ANTEDILUVIAN' SUBJECTS AND THE MAIN PAINTING HERE CAPTURES MANY OF THE QUALITIES OF THE PRIMITIVE HERO: HIS PROXIMITY TO THE WILD, THE PREHISTORIC ENVIRONMENT AND, IN THE STYLE OF THE ART, THE DARK, PRIMEVAL PERSONA THAT THE CHARACTER EXUDES.

Media and Execution

• Oils can be used to create highly realistic forms as well as dense, flat areas, both of which can be seen in this example.

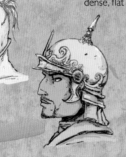

Development

• Greek mythology is full of super-powered heroes, the most famous of which was Heracles, famous not only for his power and strength, but also his guile and cunning (first sketch above).
• Gilgamesh (second sketch) was said to be a Sumerian king. His legend gives him superhuman powers.
• Roland (third sketch) was a hero of medieval literature throughout France and Germany and was based on a living figure. It was said he had an unbreakable enchanted sword named Durendal.
• Siegfried (far right) features in the epic poem the *Nibelungenlied*, which tells of how he slayed the dragon Fafnir, stole his treasure and then bathed in its blood, which made him invulnerable.

FURTHER STUDY:
Tarzan, Sumerian myth, Greek myth, Medieval and Romantic legends and myths

ART BY FINLA

Boy Hero

THE BOY HERO IS A CLASSIC ARCHETYPE OF THE FANTASY GENRE AND CAN BE FOUND AT THE CENTRE OF A WIDE RANGE OF STORIES. THIS TYPE OF CHARACTER IS WIDESPREAD BECAUSE HE APPEALS TO ALL AGES AND IS ACCEPTABLE TO BOTH MALE AND FEMALE FANS.

BOY HEROES TEND TO HAVE AN INNOCENCE THAT PROVIDES THEM WITH MORAL INTEGRITY AND NO SHORTAGE OF FEARLESSNESS. THE DYNAMIC POSE OF THIS FIGURE WAS TAKEN FROM WATCHING MY SON RUN ACROSS THE GARDEN - I PARTICULARLY LIKED THE WAY HIS LIMBS SEEMED TO FLAIL IN ALL DIRECTIONS.

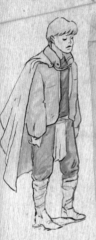

Development
• Try mixing a blend of modern and medieval clothes to develop a look for your character (left).
• Blonde hair (right) works well with darker skin tones for a healthy, suntanned look.
• Experiment with accessories such as jewellery and additions to the hair (far right). The more you add, the more mature your character will look.

Media and Execution
• Fine pencil, technical ink pens and Photoshop.
• Use pencil to make a first rough sketch. Erase the construction lines and get the work tight before moving to inks or a clean, hard pencil drawing.
• The proportions of a child vary from those of an adult: the limbs can be skinnier, and the head is proportionally larger.
• Emphasize the childlike quality by making the hands and feet larger than normal.

FURTHER STUDY:
Frodo Baggins,
Harry Potter,
Lemony Snicket,
Narnia

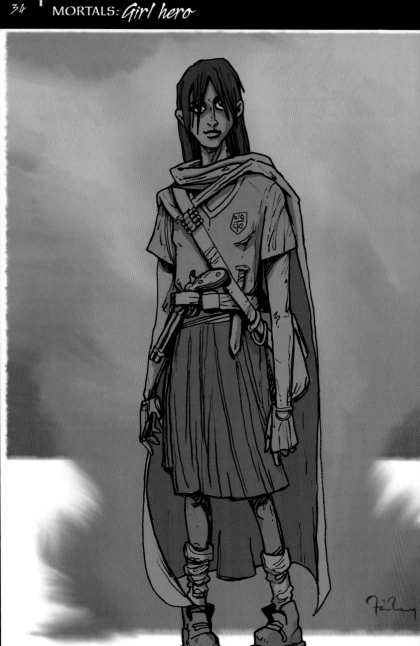

Girl hero

THE GIRL HERO IS A CLASSIC ARCHETYPE WHO APPEARS IN A WIDE RANGE OF FANTASY ART AND STORIES. WE SEE OURSELVES IN THE BOY HERO OR THE GIRL HERO, SO IT CAN BE GREAT FUN TO BASE THESE CHARACTERS ON OURSELVES, OR PEOPLE WE KNOW. I DEVELOPED A STRONG IMAGE OF THIS GIRL'S PERSONALITY WHEN I DREW HER - SHE IS QUITE AWKWARD, A BIT LANKY AND FEELS UNSURE OF HERSELF, SHOWN BY THE WAY SHE HIDES BENEATH HER FRINGE.

DETAILS TELL A LOT ABOUT A CHARACTER: THE SCHOOL BADGE IS A REMNANT OF THE WORLD SHE LEFT BEHIND AND THIS CONTRASTS WITH THE ARCHAIC PISTOL IN HER BELT, WHICH SUGGESTS SHE'S BEEN AROUND PIRATES OR BRIGANDS. HER RAGGED CLOTHES SUGGEST THAT SHE HAS BECOME USED TO A LIFE OF DISCOMFORT AND LIVING ON HER WITS.

Development

- Experiment with a more futuristic, streamlined look (left).
- Suggest a tough, practical look with short hair, work clothes and heavy gloves (below).
- Use signature elements, such as a coloured stripe in the hair, to make a character identifiable (below right).

ART BY FINLAY

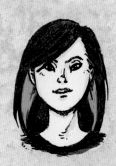

Media and Execution

- Fine pencil and Photoshop.
- The colour range of the character is very limited, but there are subtle differences between every element of clothing.
- The background colours were copied from a photo of some flames then blended using the Smudge tool.
- The background colour shape was adjusted to match the figure.

FURTHER STUDY:
Hermione Granger (*Harry Potter*), Princess Leia, Blendsa (*Swedish folk hero*)

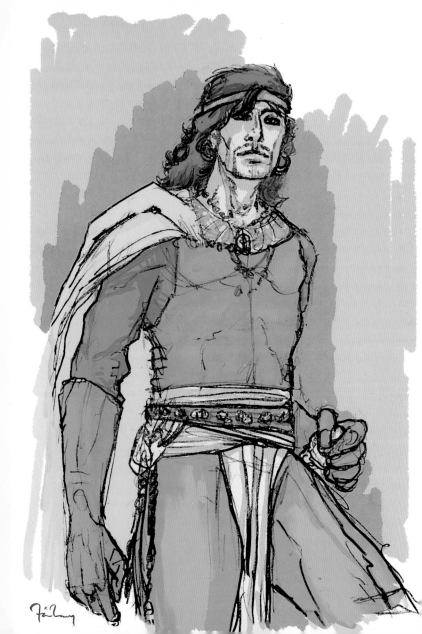

King

A KING IS THE HEAD OR LEADER OF A COUNTRY OR TRIBE. IN ANCIENT TIMES KINGS WERE OFTEN CONSIDERED SUPERHUMAN, AND THEIR HEROIC ACHIEVEMENTS PASSED INTO LEGEND AND BECAME EMBROIDERED WITH TIME. A 'HIGH KING' WAS A KING WHO RULED OVER SEVERAL OTHER KINGS, SUCH AS ARTHUR, UTHER PENDRAGON AND VORTIGERN, ALL CLASSIC ARCHETYPES OF FANTASY FICTION.

A GOOD KING IS NOT LIKELY TO BE AN IMPETUOUS HERO WHO TAKES OFF ON QUESTS; HIS IS A LIFE OF DUTY TO HIS PEOPLE AND HE BEARS A GREAT BURDEN OF RESPONSIBILITY. OTHER KING TYPES MAY BE MORE SELF-INTERESTED IN WHICH CASE THEY BECOME TYRANTS AND USUALLY COME TO A STICKY END.

Development

• The classic king is likely to be middle-aged and have a white beard (right) – but he shouldn't be too old, as he is likely to be an active character.
• Kings are likely to have scars (below), as they were expected to prove themselves in combat.
• Much of character development is about styling: try less obvious haircuts and clothes, such as short hair and a neat tunic.
• Fine clothes are common, and ermine fur has long been associated with nobility.

Media and Execution

• Rough pencil and Photoshop.
• A loose sketch was scanned into Photoshop.
• The colours were applied in rough, broad strokes and then blended together using smudging techniques.

FURTHER STUDY: Arthur, Minos, Agamemnon, sultans, rajas

ART BY FINLAY

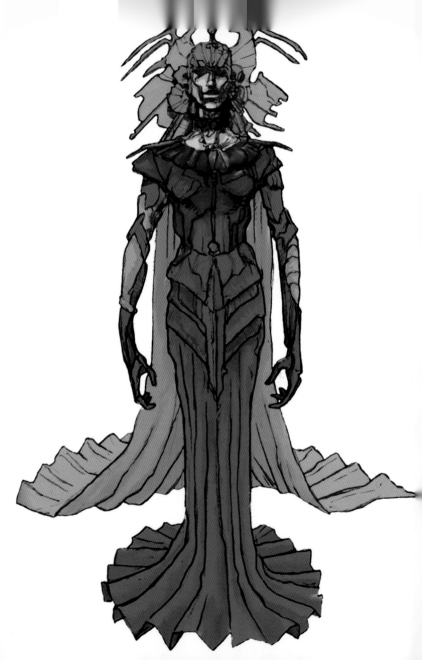

QUEEN

WHETHER SHE IS THE LEGENDARY SCOTTISH QUEEN SCATHACH, WHO RAN A SCHOOL FOR YOUNG WARRIORS, OR THE REAL QUEEN RANAVALONA OF MADAGASCAR, WHO PRESIDED OVER A REIGN OF TERROR ON HER VAST ISLAND IN THE MID-19TH CENTURY, HISTORY AND MYTH IS FULL OF QUEENS WHO OFTEN MAKE THE MOST INTERESTING CHARACTERS.

QUEENS CAN BE MORTAL BEINGS WHO ARE PRONE TO THE SAME WEAKNESSES AND FLAWS AS THEIR SUBJECTS, OR THEY CAN BE SEMI-DIVINE CREATURES WITH GODDESS-LIKE ABILITIES. WHEN DESIGNING SUCH A CHARACTER, CONSIDER WHAT ROLE YOU WANT HER TO PLAY IN YOUR STORY, AND CARRY OUT SOME RESEARCH TO GET A STYLE AND PERSONALITY.

Development

• There are no limits as to just how extravagant a Queen's costume can be. One outrageous feature, such as elaborate sleeves, can define a character (above right).
• Sometimes it's good to ignore practicality when designing your characters: let your imagination fly and produce dozens of ideas before settling on one you most like.
• In short… don't restrict yourself!

Media and Execution

• Fine pencil and Photoshop.
• The image of a Queen of Death character was sketched quickly in pencil (below right).
• The elaborate clothes and jewellery were built up with a succession of rough shapes loosely cast around her face, and more detail was then added.
• The final image came together in Photoshop, when colour was added on several 'multiply' or see-through layers that allowed the colours of each element to be changed until the whole image began to harmonize.

FURTHER STUDY: Queen Nefertiti, Queen Ranavalona of Madagascar, Queen of Sheba ART BY FINLAY

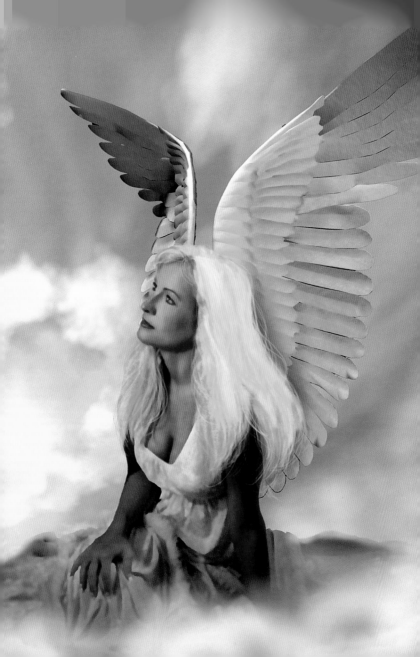

Angel

AN ANGEL IS A SUPERNATURAL BEING FOUND IN MANY RELIGIONS, AND ANGELS HAVE BECOME IMMENSELY POPULAR THROUGHOUT ALL GENRES OF STORYTELLING. THEIR MAJOR ROLE IS THAT OF MESSENGERS, SUCH AS THE ANGEL WHO BROUGHT NEWS OF THE BIRTH OF JESUS TO SHEPHERDS. THERE ARE MANY DEFINITIONS OF WHAT AN ANGEL MIGHT LOOK LIKE; ONE POPULAR BELIEF IS THAT THEY ARE 'FORMED OF FIRE, AND ENCOMPASSED BY LIGHT'. WHILE IN HUMAN FORM THEY CAN CARRY OUT IMPORTANT MISSIONS AND INFLUENCE THE COURSE OF EARTHLY EVENTS, WHICH MAKES THEM USEFUL IN STORYTELLING TERMS BECAUSE THEY CAN POP UP WHENEVER NEEDED.

THE MOST COMMON DEPICTION OF ANGELS IS FOUND IN CHRISTIAN ICONOGRAPHY, WHERE THEY ARE DRESSED IN FLOWING WHITE ROBES AND HAVE SWAN-LIKE WINGS, WHICH ARE SAID TO DEFINE THEM AS A SPIRIT.

Development

• The Jinn (also known as genies) are said to be a lower order of angels.
• In Christianity, there are many archangels, including Gabriel, Jibrail, Mikail, Israfil and Izrail (the angel of death).

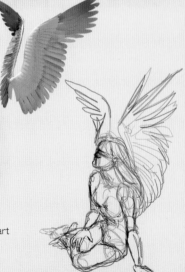

Media and Execution

• Poser 3D software, Photoshop and Vue d'Esprit.
• A photo of a model was scanned into Photoshop.
• The Smart Blur, Airbrush and Eyedropper tools were used to trim and smooth out the figure and add hair.
• The photo was imported into Poser and the wings were added.
• The sky was created in Vue d'Esprit and was then dropped in behind the figure in Photoshop.

FURTHER STUDY: Mythology, Christianity, Renaissance art

ART BY BOB HOBBS, MODEL MICHELLE ZIMMERMAN

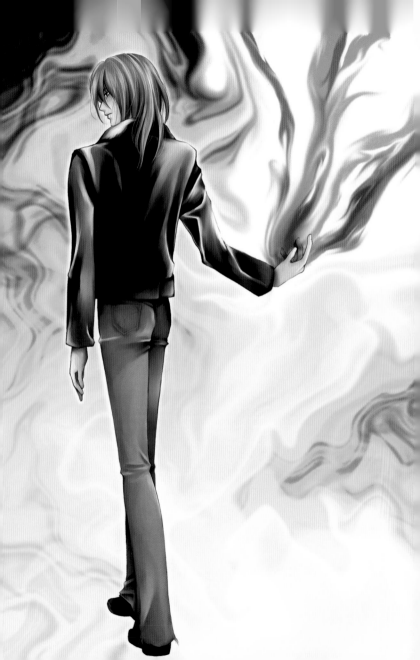

asha

ASHA IS NOT THE NAME OF A HERO BUT A CONCEPT FROM THE ANCIENT PERSIAN RELIGION ZOROASTRIANISM. THE WORD ITSELF IS AN IMPORTANT PRINCIPLE OF THE BELIEFS OF THE RELIGION AND REPRESENTS TRUTH, JUSTICE AND ORDER. LIKE ALL GOOD POWERS OF LIGHT IT HAS ITS DARK SIDE IN THE WORD 'DRUJ', WHICH REPRESENTS CHAOS AND UNTRUTH. POWERFUL CONCEPTS LIKE THESE HAVE PROVIDED THE BACKBONE OF MODERN FANTASY EPICS SUCH AS *THE LORD OF THE RINGS* AND *STAR WARS*, WITH THEIR ENDURING IMAGERY OF LIGHT AND DARK AND THE ETERNAL STRUGGLE BETWEEN GOOD AND EVIL.

Development

• Even a casual study of ancient religions will provide fertile ground for new fantasy worlds.

• When taking a concept, it is up to you to define the character; one way to do this is to take an emotional approach.

• Ask yourself how this character would behave if they were good or evil, selfish or generous, quiet or noisy.

• This character appears quite relaxed and laid-back – he wears jeans and a short leather jacket and is casually looking the other way while he conjures up some energy from the tips of his fingers.

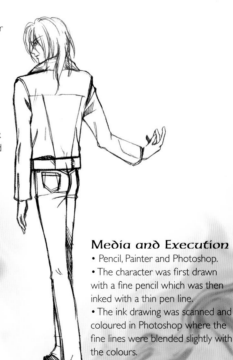

Media and Execution

• Pencil, Painter and Photoshop.

• The character was first drawn with a fine pencil which was then inked with a thin pen line.

• The ink drawing was scanned and coloured in Photoshop where the fine lines were blended slightly with the colours.

FURTHER STUDY: Zoroastrianism

ART BY SAYA URABE

Asian goddess

HINDUISM AND THE RELIGIONS OF THE FAR EAST HAVE VAST PANTHEONS OF GODS/ GODDESSES AND DEMONS OF EVERY DESCRIPTION IMAGINABLE (AND A GREAT MANY UNIMAGINABLE) - HINDUISM ALONE IS SAID TO INCLUDE MILLIONS OF DEITIES! THE VISUAL DEPICTION OF HINDU DEITIES IN PARTICULAR IS EXTREMELY COLOURFUL/ AND THE BOLD APPROACH TO DESIGN AND COLOUR COULD ADD SPICE TO YOUR WORK.

YOU CAN ABSORB IMAGES OR IDEAS FROM FIGURES LIKE KALI INTO YOUR OWN DESIGNS. CHOOSE WHETHER YOU WANT TO LEAVE OUT CERTAIN ELEMENTS/ SUCH AS THE SKULL NECKLACE SHOWN BELOW LEFT - EITHER TO AVOID OFFENDING FOLLOWERS OF RELIGIONS/ OR BECAUSE IT'S GOOD TO PUSH YOUR CREATIVITY AND USE EXISTING ICONS AS A SPRINGBOARD TO COME UP WITH YOUR OWN CREATIONS.

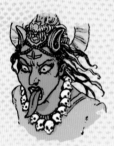

Development

• Build up ornate jewellery using repeated forms such as small circles and leaf, tooth and petal shapes (right).
• The accoutrements (below) that appear in the art of Asian religions are rich in symbolism and meaning – use these objects as references to inspire storylines and add detail, or use them as a starting point for your own myths.

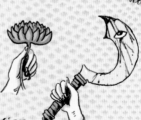

Media and Execution

• Fine pencil and Photoshop.
• The model was photographed with her arms in four positions.
• These were then crudely cut and pasted into one image in Photoshop.
• A new dress and jewellery were added, and the original photo was digita painted over.

FURTHER STUDY: Asian mythology, avatars, Asian religion

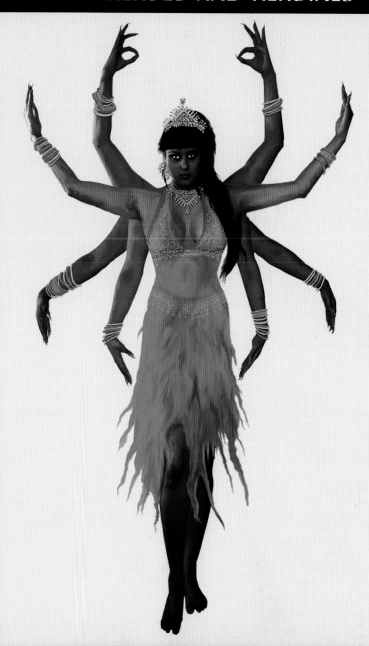

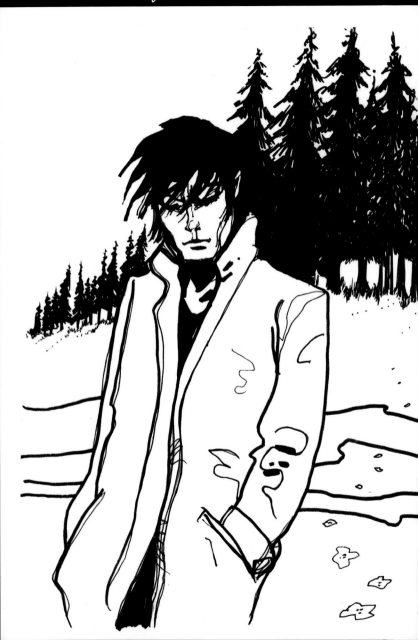

LEGATUS

THERE ARE MANY TYPES OF ANGELS, AND IT'S LONG BEEN BELIEVED THAT THERE ARE ANGELS THAT TAKE HUMAN FORM. THESE ARE CALLED THE LEGATII, AND MANY OF THEM DO NOT KNOW WHAT THEY ARE, BUT HAVE BEEN SENT TO EARTH FOR A PURPOSE, WHICH THEY HAVE TO DISCOVER.

THE PROCESS OF WRITING A STORY CAN BE A JOURNEY THAT LEADS TO FURTHER DISCOVERIES, WHICH IN TURN CAUSE TWISTS AND TURNS IN THE STORY. THE IDEA OF SEARCHING FOR ONE'S IDENTITY IS A POWERFUL THEME IN ALL TYPES OF FICTION. I WAS FASCINATED BY THE IDEA OF A CHARACTER WHO HAD 'CROSSED OVER' INTO THE SPIRIT WORLD TO FIND HIS LOST LOVE, BUT WAS UNAWARE HE HAD BECOME A TYPE OF ANGEL.

Development
• When creating a character, it is necessary to be able to draw the same character over and over again.
• This act of laborious repetition may seem like being in a trance – but it can also be enjoyable when the character begins to come to life.
• The look here is particularly stark, but it is also very fluid and allows the artist to work quickly.

Media and Execution
• Black technical ink pens.
• Quick sketches were made in pencil, to help decide how much solid black to add.
• Very little solid black ink was used, and there was an absolute minimum of line work and no tonal work.
• Your ability to express a personality in a flourish of the pen can go a long way to building confidence, though it might take time to reach that stage.

FURTHER STUDY: Finlay Cowan, Subway Slim, Miss London

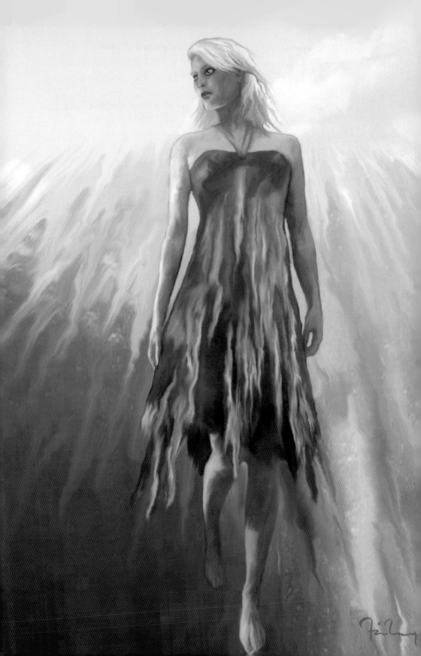

Lorelei

LORELEI IS THE NAME OF ONE OF THE 'RHINE MAIDENS' OF GERMAN MYTH, A TYPE OF SIREN WHO LURED SAILORS TO THEIR DEATHS ON THE ROCKS OF THE RHINE. A PARTICULARLY DANGEROUS SECTION OF THE RIVER IS NAMED LORELEI, WHICH MEANS 'MURMURING ROCKS'. STRONG WATER CURRENTS IN THE AREA MAKE A MURMURING SOUND WHICH IS AMPLIFIED BY THE ROCKS ON THE SHORE, AND THIS HAS GIVEN RISE TO THE MYTH OF THE SIREN SONG.

THE STORY OF LORELEI TELLS OF A BEAUTIFUL MAIDEN WHO THREW HERSELF INTO THE RHINE BECAUSE OF A FAITHLESS LOVER AND BECAME A SIREN, LURING MEN TO THEIR DEATHS. THIS ENDURING MYTH HAS FASCINATED ARTISTS FOR CENTURIES, THROUGH ITS INTOXICATING MIX OF DESIRE, TRAGEDY AND SEDUCTION.

Development

• Your characters don't always have to match the current perception of what is considered fashionable, so be daring.
• Try out different hairstyles: for a strong Central European look (above right , use hairstyles of the 1930s as inspiration.
• Mix and match: for example, a strong jawline with a modern hairstyle (right).

Media and Execution

• Fine pencil and Photoshop.
• A rough drawing was based on a photo of a friend.
• The drawing was scanned and different areas of the line were coloured in Photoshop.
• The Smudge tool was used to blend the clothes and water together.

FURTHER STUDY: Siren, Nymph, Nix, Naiads

ART BY FINLAY
MODEL NICOLA GROVES

LUNAR GODDESS

THIS GODDESS HAS SO MANY FORMS AND APPEARS IN SO MANY CULTURES THAT IT WOULD TAKE AN ENTIRE BOOK JUST TO PROVIDE A SUMMARY. WHETHER SHE IS ATARGARTIS, ASTARTE OR ISIS, SHE IS PERHAPS THE MOST WELL-KNOWN DEITY IN HISTORY. SHE REPRESENTS LIFE ITSELF – SHE IS NATURE, THE STARS AND THE EARTH ALL IN ONE. SHE IS OFTEN DESCRIBED AS A TRIPARTITE GODDESS AND REPRESENTS BIRTH, LIFE AND DEATH (OR REBIRTH) AS SEEN IN THE CYCLE OF THE SEASONS.

ARTISTS THROUGHOUT THE CENTURIES HAVE BEEN INSPIRED BY HER BECAUSE SHE ALSO REPRESENTS FERTILITY AND THE TREMENDOUS SUBCONSCIOUS POWERS OF CREATIVITY AND ART.

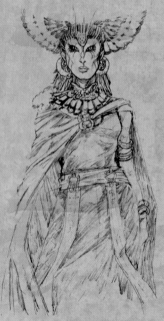

Development

- The imagery of the owl emphasizes the lunar quality.
- Use eternal symbols such as Isis (right), who arose in the culture of Ancient Egypt but who was adopted by ancient Greece and was later absorbed into Roman culture.
- The Venus symbol (below right) is as old as the cult of the Goddess herself and has been taken up by modern day practitioners of Wicca and the traditions of Druidry. It is a strong feminine symbol and shows the three phases of the moon.

Media and Execution

- Fine pencil and Photoshop.
- The figure, tree, owls and other elements were all drawn separately on tracing paper then scanned into the computer.
- Each area was coloured on a separate layer for more flexibility.
- The final image was merged on one layer and the edges of each element blended using a mixture of Smudge and Burn tools.

FURTHER STUDY: *The Golden Bough*, Anu (Irish), Freya (Norse), Venus, Kali (Hindu), Kwan Yin (Chinese), Diana (Greek), Anahit (Armenian)

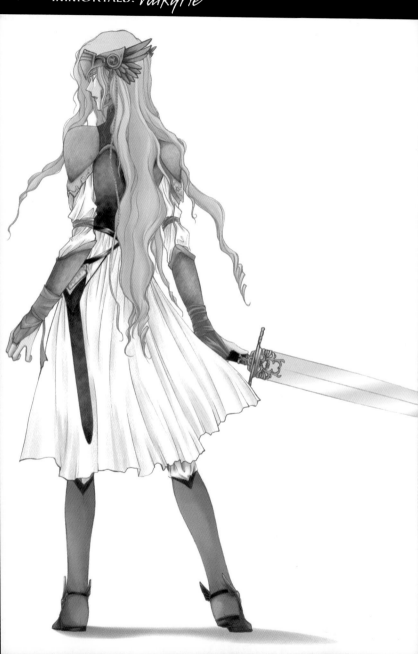

Valkyrie

THE VALKYRIES ARE PRIESTESSES FROM NORSE MYTH WHOSE DUTY WAS TO FLY OVER BATTLEFIELDS, CHOOSING THE SLAIN WARRIORS WHO HAD DISTINGUISHED THEMSELVES WELL ENOUGH IN BATTLE TO BE ALLOWED ENTRY TO VALHALLA, THE AFTERLIFE OF THE NORSE PEOPLES. THEY ARE OFTEN DEPICTED AS BLONDE MAIDENS WHO FLY WINGED HORSES, BUT HISTORICALLY, THEY WERE ASSOCIATED WITH THE WOLVES THAT ROAMED THE BATTLEFIELDS AFTER THE FIGHTING WAS OVER.

THE COMPOSER RICHARD WAGNER INCORPORATED THE VALKYRIES INTO TWO OF HIS OPERAS, DIE WALKÜRE AND GÖTTERDÄMMERUNG, IN WHICH HE RETOLD THE STORY OF THE VALKYRIE BRUNHILDE AND HER LOVE FOR THE WARRIOR SIEGFRIED.

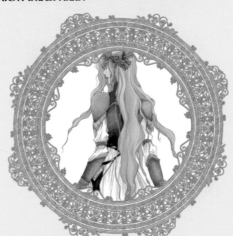

Media and Execution
• Fine pencil and Photoshop.
• A fine line pencil drawing was scanned into Photoshop.
• Delicate colour textures were then added to the armour in Painter, giving it a mottled, weathered appearance.

Development
• Experiment with an elaborate ornamental border (above) to lend the image a stronger mythical feel, reminiscent of old storybooks.
• The artist has added her own interpretation to the character, portraying her with her back to us, emphasizing aloofness or detachment.
• The character bears the classic hallmarks of long blonde hair and a winged headpiece typical of many depictions of Valkyries.

ART BY SAYA URABE **FURTHER STUDY:** Wagner, Norse Myth, Brunhilde, Idisi, Disen, Alaisiagae

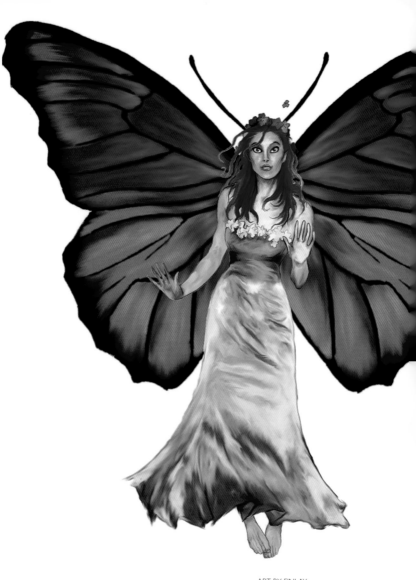

ART BY FINLAY
MODEL ÅSA HASSELBLAD

Queen Mab

THE WORLD OF FAERIES IS VAST, AND THEY APPEAR IN ALMOST EVERY CULTURE. THEY ARE SMALL PEOPLE, STRONGLY CONNECTED TO NATURE AND USUALLY HAVE MAGICAL POWERS. CELTIC FOLKLORE HAS HUNDREDS OF DIFFERENT SUBSPECIES OF FAERY, SUCH AS THE LUNANTISHEE, WHO WILL NOT ALLOW A BLACKTHORN TREE TO BE CUT ON MAY DAY, OR THE PLANT RHYS DWFEN, WHO INHABIT AN INVISIBLE LAND IN WALES.

MAB IS KNOWN AS THE QUEEN OF THE FAERIES AND IS SAID TO BE A TRICKSTER. IN SOME STORIES, SHE RULES OVER THE ELLYLLON, TINY DIAPHANOUS FAERIES THAT LIVE ON TOADSTOOLS AND FAERY BUTTER.

Development

• Try using wing shapes from insects and butterflies, and explore variations such as butterfly wings on the head (right).
• Faeries are symbolic of nature and often depicted dressed in leaves (centre right).
• Try using modern fashion elements such as bright colours and cute hairstyles (below).

Media and Execution

• Fine pencil and Photoshop.
• A photo was taken of the model dressed as a faery.
• A pencil drawing was laid over the top in Photoshop before blending and painting techniques were used to turn the original image into an illustration.
• Significant changes were made to the proportions and features.

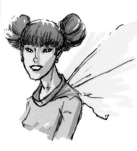

FURTHER STUDY: fae, faerie, fand, Tuatha dé Dannan, Fata, Nymph, Finvarra, Little People, Weisse Frau, Silvanes, Fachan, *Romeo and Juliet* (Shakespeare)

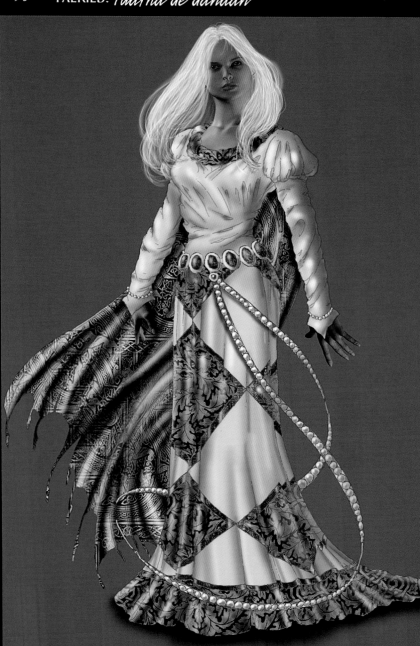

TUATHA DE DANAAN

THE TUATHA DÉ DANANN ('PEOPLES OF THE GODDESS DANU') WERE
THE FIFTH GROUP OF INHABITANTS OF IRELAND, ACCORDING TO THE
LEBOR GABALA ERENN (BOOK OF INVASIONS).LEGEND SAYS THAT THEY
ARE THE FAERY FOLK WHO INHABIT THE MOUNDS, OR SIDHE, OF THE
IRISH COUNTRYSIDE. AFTER THEIR DEFEAT BY THE MILESIANS, THEY
RETREATED TO AN UNDERGROUND WORLD TIR NA N-OG (THE LAND
OF YOUTH). OVER TIME LEGEND REDUCED THEM IN STATURE TO THE
IMMORTAL LITTLE PEOPLE WE KNOW TODAY.

 TWO FUNDAMENTAL ASPECTS OF FAERIE AND ELF IMAGERY COME
FROM THIS TRADITION: THE IMAGE OF THEM AS FAIR, BEAUTIFUL AND
DRESSED IN WHITE, AND THE IMAGE OF THEM LIVING UNDER HILLS
AND MOUNDS.

Development

• Although the traditional
colour is white, think about
using a green colour scheme
inspired by 'green man'
imagery.
• Research Celtic
textures and
patterns from
books or online,
then alter and paint
them on as patterns
to give the outfit
interest and a Celtic feel
(see below right).

Media and Execution

• Pen and ink, Poser 3D software and Photoshop.
• The body and clothing were drawn in pen and ink.
• The face was created in Poser.
• The drawing was scanned into Photoshop and
painted with the Airbrush tool.

FURTHER STUDY: Irish legends, Danu,
Celtic mythology, Finvarr

ART BY BOB HOBBS

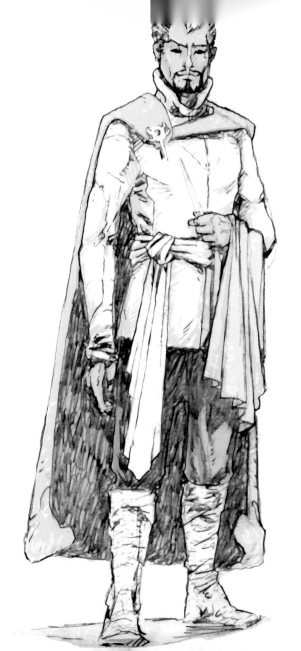

magus

THE WORD 'WIZARD' COMES FROM THE MEDIEVAL *WYS*, MEANING 'WISE', SO IT CAN MEAN ANY WISE MAN. THERE ARE A GREAT MANY VARIANTS ON WIZARDS, SUCH AS [NE]CROMANCERS AND SORCERERS; IN RUSSIAN FOLKLORE, KOSHCHEI [TH]E DEATHLESS IS AN IMMORTAL WIZARD, AND POLYNESIAN MYTH [TE]LLS OF ONO, A WIZARD BELONGING TO A GROUP OF THREE [TR]ICKSTER HEROES.

A WIZARD CAN BE A MAN OR WOMAN WHO HAS SOUGHT SOME [KI]ND OF HIGHER KNOWLEDGE OR DEEPER UNDERSTANDING [OF] THE MYSTERIES OF THE UNIVERSE.

Development

The pointed hat (right) was traditionally worn by [al]chemists, who were renowned as seekers of knowledge.
The deep symbolic relationship between books, [k]nowledge and power remains embedded deep in the [h]uman psyche to this day.
Wizards surround themselves with many curiosities and [o]ddities, such as pickled lizards and snakes (below right).
The image of a wizard or sorcerer from the Middle East [w]as inspired by looking at paintings of the 18th [a]nd 19th century 'Orientalists' (below centre).

[M]edia and Execution

[F]ine pencil and Photoshop.
[A] loose pencil sketch can be quickly [col]oured with markers, coloured [pe]ncils, watercolours or in Photoshop [to] produce a 'visual', common in the [fil]m industry.
[K]eep the colours subtle and stick [to] a narrow tonal range without too [mu]ch contrast.

[FU]RTHER STUDY: necromancer, [sor]cerer, thaumaturge, Faust, [Pro]spero, Gandalf

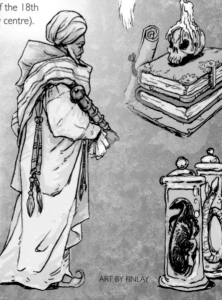

ART BY FINLAY

Sorcerer

THE DISTINCTION BETWEEN PHILOSOPHY AND MAGIC WAS BLURRED IN THE MIDDLE AGES, SO A WIZARD COULD BE A WISE MAN OR A SAGE AS WELL AS SOMEONE WHO CAST SPELLS AND LOOKED AFTER RINGS FOR HOBBITS. THE CONCEPT OF THE POWERFUL MAGICIAN MOST LIKELY DEVELOPED FROM THE ANCIENT TRADITION OF TRIBAL SHAMANS, AND OVER THE CENTURIES IT HAS GIVEN RISE TO A WIDE RANGE OF DEFINITIONS, FROM ENCHANTER TO NECROMANCER.

AS A HERO OR MENTOR FIGURE A WIZARD DISPENSES ADVICE, FORESEES THE FUTURE AND TURNS UP JUST WHEN THE HEROES ARE IN A TIGHT SPOT TO SORT THINGS OUT WITH A SPELL OR TWO. AS A VILLAIN HE HOLDS SWAY OVER THE ARMIES OF DARKNESS, UNLEASHES THEM ON AN UNSUSPECTING PUBLIC AND USUALLY ENDS UP GETTING EATEN BY HIS OWN DIABOLICAL CREATIONS.

Development

- Wizards can be depicted in a wide variety of guises, from the wizened countenance of Gandalf to the young and modish Harry Potter, so don't just stick to tried and tested.
- Try basing your characters on the clothes of a Victorian gentleman explorer professor or, by contrast, a Middle Eastern Sultan of the 18th century.

Media and Execution

- Poser 3D software, 3D Studio MAX and Photoshop.
- The basic figure was created in Poser, which allowed the figure to be posed, and ageing parameters and lighting applied.
- The cloak, staff and red robe underneath were all applied through DAZ software.
- The crystal ball was created in 3D Studio MAX, rendered out and imported into Photoshop and a glow applied around it.
- The white hair and beard were all done by hand in Photoshop, using a Wacom tablet and pen.

FURTHER STUDY: Merlin, Dumbledore, Gandalf, Saruman, Faust, Thoth, the Telchines, Väinämöinen

ART BY BOB HOBBS

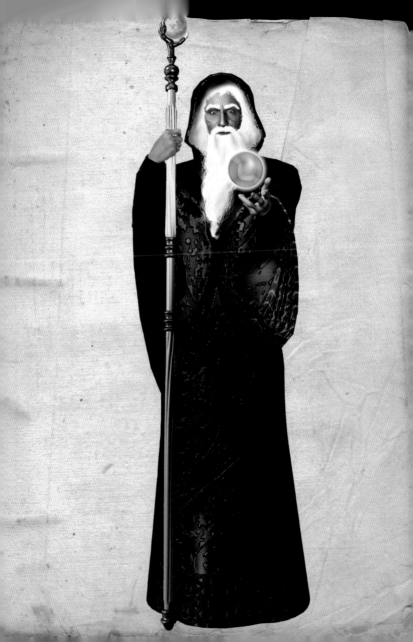

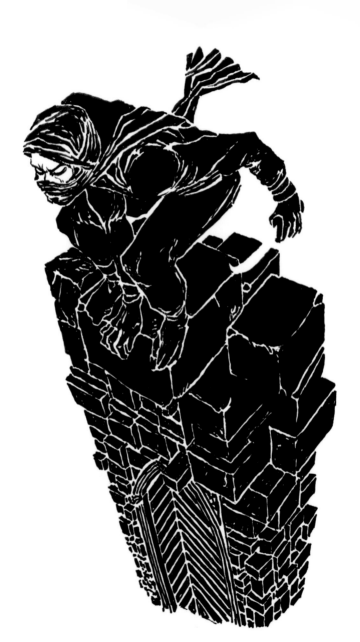

Assassin

ASSASSIN IS THE EUROPEAN NAME GIVEN TO A SECT THAT FLOURISHED IN THE ELBURZ MOUNTAINS OF PERSIA (NOW IRAN) IN THE 11TH CENTURY. THE MEMBERS OF THE SECT DEVOTED THEIR LIVES TO THEIR LEADER HASSAN IBN SABBAH, WHO WAS KNOWN AS 'THE OLD MAN OF THE MOUNTAIN', AND USED MURDER AND SUBTERFUGE AS THEIR METHOD OF GAINING CONTROL OF MANY STRONGHOLDS THROUGHOUT THE MIDDLE EAST.

ASSASSINS HAD NO FEAR OF DEATH AND BELIEVED THEY COULD FLY, THEIR FEARLESSNESS STRIKING TERROR INTO THE HEARTS OF THEIR ENEMIES. THEY ARE BELIEVED TO BE AMONG THE FIRST WARRIORS IN HISTORY TO USE GUERRILLA TACTICS AS A MEANS OF WARFARE. EVENTUALLY THE TERM 'ASSASSIN' WAS USED TO DESCRIBE ANYONE WHO KILLS FOR A POLITICAL REASON.

Development

• A wide variety of weapons have evolved over the centuries. Ninjas use throwing stars and nunchukas. You can invent your own, like the double-bladed dagger, left.
• Modern assassins usually take the form of snipers who use a high-powered rifle from a safe distance, allowing them to escape quickly.
• The assassins' belief that they could fly gave rise to the idea of placing the figure here on a vertigo-inducing tower, to produce a sense of fearlessness.

Media and Execution

• Brush, ink and felt-tip pens.
• This technique was inspired by Frank Miller, creator of the 'Sin City' graphic novels: only shadows are drawn, and the original lines are left in white.
• The pencil drawing was put on a lightbox with a fresh sheet of paper over it.
• All the spaces between the pencil lines were filled in, being careful not to draw over any of the lines, to creates a kind of 'negative' image.
• The difficult pose here was drawn in three-point perspective. It creates a sense of an agile figure poised to strike, captured in the moment before action.

FURTHER STUDY: Hassan Ibn Sabbah. Hashishin, ninja

ART BY FINLAY

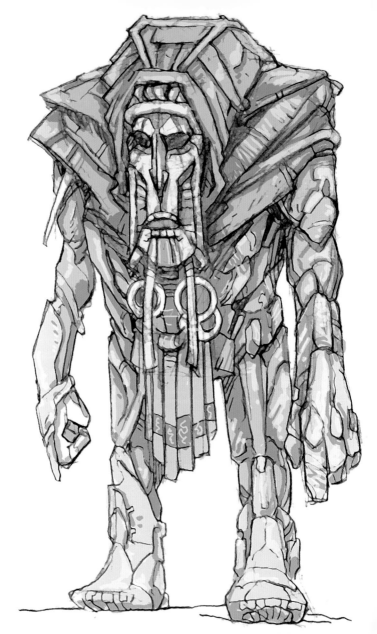

Henchman

A HENCHMAN IS A BODYGUARD, USUALLY EMPLOYED BY A PHYSICALLY CHALLENGED VILLAIN TO LITERALLY ADD WEIGHT TO THEIR THREATS AND PLANS FOR WORLD DOMINATION. HENCHMEN ARE USUALLY LARGE AND STUPID AND ARE EASILY OUTWITTED BY HEROES.

FANTASY FICTION HAS A GREAT MANY USES FOR HENCHMAN, WHO ARE GENERALLY PORTRAYED AS RATHER PATHETIC CREATURES WHO CAN OFTEN BE CONVINCED OF THE ERROR OF THEIR WAYS AND REDEEM THEMSELVES BY CHANGING TO THE SIDE OF GOOD AT THE VERY LAST MOMENT - A USEFUL STORY DEVICE.

Media and Execution

• Fine pencil and Photoshop.
• The figure was drawn in loose pencil, letting the pencil explore the page to come up with a variety of strange shapes and patterns.
• It was traced off on a lightbox to produce a clean-line version, which was also drawn in pencil before scanning and colouring in Photoshop.
• A very limited tonal range was used, so no single area of the figure stood out too much.
• A variety of shadows were added to give the figure depth. Highlights were added at the end to give it a slightly metallic look.

FURTHER STUDY: Henri Regnault, Orientalist painters, evil geniuses

Development

• Break away from clichés and develop a new look for a character by using unexpected visual reference points.
• I looked at several types of African tribal masks (right and above right) and developed them into a more robotic look for the main picture.
• The archetypal henchman is the strong, silent type; the drawing here (far right) was inspired by Henri Regnault.

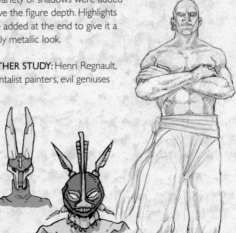

ART BY FINLAY

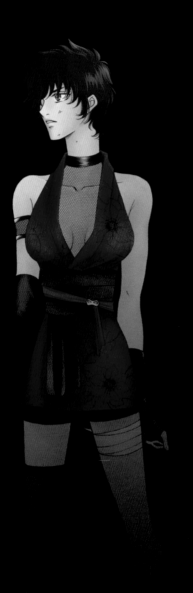

Kunoichi

THIS IS A JAPANESE WORD FOR A TYPE OF FEMALE NINJA. FEMALE MEMBERS OF NINJA FAMILIES WOULD RECRUIT YOUNG ORPHANED GIRLS TO BE TRAINED, ESPECIALLY IN THE ART OF SEDUCTION, AND USE THEIR FEMININE WILES TO MANIPULATE MALE LEADERS OF THEIR ENEMIES' ORGANIZATIONS. THEY WERE TAUGHT TO AVOID FALLING IN LOVE WITH THEIR TARGETS.

ORIGINALLY KUNOICHI WERE ASSASSINS, BUT IN MODERN TIMES THEY HAVE BEEN RECRUITED AS PRIVATE LAW-ENFORCEMENT AGENTS. THE WORD IS NOW USED FOR ANY TYPE OF FEMALE NINJA AND HAS BECOME VERY POPULAR IN MODERN CULTURE, WITH VARIOUS PERSONALITIES APPEARING IN COMICS, COMPUTER GAMES AND ANIME.

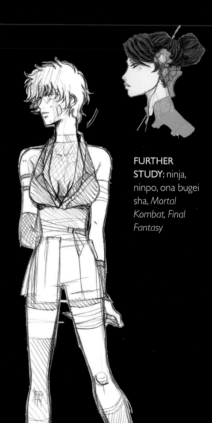

Development
• This is an archetypal kunoichi – sexy, independent and tough.
• The bandage on her leg indicates an injury in the line of duty; this is important as it suggests she makes mistakes and therefore makes her appears more human.
• Her gaze is directed away from the viewer, giving the sense that she is thoughtful; if she was looking directly at us she would appear more confident.
• Adding flowers to the hair (far right) makes us feel she is gentle and feminine, and can create a surprise when she turns out to be a fighter or assassin.

Media and Execution
• Fine pencil, Photoshop and Painter.
• The character was drawn with a fine pencil then inked with technical pens.
• It was then scanned and coloured in Photoshop and Painter.

FURTHER STUDY: ninja, ninpo, ona bugei sha, *Mortal Kombat, Final Fantasy*

MAIN ART AND SKETCH BY SAYA URABE
VARIATION ART BY FINLAY

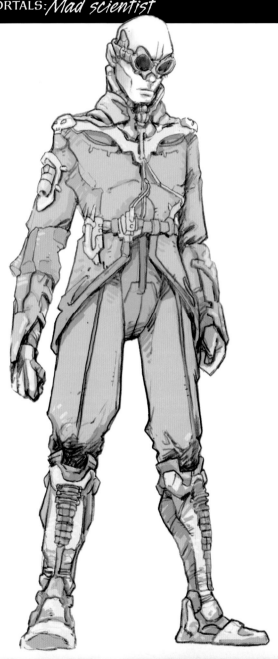

MAD SCIENTIST

MAD SCIENTISTS ARE A STAPLE CHARACTER IN THE GENRE OF SCIENCE FICTION B-MOVIES. IN RECENT YEARS A GREAT DEAL OF VICTORIAN IMAGERY HAS CREPT INTO THE GENRE OF FANTASY FICTION, AND WITH IT HAVE ARRIVED NUMEROUS CHARACTER TYPES FROM THE WORLDS OF HG WELLS AND JULES VERNE. THE MAD SCIENTIST IS USUALLY FOUND IN A BASEMENT OR HILL-TOP LABORATORY SURROUNDED BY ARCHAIC EQUIPMENT SUCH AS VAN DE GRAAFF GENERATORS AND TESLA COILS, QUITE OFTEN PLANNING TO PROVE THE WORLD WRONG FOR IGNORING HIS GENIUS. HE TENDS TO BE MOTIVATED BY A NEED FOR REVENGE OR A DESIRE TO ACHIEVE IMMORTALITY.

Development

• The image of the mad scientist, with his wild hair and intense demeanour (right), is closely related to the image and symbolism of the archetypal alchemist.
• Much of the idea of the mad scientist has its roots in Mary Shelley's Victor Frankenstein.
• The main characteristics of the stereotype arrived after World War II, when the activities of Nazi and Soviet scientists came to light.
• Try a futuristic look, with the scientist wearing an elaborate mechanical device that suggests he is experimenting upon himself.

Media and Execution

• Fine pencil and Photoshop.
• Marker-style colouring in Photoshop was used to try various colour palettes (right) using the Hue/Saturation command.
• The colour range was originally limited to a pale colour scheme of greys and blues, but after experimentation a less obvious palette of pale crimsons offset with light blue was used.

FURTHER STUDY: Albert Einstein, Rotwang (from *Metropolis*) Jeremy Bentham, Trofim Lysenko

ART BY FINLAY

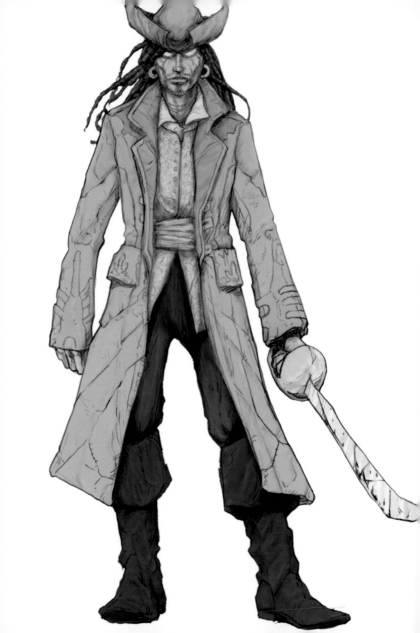

PIRATE

THE HISTORY OF PIRACY IS PEOPLED WITH LARGER-THAN-LIFE CHARACTERS SUCH AS THE FAMOUS BLACKBEARD, WHO WOULD PLACE FIRECRACKERS IN HIS BEARD BEFORE BATTLE. NOWADAYS IT IS HARD TO TELL BETWEEN THE GOOD GUYS AND THE BAD GUYS, WITH THE LAWMEN OFTEN DEPICTED AS THE LATTER AND THE NE'ER-DO-WELL FREEBOOTER AS THE HERO OF THE PIECE. WHATEVER THE CASE, THE ICONIC IMAGE OF THE DARING ADVENTURER PIRATE, FOREVER CAUGHT BETWEEN A ROCK AND A HARD PLACE, IS AS FRESH AND APPEALING AS EVER.

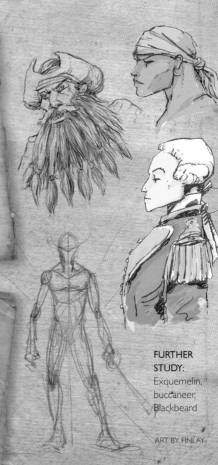

Development

- Headbands, scarves and other flamboyant touches are de rigueur amongst pirates (right).
- Pirates wear a large silver earring so they always have the funds on them to be buried.
- The archetypal deckhand wears a bandanna to keep his hair out of his eyes and protect his head from the elements.
- The British Navy (bottom right) was one of the many forces charged with the duty of chasing and capturing pirates, most often to protect its own state-sanctioned piracy.

Media and Execution

- Fine pencil and Photoshop.
- This image was coloured using the simplest possible techniques.
- A narrow range of colours was added on a separate layer in Photoshop.
- Shadows and highlights were produced using the Dodge and Burn tools.
- The colours were not blended, nor were the pencil lines into the colour: they were left as in the original drawing.

FURTHER STUDY:
Exquemelin, buccaneer, Blackbeard

ART BY FINLAY

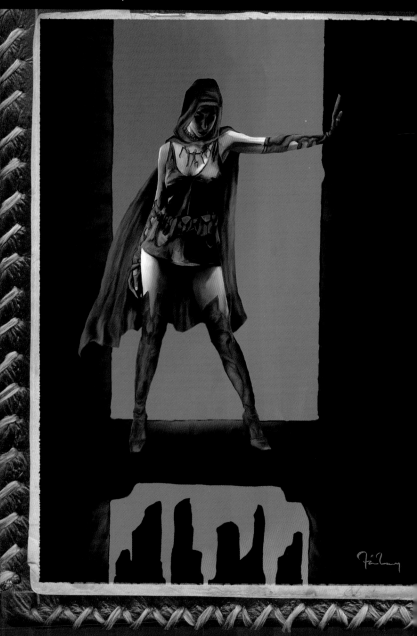

THIEF

THIEVES CAN BE GOOD OR BAD, AND ARE OFTEN PORTRAYED AS TREASURE HUNTERS OR ROBIN HOOD-TYPE CHARACTERS WHO STEAL FROM PEOPLE THAT, IT APPEARS, DESERVE TO BE STOLEN FROM.

THE THIEF HERE IS DEFINED BY A STANCE AND COSTUME THAT SUGGEST SHE IS FOCUSED RATHER THAN BRASH, AND HER THOUGHTFUL EXPRESSION IMPLIES SHE IS CONSIDERING HER OPTIONS BEFORE ACTING EFFICIENTLY... AND SILENTLY.

Development

• You must have a good sense of how the character feels, thinks and behaves, to make him or her reach the audience emotionally.
• Try different poses to express body language (right), and redraw the same figure over and over until you have settled
on the precise details.
• Very rough sketches that experiment with shadow and colour will help you find your way to the look of your final character (below).

Media and Execution

• Fine pencil and Photoshop.
• Using a photograph of a model requires hard work to push the image into a fantasy context.
• Hand-drawn clothes and accessories were drawn separately and added in Photoshop.
• All the elements were then carefully blended together to make the image more of a painting and less of a photograph.

FURTHER STUDY: Aladdin, Robin Hood

ART BY FINLAY
MODEL CHIARA GIULIANINI

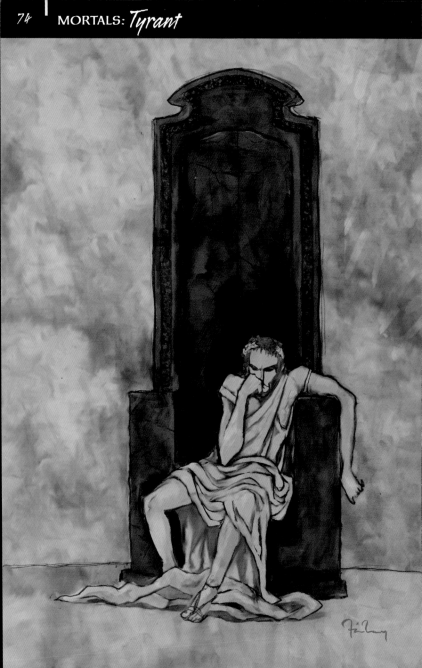

TYRANT

A TYRANT IS A TYPE OF RULER WHO HAS GAINED POWER BY DECEIT OR FORCE. TYRANTS ARE GENERALLY SELF-SERVING, OPTING TO INDULGE THEMSELVES WITH THE BUILDING OF NUMEROUS PLEASURE PALACES WHILE THEIR PEOPLE STARVE. THEY ALSO TEND TO BE MORALLY UNSOUND, SENDING THOUSANDS OF THEIR PEOPLE OFF TO POINTLESS WARS PURELY TO SATISFY THEIR VANITY. TYRANNY IS NOT A GOOD CAREER OPTION THOUGH - MOST TYRANTS ARE INSANE AND ALMOST ALWAYS COME TO AN UNPLEASANT END.

Development

Tyrants come in many shapes and sizes:
• There is the 'brooding Napoleon' type (top right)…
• The 'cadaverous psychopath', skilled in political intrigue (top far right)…
• The 'corpulent despot', usually from a religious background (below right)…
• And the 'homicidal general' (below far right).

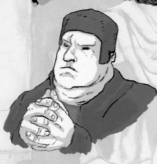

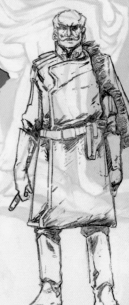

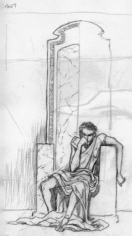

Media and Execution

• Loose pencil and Photoshop.
• This character is brooding and is obviously quite decadent, not a disciplined military leader.
• He is used to a life of comfort and lacks the toned musculature of a warrior.
• Framing the figure in an enormous throne emphasizes his vast ego but also shows how small and weak he is.

FURTHER STUDY: despot, Nero, Hitler, Pol Pot, Stalin, Ceaucescu, Idi Amin, Saddam Hussein

ART BY FINLAY

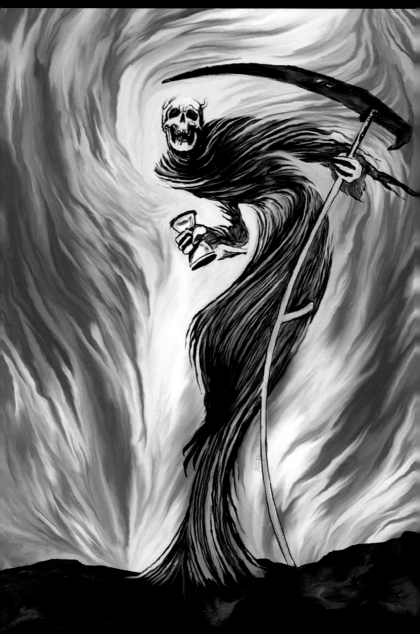

Death

THE IMAGE OF DEATH AS A PERSON HAS HAD A POWERFUL INFLUENCE ON THE HUMAN PSYCHE SINCE EARLY TIMES, AND DEATH DEITIES CAN BE FOUND IN MOST CULTURES. IN MANY CULTURES THE FIGURE IS GIVEN THE STATUS OF A GOD, OFTEN HAVING SEVERAL ROLES, SUCH AS A BRINGER OF BOTH LIFE AND DEATH.

THE FIGURE OF DEATH IS A POWERFUL DEVICE IN FANTASY STORYTELLING, AS IT IS SO FAMILIAR AND ENDURING THAT IT CAN BE INTERPRETED IN ANY NUMBER OF WAYS, FROM DEADLY TO HUMOROUS. DEATH'S CHARACTERISTIC SCYTHE HAS ITS ROOTS IN THE USE OF THE SCYTHE AS A TOOL FOR BRINGING IN THE HARVEST IN THE PRE-INDUSTRIAL WORLD, WHICH LED TO THE IDEA OF THE GRIM REAPER HARVESTING HUMAN SOULS.

Development

• The image of the Grim Reaper belongs to European traditions, which featured it as a figure in a dark, hooded cloak (above right).
• One of the most famous modern interpretations of death appears in *The Seventh Seal*, a highly symbolic film made in 1957 by director Ingmar Bergman (above centre).
• The Angel of Death appears in Hebrew and Christian religious traditions as one of the heavenly servants of the Almighty.
• The depiction here (left) shows how a drop of 'gall' on the tip of an angel's sword causes the soul to leave the body.

FURTHER STUDY: Four Horsemen of the Apocalypse, Thanatos (Greek), Anubis (Egyptian), Yan Lao (Chinese), Yama (Hindu), Hel (Norse), Mictlantecuhtli (Aztec)

Media and Execution

• Fine pencil and Photoshop.
• The image was drawn in pencil and scanned.
• A photo of the sky was pasted into the background and the smudge tool redesigned it into swirling patterns, which were inspired by Edvard Munch's painting *The Scream*.

ART BY FINLAY

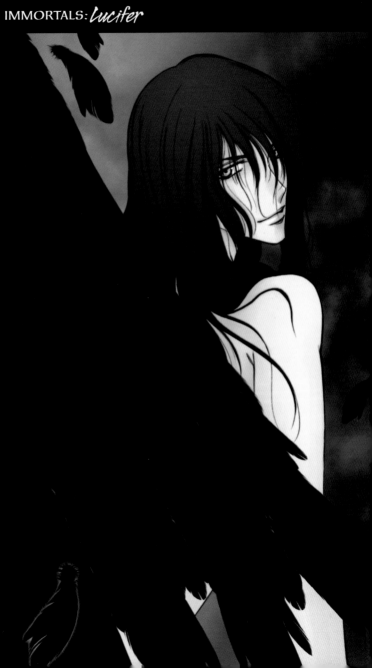

Lucifer

'PLEASE ALLOW ME TO INTRODUCE MYSELF, I'M A MAN OF WEALTH AND TASTE...' SO GOES THE ROLLING STONES' CLASSIC 'SYMPATHY FOR THE DEVIL'. THERE HAS BEEN A LONG TRADITION OF SATAN IN THE GUISE OF A GENTLEMAN - CHARMING, UNDERSTATED AND ERUDITE.

THE FIGURE OF LUCIFER APPEARS THROUGHOUT CHRISTIAN, HEBREW AND ROMAN TRADITIONS; THE NAME MEANS 'LIGHT' OR 'MORNING STAR'. LUCIFER WAS AN ARCHANGEL, BELOVED OF GOD, WHO WAS MOTIVATED BY THE SIN OF PRIDE TO REBEL AND WAS CAST DOWN TO EARTH BY WAY OF PUNISHMENT. IN *PARADISE LOST*, THE EPIC POEM BY JOHN MILTON, HE WAS AIDED BY BEELZEBUB AND MAMMON AND WENT ON TO ORGANIZE HELL; HE WOUND UP IN THE GARDEN OF EDEN, WHERE HE TEMPTED ADAM AND EVE IN THE GUISE OF A SERPENT.

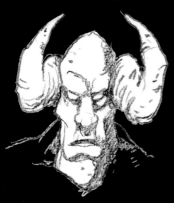

Media and Execution
• Fine pencil. Photoshop and Painter.
• The character was drawn with a fine pencil then inked with technical pens.
• It was then scanned and coloured in Photoshop and Painter.

FURTHER STUDY: *Paradise Lost* (Milton), *The Tragical History of Dr Faustus* (Marlowe), *The Master and Margarita* (Bulgakov)

Development
• Here, Lucifer is depicted in his guise as an elegant and attractive figure.
• The wings suggest he is an angel, but as they are black, they associate him with evil.
• Lucifer has been portrayed in a wide variety of looks and styles. The two studies on this page show him in a more demonic form.
• Copy the horns from photos of different types of gazelles and mountain goats.

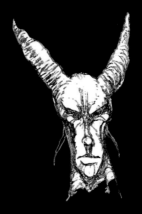

MAIN ART BY SAYA URABE, VARIATION ART BY FINLAY

DAEMON

IN RELIGION, FOLKLORE AND MYTHOLOGY A DEMON IS DESCRIBED AS A SUPERNATURAL BEING GENERALLY CONSIDERED MALEVOLENT. THESE CREATURES ARE OFTEN DEPICTED AS A FORCE CONJURED UP BY A MAGICIAN AND ARE USUALLY HARD TO CONTROL.

DEMONS APPEAR IN EVERY RELIGION, FROM ANCIENT HEBREW TO GREEK, AND THOUSANDS OF THEM HAVE BEEN NAMED AND DEFINED WITH A WHOLE MULTITUDE OF POWERS. IN ANCIENT GREEK, THE WORD MEANT 'SPIRIT' OR 'HIGHER SELF', MUCH LIKE THE LATIN *GENIUS*, THE SOURCE OF THE WORD *GENIE*. IN THE HEBREW BIBLE THEY ARE DIVIDED INTO TWO TYPES; THE SEI'RIM (THE HAIRY ONES) WHO WERE GOAT-LIKE CREATURES, SUCH AS AZAZEL, THEIR LEADER DEMON OF THE WILDERNESS, AND THE STORM DEMON LILITH.

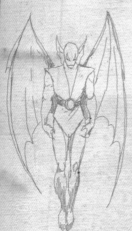

Media and Execution

• Poser 3D software and Photoshop.
• A basic male figure in Poser was given major alterations: the head and ears were exaggerated, the fingernails were extended and the fingers posed like claws.
• The demon wings came from DAZ software. The hellish red lighting was done in Poser.
• The figure was rendered and exported to Photoshop, where the tunic and the belt were created (top right).
• The claws were created in Photoshop (right).

Development

• Demons can take any form; they can be based on goats, fish, snakes and reptiles.
• Some are considered to be fallen angels, and in fiction they form a counterpoint to the world of angels and celestial beings.
• The ancient book of magic known as the *Key of Solomon* is said to contain spells for calling forth and controlling demons.

FURTHER STUDY: Lilith, *The Exorcist, Hellboy, Key of Solomon*, Semyazza, Goetia, Haggadah, Samael

ART BY BOB HOBBS

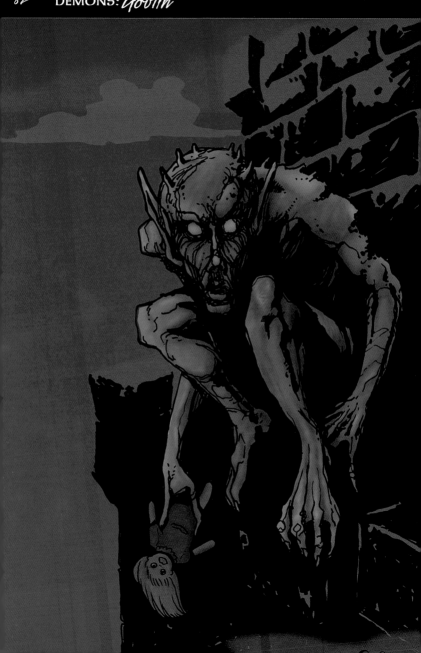

GOBLIN

A GOBLIN IS A SMALL KIND OF DEMON GENERALLY DEPICTED AS UGLY AND MALEVOLENT. AS WITH MANY FOLK CREATURES, NAMES ARE NON-SPECIFIC AND GOBLINS BECOME CONFUSED WITH DEMONS, FAERIES, GNOMES AND DWARVES, DEPENDING ON THEIR COUNTRY OF ORIGIN.

GOBLINS ARE USUALLY HARMFUL AND ARE CLOSELY ASSOCIATED WITH THE GARGOYLE SCULPTURES ON MEDIEVAL CHURCHES. IN MANY STORIES THEY EAT HUMANS AND KIDNAP CHILDREN. IT IS SAID THAT A GOBLIN'S SMILE WILL CURDLE THE BLOOD AND ITS LAUGH WILL TURN MILK SOUR.

Development

• The gargoyles that appear on old churches were the reference for this creature, and they influenced its posture. A child's doll was added, suggesting that the creature has either kidnapped and killed a child or the doll has been stolen, having ignited a spark of compassion in the goblin's dark, cold heart.

• Work fast and do a large number of drawings in a short space of time, giving each a slight variation.

• Try out different horn styles and vary the shapes of noses and mouths. Give each a different colour and consider individual character traits based on stories found in your research (see right).

Media and Execution

• Fine pencil and Photoshop.

• The intention was to create a comic style with hard blacks and flat colour.

• The original was inked with pens and brushes, then areas of flat colour were painted on in Photoshop.

• The artwork was finished with some tonal work to add depth and detail.

FURTHER STUDY: hobgoblin, nilbog, lutin, tokebi

ART BY FINLAY

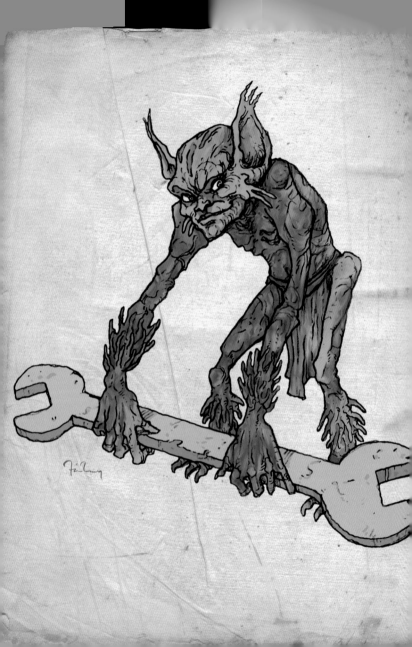

Gremlins and imps

GREMLINS ARE ONE OF THE MOST MODERN OF ALL CREATURES THAT HAVE EMERGED FROM FOLKLORE. THEY APPEARED DURING WORLD WAR II, WHEN AMERICAN AVIATORS AND THEIR GROUND CREWS BLAMED THEM FOR MECHANICAL PROBLEMS DURING FLIGHT MISSIONS. THEY ARE OBVIOUSLY BASED ON THE HUGE VARIETY OF GOBLINS, SPRITES AND ESPECIALLY MISCHIEVOUS BROWNIES THAT HISTORY HAS ENDOWED US WITH, BUT THEY ARE SPECIFIC TO THE INDUSTRIAL WORLD - GREMLINS BREAK MACHINES, AND THIS WOULD NOT HAVE BEEN POSSIBLE IN A PRE-INDUSTRIAL WORLD!

Development

• Imps are possibly the ancestors of gremlins – tiny sprites or faery-type creatures that have been caught by a human and are kept in a small bottle or even a ring.

• The owner of an imp has usually trapped it by magic, and it carries out mischievous missions on the owner's behalf.

• In one interpretation I created a sexy creature, as imps are often portrayed as being attractive females, rather like Tinkerbell (below left).

• In the other, the imp has a more demon-like appearance, which is altogether less human but still quite attractive (below right).

Media and Execution

• Fine pencil and Photoshop.

• In the rough sketch perspective lines were used to help give the character a dynamic stance and emphasize its shape.

• The trick with a creature like this is to create massively over-proportioned hands head and feet, and contrast them with skinny limbs.

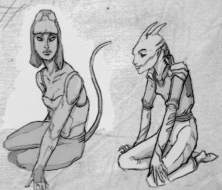

FURTHER STUDY: gremlin, imp, djinn, genie

ART BY FINLAY

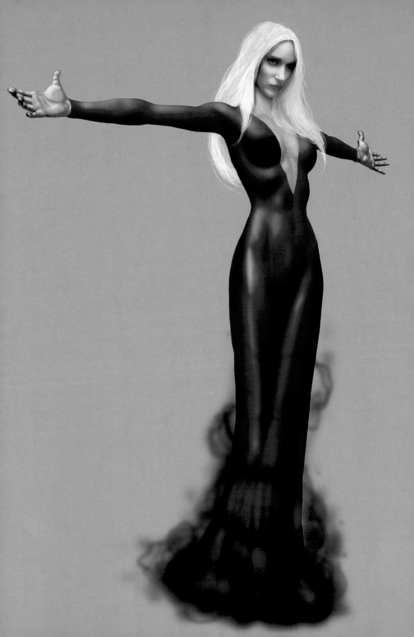

Lilith

LILITH IS A FEMALE NIGHT DEMON BELIEVED TO HARM MALE CHILDREN AND MEN. SHE WAS DESCRIBED AS A LAMIA 'WITCH' BY HIERONYMUS OF CARDIA, AND AS A 'SCREECH OWL' IN THE KING JAMES VERSION OF THE BIBLE. BUT HER REAL CLAIM TO FAME IS IN LATE MEDIEVAL JEWISH LEGEND, WHERE SHE WAS THE FIRST WIFE OF ADAM. WHEN SHE REFUSED TO BE THE INFERIOR BEING, SHE LEFT THE GARDEN OF EDEN. AT ADAM'S REQUEST THREE ANGELS CAME DOWN TO HER, TO TRY AND BRING HER BACK. WHEN SHE REFUSED THEY ORDERED THAT SHE WOULD HAVE TO KILL 100 OF HER CHILDREN, CALLED LILIN, EVERY DAY. LILITH IS SOMETIMES CONSIDERED TO BE THE PARAMOUR OF SATAN, ALTHOUGH THIS IS PROBABLY A MALICIOUS RUMOUR SPREAD BY THE PRIESTHOOD TO DENIGRATE HER AS A FEMALE DEITY.

Development

• Lilith is identical to the Middle Eastern succubus and the Scandinavian Mara.
• She is often identified as the mother of all incubi and succubi.
• Certain branches of witchcraft worship Lilith as their matron deity; they do not consider her Satanic, but rather a symbol of female power in the tradition of Aphrodite, Isis and Sibilla.

Media and Execution

• Pen and ink, Poser 3D software and Photoshop.
• The figure was created in Poser, then rendered and exported to Photoshop.
• Once in Photoshop the figure was given a new hairstyle with the airbrush tool.
• The character was airbrushed with a blue bodysuit with a semi-transparent textured bodice.
• The model's face was scanned from a photo and blended with the body.
• The wispy black tendrils of vapour at her feet were airbrushed last.

FURTHER STUDY: Dead Sea Scrolls, Jewish mythology, Talmud, succubi, witchcraft

ART BY BOB HOBBS, MODEL LILITH STABS

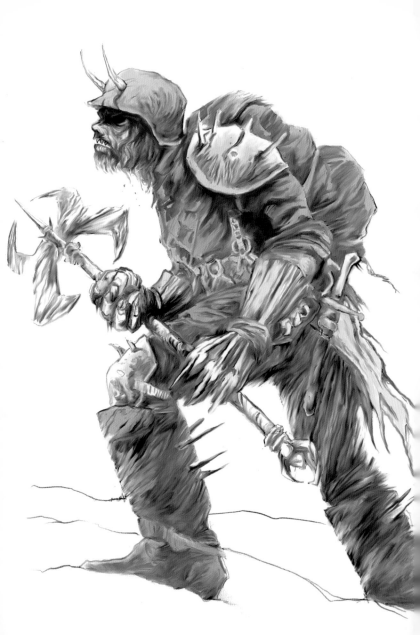

ORC

JRR TOLKIEN USED TROLLS IN HIS BOOK *THE HOBBIT* - THESE CREATURES WERE OF SCANDINAVIAN ORIGIN AND POSSIBLY INSPIRED THE CREATION OF HIS ORCS, THE GROTESQUE, VIOLENT CREATURES THAT HAVE BECOME A STAPLE OF THE FANTASY GENRE. MANY HIDEOUS GARGOYLES ADORN CHURCHES AND ILLUMINATED MANUSCRIPTS AND IN JAPAN THERE IS A LONG TRADITION OF OGRES.

IN THIS EXAMPLE I USED THE IMAGERY OF RUSSIAN AND AMERICAN PROPAGANDA POSTERS FROM WORLD WAR II THAT DEPICTED THE GERMAN *WEHRMACHT* AS A RAPINE BEAST. YOU CAN TRANSPOSE IMAGERY FROM ANY HISTORICAL SOURCE INTO A FANTASY CONTEXT AND SO FIND FRESH SOURCES OF IDEAS.

Development

• Orc costume is likely to be handmade. Everything about them suggests disorder and chaos (right).
• Many orc types are based on pigs (below right).
• You can also use reptiles and fish as inspiration for character features (below left).

Media and Execution

• Soft pencil and Photoshop.
• The final artwork was rendered in soft pencil with a lot of attention given to shadow.
• The picture was scanned then blended using the Blur tool in Photoshop. The image is very grey, in keeping with its atmosphere of doom.
• Added colour created subtle tonal variations.

FURTHER STUDY: ogre, demonology, propaganda

ART BY FINLAY

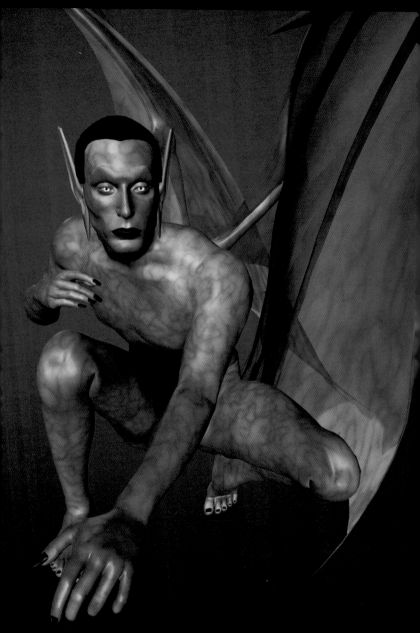

Incubus

IN WESTERN MEDIEVAL LEGEND, AN INCUBUS IS A DEMON IN MALE FORM WHO VISITS WOMEN AT NIGHT WHEN THEY ARE SLEEPING. THE INCUBUS DRAINS ENERGY FROM THE WOMAN IN ORDER TO SUSTAIN ITSELF. IN SOME CASES IT CAN KILL THE VICTIM OR LEAVE HER FEELING WEAK OR FRAGILE. INCUBI WERE SOMETIMES SAID TO CONCEIVE CHILDREN; THE HALF-HUMAN OFFSPRING OF SUCH A UNION IS A CAMBION. THE MOST FAMOUS LEGEND OF SUCH A CASE IS THAT OF MERLIN, THE FAMOUS WIZARD FROM ARTHURIAN LEGEND.

ALTHOUGH INCUBI CAN BE MALICIOUS, MANY FOLK IN THE BATHHOUSES AND CAFÉS OF THE MEDIEVAL NEAR EAST WOULD TELL STORIES OF THEIR RELATIONSHIP WITH THEIR INCUBUS OR SUCCUBUS, OFTEN BOASTING OF LOVE AFFAIRS THAT WOULD CONTINUE FOR YEARS.

Media and Execution

• Poser 3D software and Photoshop.
• A basic male figure was altered in Poser – the parameter dials were used to make the ears long and pointed, and to arch the eyebrows.
• The fingernails were extended and a dark blue pearlescent texture was added to the skin.
• The default hair, lips, pupils, toenails and fingernails were made dark blue.
• The demon wings were added using DAZ software and were given a similar blue pearlescent texture (see above).
• The only work required in Photoshop was to create the violet background.

Development

• The word incubus is derived from the Latin prefix in-, which in this case means 'on top', and cubo, which means 'I lie'. The plural is incubi.
• Djinns are the Middle Eastern version of angels and demons, and incubi are often included among them, although they are not strictly the same.
• Incubi and succubi were said by some not to be different genders but the same demons able to change their sex.

FURTHER STUDY: *The Book of the 1001 Nights*, djinn, ifrit, succubus, demon, night terrors, nightmare, Alp, Mara, Etienien ART BY BOB HOBBS

Succubus

A SUCCUBUS IS A DEMON THAT APPEARS IN THE FORM OF A FEMALE TO SEDUCE MEN IN DREAMS. THEY ARE GENERALLY DEPICTED AS BEAUTIFUL WOMEN, OFTEN WITH THE DEMONIC WINGS OF A BAT, AND OCCASIONALLY THEY ARE GIVEN OTHER DEMONIC FEATURES SUCH AS HORNS OR A TAIL WITH AN ARROWED TIP.

SUCCUBI APPEAR IN DREAMS THAT THE VICTIM CANNOT FORGET, AND IN SOME CASES, THE MALE FALLS IN LOVE WITH THE SUCCUBUS. THIS MYTH MAY HAVE EVOLVED AS AN EXCUSE GIVEN BY LOVESICK MEN TO THEIR SUSPECTING WIVES WHEN THEY HAD FALLEN IN LOVE WITH ANOTHER WOMAN.

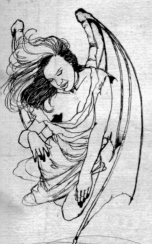

Development
• Lilith and the Lilin (Jewish), Lilitu (Sumerian) and Rusalka (Slavic) are also considered to be types of succubi.
• Succubi may have originated in the Near Eastern traditions of *The Book of the 1001 Nights*, and are a part of the demonology of Islam.
• Monks appear to have been particularly vulnerable to, and targeted by, succubi.

Media and Execution
• Fine pencil and Photoshop.
• This image started out as a rough pencil sketch based on a photo of the model.
• Textures for the dress and wings (right) were taken from a collection of JPEG texture files collected over the years. Airbrushing was added on top for depth.
• The skin and strands of the flowing hair were airbrushed in with a Wacom graphics tablet and pen.

ART BY BOB HOBBS, MODEL SAMANTHA WHITE

FURTHER STUDY: Djinn, *The Book of the 1001 Nights*, Lilith, demon, energy vampire

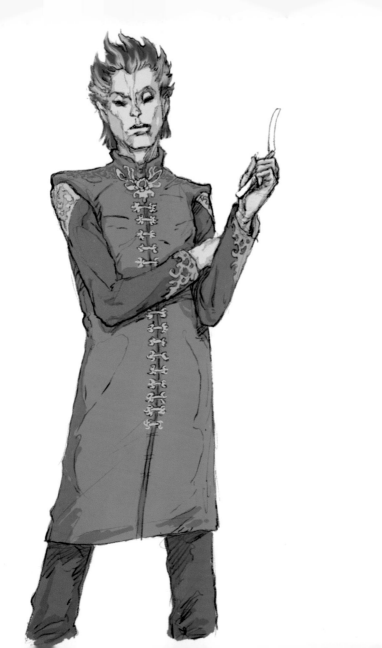

Asian Vampire

IN INDIAN FOLKLORE A VAMPIRE IS CALLED A BAITAL. WHILE RESEARCHING IDEAS FOR A GRAPHIC NOVEL I CAME ACROSS THE STORY OF 'VIKRAM AND THE VAMPYRE' BY R F BURTON. I LIKED THE IDEA OF AN INDIAN VAMPIRE BUT MADE IT LESS LIKE A BAITAL AND MORE LIKE AN ASIAN VERSION OF DRACULA - ELEGANT, CHARMING AND A DRINKER OF HUMAN BLOOD. AT THAT TIME I WAS FRIENDS WITH THE MUSICIAN TALVIN SINGH. WE'D MEET AND EXCHANGE STORIES AND I SKETCHED HIM WHILE HE PLAYED HIS TABLA, DEEP IN A TRANCE-LIKE STATE. I USED HIS SIGNATURE BLUE HAIRSTYLE FOR MY CHARACTER. IN TURN, HE RECORDED A TRACK 'VIKRAM THE VAMPYRE'.

Development

• Experiment with various types of face painting to make the character more interesting (right).
• For a variation on vampires' teeth I based them on the Indian elephant god Ganesha (centre).
• To make the teeth into tusks I pointed them up rather than in the usual position – a spin on the traditional vampire format (below).
• The cut-throat razor my vampire carries symbolizes V for Vikram. The idea came from a razor my father-in-law owned when serving in India during World War II. Mementoes like this can inspire you and provide interesting detail for characters.

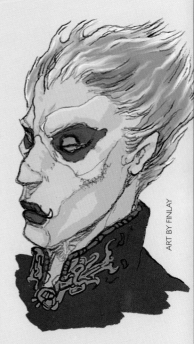

ART BY FINLAY

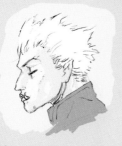

Media and Execution

• Fine pencil and Photoshop.
• A series of loose pencil sketches were produced before a favourite was chosen.
• The original sketch was scanned and coloured in Photoshop.

FURTHER STUDY: Mulo (Gyspy vampiric deity), *Vikram and the Vampyre* (Hindu folktale)

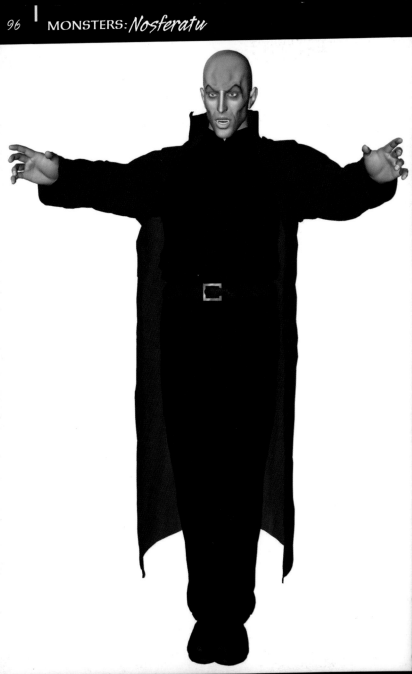

Nosferatu

THE WORD VAMPIRE COMES FROM THE EARLY 18TH-CENTURY SERBIAN *VAMPIR* OR HUNGARIAN *VÁMPÍR*. VAMPIRES APPEAR IN A GREAT MANY FOLK TRADITIONS, BUT THEY ARE PARTICULARLY COMMON IN THE MOUNTAINOUS REGIONS OF EASTERN EUROPE. THE VAMPIRE MYTH WAS CONSOLIDATED FOREVER IN THE POPULAR IMAGINATION WHEN BRAM STOKER TOOK THE FOLKLORE OF THESE REGIONS AND CROSSED IT WITH THE TRUE STORY OF THE MURDEROUS COUNT VLAD THE IMPALER TO CREATE COUNT DRACULA.

VAMPIRES ARE SAID TO BE THE RE-ANIMATED CORPSES OF HUMAN BEINGS; THEY SUBSIST ON HUMAN BLOOD, BUT CAN ALSO APPEAR AS HALF-HUMAN DEMONS AND OTHER HYBRID CREATURES.

Development

- Vampire characteristics vary widely: the Asian Baital and Tamil Pey are more like demons, and many Irish and Scottish sprites have vampiric qualities.
- *Nosferatu* was the name given to the vampire in the 1922 German expressionist film.
- The Romans had traditions of vampires, who were said to have red hair.

Media and Execution

- Poser 3D software and Photoshop.
- The figure was created almost entirely with Poser software.
- All the clothing came with the program, so it was simply a matter of posing the figure, dressing it and then applying the parameter dials to shape the head and facial features.
- The default Poser hair was touched up by hand in Photoshop, which allowed the individual hairs to be drawn in to give it more texture.

FURTHER STUDY: *Dracula*, nosferatu, Barnabas Collins, Lestat

ART BY BOB HOBBS

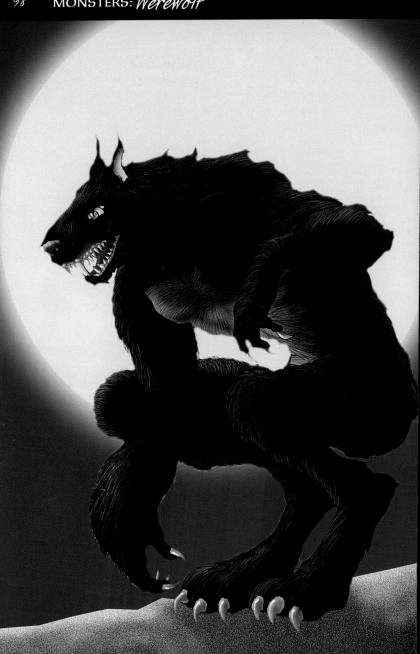

WEREWOLF

A WEREWOLF IS A PERSON WHO CHANGES SHAPE AND BECOMES A WOLF FOR SHORT PERIODS OF TIME, EITHER DELIBERATELY BY USING MAGIC OR AS A RESULT OF BEING CURSED. THE NAME IS SAID TO COME FROM THE OLD ENGLISH *WER* (OR *WERE*) MEANING 'MAN', AND *WULF*, WHICH IS THE ANCESTOR OF MODERN ENGLISH 'WOLF' AND CAN ALSO MEAN 'BEAST'. THE IDEA OF THE TRANSFORMATION TAKING PLACE AT FULL MOON WAS SUGGESTED BY THE MEDIEVAL CHRONICLER GERVASE OF TILBURY, AND THE IDEA BECAME A COMMON FEATURE IN MODERN FICTION, ALTHOUGH NOT TYPICAL OF THE ORIGINAL FOLK STORIES.

WEREWOLF TRADITIONS APPEAR WORLDWIDE BUT ARE PARTICULARLY STRONG IN EASTERN EUROPE, WHERE WEREWOLVES ARE SOMETIMES BELIEVED TO BECOME VAMPIRES AFTER DEATH.

Development

• Part of the werewolf myth may come from the Old Norse *ulfhednar*, which referred to equivalents of the bear-like *berserkr*, who were said to wear a wolf skin into battle.
• The medieval serial killer Gilles de Rais was rumoured to be a werewolf.
• Consider a 'Blade'-style approach, with a half-human werewolf who is a good guy and appears to be mostly human with some wolf-like attributes.

Media and Execution

• Fine pencil and Photoshop.
• The figure was sketched in pencil and scanned into Photoshop (above left).
• Flat colour was added before detail was painted using the Airbrush tool (centre).
• A time-intensive element was the fur: all the individual hairs that would be visible in moonlight were drawn with a Wacom graphics tablet and pen (right).
• The final elements added were the snow-covered roof, moon, night sky and shadows.

FURTHER STUDY: wolfman, lycanthropy, shapeshifter

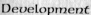
ART BY BOB HOBBS

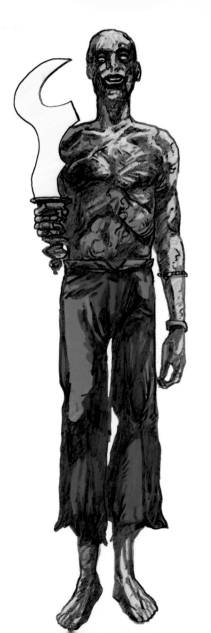

ZOMBIE

THE ZOMBIE HAS ITS ROOTS IN THE LAMENTABLE HISTORY OF THE SLAVE TRADE AND HAS EMERGED AS A POPULAR FOLK LEGEND FROM THE CARIBBEAN AND NORTH AMERICA. UNLIKE MOST FANTASY CHARACTERS IT DOES NOT HAVE ITS ROOTS IN EUROPEAN MYTHOLOGY, BUT IT HAS BECOME A POPULAR CHARACTER IN FANTASY FICTION, MOST OFTEN USED BY VILLAINS WHO CONJURE UP ARMIES OF THE LIVING DEAD TO DO THEIR BIDDING. ZOMBIES APPEAR IN THE VOODOO RELIGION AS THE BODY OF A DEAD PERSON THAT HAS BEEN RE-ANIMATED INTO A KIND OF LIVING-DEAD STATE BY USE OF MAGIC. THERE ARE SIMILAR FIGURES IN NORSE MYTHOLOGY CALLED *DRAUGR*, WHO WERE THE CORPSES OF DEAD SOLDIERS BROUGHT BACK TO LIFE TO FIGHT AGAIN.

Development

• When transferring your zombie into a fantasy context you can break with tradition. In this case I did away with the imagery of rotting flesh and gave the figure a more powerful demonic appearance (below).
• I tried various postures including this one where I attempted to define the zombie's lumbering, shuffling gait (right).

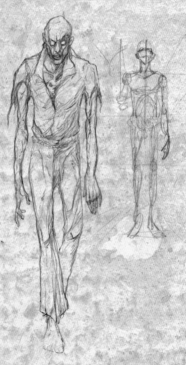

Media and Execution

• Fine pencil and Photoshop.
• The starting point was a photograph of a tribesman in Africa.
• This was traced and then modified to make the figure look far more grotesque.
• The skin was drawn to make it look like generic rotting flesh without too much specific detail.

FURTHER STUDY: voodoo, Felicia Felix-Mentor, George A Romero (film maker) ART BY FINLAY

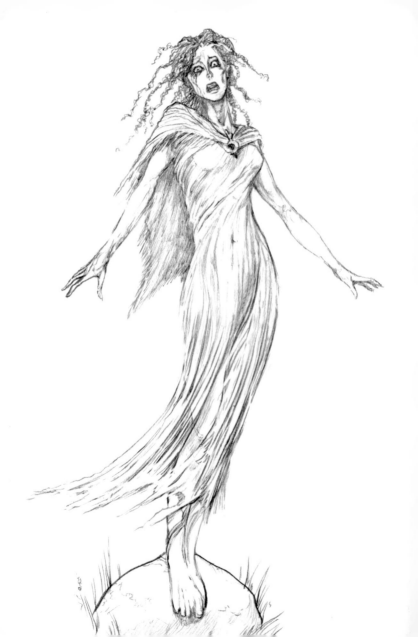

Banshee

THE WORD BANSHEE COMES FROM THE GAELIC *BEN SIDE*, WHICH MEANS 'FAERY WOMAN'. THE *SIDE* OR *SIDHE* ARE A RACE OF PRE-CHRISTIAN CELTIC DEITIES. GAELIC FOLKLORE IS ENORMOUSLY RICH IN FANTASY CHARACTERS. THE BANSHEE IS ONE THAT MANY HAVE HEARD OF BUT FEW KNOW WHAT IT IS. ACCORDING TO TRADITION, WHEN SOMEONE DIES, A WOMAN NAMED A 'KEENER' SINGS A MOURNFUL SONG AT THEIR FUNERAL. THIS WAS SAID TO HAPPEN ONLY FOR FIVE IMPORTANT IRISH FAMILIES, EACH WITH THEIR OWN FAERY. THE 'KEENER' TRADITION EVOLVED INTO THE IDEA OF A SPECTRAL WOMAN WHO APPEARED WHEN A FAMILY MEMBER DIED. BANSHEES ARE THUS KNOWN FOR THEIR SAD AND PIERCING SONG - A PORTENT OF DOOM OR BAD NEWS.

Development

• Leanan Sidhe (right) is a female vampiric spirit related in many ways to the banshee. In Ireland she is a muse and an inspiration to poets and artists but she feeds off their life force and they waste away to death, a risk that many are prepared to take.

• Be prepared to change certain elements of posture – I wasn't happy with the outstretched arm and decided to use a more fluid pose.

• The Gwillion (left) are malevolent female spirits who inhabit the mountains of Wales and mislead travellers at night. They were said to be able to take the form of goats.

• Try to capture the personality of the subject. The hairstyle and shawl are a vague reference to traditional Irish clothing. Banshees were often depicted dressed in green or black with a grey cloak.

Media and Execution

• Technical pencil and eraser.
• Use a fine pencil and build up a lot of tone in successive sweeps across the image.
• Use a fine eraser to create highlights and clean up your drawing then go back over with the pencil again. Switch between pencil and eraser regularly.

FURTHER STUDY: Bean Sidhe, wailing women, keener, Caoineadh ART BY FINLAY

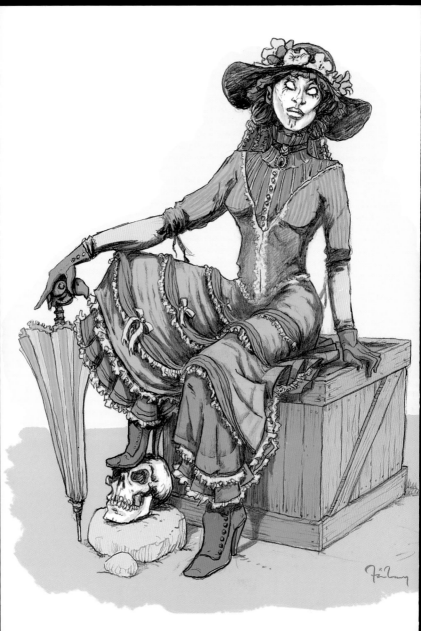

FALLEN GODDESSES

THE RELIGION OF VOODOO IS PEOPLED WITH DOZENS OF FASCINATING CHARACTERS, BUT I DECIDED TO CREATE A NEW CHARACTER DRESSED IN THE COSTUME OF 18TH CENTURY NEW ORLEANS. FALLEN GODDESSES ARE COMMON IN FOLKLORE - MANY OF THEM EXISTED FOR CENTURIES AS WISE WOMEN, HEALERS OR PAGAN GODDESSES BUT WERE DEMONIZED OVER THE CENTURIES BY ORGANIZED RELIGIONS.

Media and Execution

• Pencil and Photoshop.
• A very fine pencil drawing with a lot of tone and detail was produced.
• The drawing was scanned and coloured in Photoshop.
• The shadow areas on the pencil drawing were matched with shadow areas of colour.

FURTHER STUDY: Bean Nighe, Sibillini Goddess, Madame Loa, Lilith

Development

• Sibilla (right) is one of the ancient earth goddesses of Europe. She was said to be a witch who had a mass of serpents under her dress. The legend of Sibilla appears throughout romantic fiction and was the inspiration for Wagner's *Tannhauser*.
• Grwach Y Ribin (above right) is a Welsh spirit whose appearance is an omen of death. The name means 'hag of warning' and she was said to be one of the Mother Goddesses who was degraded to a demon.
• I placed the figure on a packing crate to suggest the exotic location of a sea port like New Orleans. I liked the idea of a very elegant dead woman who appears as a type of ghost that one should give offerings of alcohol and candy to in order to gain her favour.

ART BY FINLAY

Hags

HAG IS A NAME USED IN SEVERAL CULTURES TO DESCRIBE VARIOUS TYPES OF FEMALE SPIRITS WHO MOSTLY APPEAR AS GROTESQUE OLD WOMEN BRINGING BAD LUCK OR MISFORTUNE OF SOME KIND, MUCH IN THE SAME WAY THAT BANSHEES BRING A FOREWARNING OF A DEATH. THE BIOBHAN SITH ARE VAMPIRIC SCOTTISH WOMEN WHO, UNLIKE OTHER HAGS, ARE VERY ATTRACTIVE. THEY LURE MEN INTO DANCING WITH THEM AND, ONCE THEY HAVE SEDUCED THEM, FALL UPON THEM AND DRINK THEIR BLOOD.

Media
Fine pencil and Photoshop

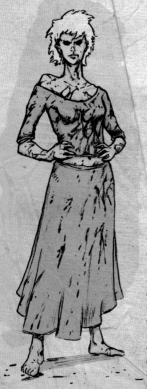

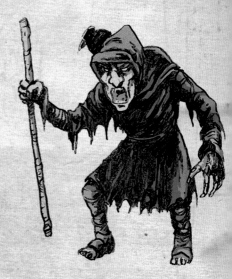

In this interpretation I decided to give the Biobhan Sith a confident posture, which suggests a vaguely threatening air. She wears the rough clothes and simple tartan of a Scottish crofter to give her a slight geographical context. The image was executed as a quick pencil sketch followed by an equally quick colour treatment in Photoshop.

Black Annis is an old woman of the Scottish highlands who appears at night with a crow on her shoulder and is said to bring bad luck but was originally an Earth Goddess demonized by the Church and may originally have been a symbol of nature. She is also known as Cailleac Bhuer, the Blue Hag and the Stone Woman.

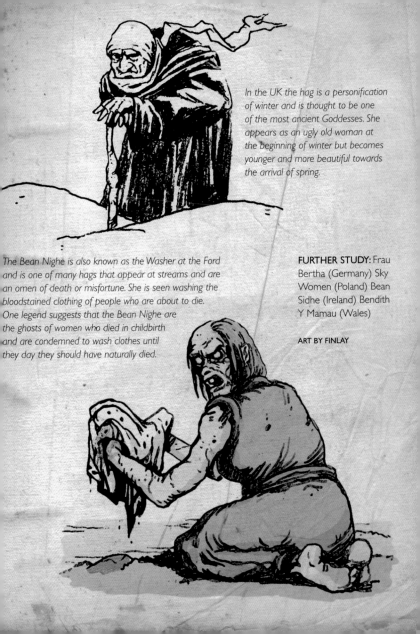

In the UK the hag is a personification of winter and is thought to be one of the most ancient Goddesses. She appears as an ugly old woman at the beginning of winter but becomes younger and more beautiful towards the arrival of spring.

The Bean Nighe is also known as the Washer at the Ford and is one of many hags that appear at streams and are an omen of death or misfortune. She is seen washing the bloodstained clothing of people who are about to die. One legend suggests that the Bean Nighe are the ghosts of women who died in childbirth and are condemned to wash clothes until they day they should have naturally died.

FURTHER STUDY: Frau Bertha (Germany) Sky Women (Poland) Bean Sidhe (Ireland) Bendith Y Mamau (Wales)

ART BY FINLAY

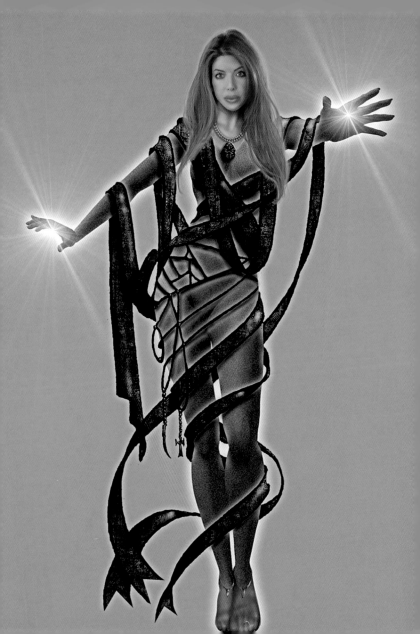

Sorceress

A SORCERESS IS A POWERFUL WOMAN WHO CAN PERFORM A NUMBER OF SUPERNATURAL ABILITIES, USING VARIOUS TYPES OF MAGIC. TRADITIONALLY, THEIR POWER COMES FROM THEIR KNOWLEDGE AND SKILL, AS WELL AS THEIR MAGICAL POWERS. A SORCERESS CAN BE BORN WITH AN INHERITED GIFT OF MAGIC BUT CAN ALSO HAVE A 'CALLING', A NATURAL INCLINATION TOWARDS THE MAGICAL ARTS. THOSE BORN WITH MAGICAL POWERS ARE LIKELY TO BE MORE POWERFUL AND LEARN MUCH MORE QUICKLY.

AS WITH OTHER TYPES OF MAGICIAN, SORCERESSES CAN FOCUS THEIR ATTENTIONS ON A WIDE VARIETY OF CRAFTS, WHICH CAN RESULT IN THEM HAVING VARYING POWERS AND ABILITIES. THEY MAY, FOR EXAMPLE, CHOOSE DIVINATION OR TRANSFORMATION.

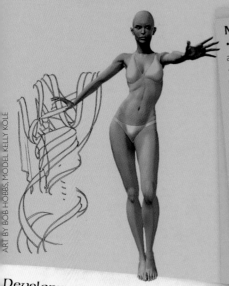

ART BY BOB HOBBS, MODEL KELLY KOLE

Media and Execution
• Poser 3D software, pen and ink and Photoshop.
• The main body was posed and lit in Poser, then rendered out to Photoshop.
• The flowing bands were drawn in pen and ink using a printout of the body as a guide. This was scanned into Photoshop.
• The head was taken from a photo. All the elements were assembled in Photoshop and blended together with the Airbrush tool, which was also used to add more volume to the red hair.
• The bands were textured, the blue skin-tight outfit was coloured in blue, then a Noise filter was added for a textured look.
• Final touches were the demon pendant on the necklace, the pale glow and lens flares on the hands.

Development
• 'Sorceress' is often used interchangeably with 'witch', although the archetypal witch is depicted as an old hag, while a sorceress is usually a younger woman.
• Consider moving away from the obvious costume choices of long flowing robes into a more modern look, involving imaginative costume details, such as the body-suit, web-like dress and hanging ribbons here.

FURTHER STUDY: witch, Hecate, Cerridwen, Circe, *Warcraft III*, *Sleeping Beauty*

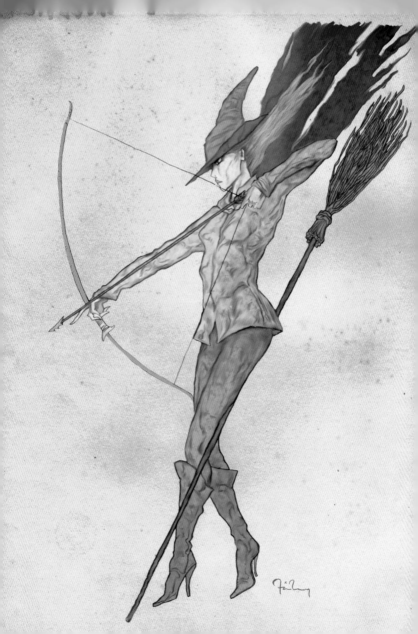

classic witch

THE TRADITIONAL IMAGE OF THE WITCH IS THAT OF THE WIZENED OLD HAG OR CRONE FLYING ON A BROOMSTICK AND ACCOMPANIED BY A BLACK CAT. SHE USES BLACK MAGIC AND THIS BELIEF HAS ITS ROOTS IN THE CHRISTIAN PERSECUTION OF WISE WOMEN WHO PRACTISED HERBAL MEDICINE BEFORE THE RISE OF SCIENCE AND ORGANIZED RELIGION – THE BROOMSTICK IMAGE CAME FROM THE POLE THEY USED TO PERFORM A KIND OF FERTILITY DANCE.

TODAY, HISTORIANS HAVE HELPED US UNDERSTAND THE REALITY OF WITCHES AND IN MANY CULTURES WITCHES ARE CLOSELY RELATED TO THE CULT OF THE EARTH GODDESS.

Development

• The main image is inspired by the Phillip Pullman type of witch, an entirely separate species, often beautiful, who were master archers.
• Your witch can be inspired by any period of history or costume such as the Edwardian Grand Dame (above right) in her high, starched collar.
• Alternatively, she can be thoroughly modern, with pale skin and a vaguely gothic hair cut (below), or she can hark back to the image of the pagan healer with a modern twist (centre).
• Experiment with outlandish costumes, paying attention to various style of collars, gowns, and jewellery.

Media and Execution

• Fine pencil and Photoshop.
• The witch was drawn in fine pencil with a hard outline so it would be easier to select the whole figure with the magic wand tool in Photoshop.
• When she was coloured, a textured area of colour from another painting was 'sampled' and laid over the whole figure.
• The final image was smoothed and blended with a mixture of Smudge and Burn tools in Photoshop.

FURTHER STUDY: Sybil Leek, Baba Yaga (Russia), Befana (Italy) Cadi (Turkey) Managilunod (Philippines)

ART BY FINLAY

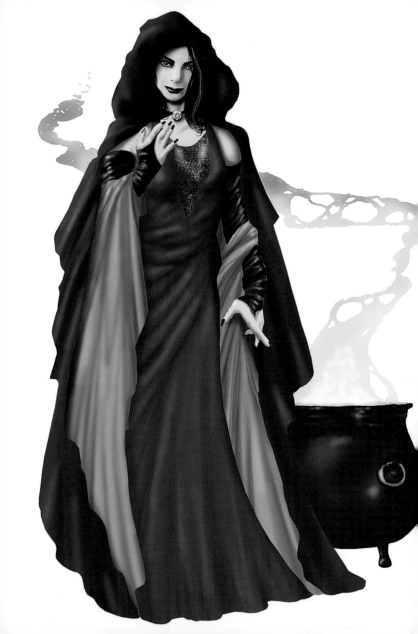

WITCH

THE WORD 'WITCH' COMES FROM THE ANGLO-SAXON WICCE, WHICH IN TURN DERIVES FROM AN INDO-EUROPEAN ROOT WORD MEANING TO BEND OR CHANGE, OR DO MAGIC OR RELIGION. THE MODERN WITCH IS CLOSER TO THE ANCIENT TRADITIONS OF HEALING AND HERBALISM THAT WERE DEMONIZED AND TURNED INTO THE IMAGE OF THE BAD WITCH BY ENCROACHING CHRISTIAN RELIGIONS. WITCHCRAFT MAY BE SEEN AS THE SUM TOTAL OF ALL A WITCH'S PRACTICES, INCLUDING SPELLCASTING, DIVINATION (FORTUNE TELLING), MEDITATION, HERBALISM, RITUAL AND RITUAL DRAMA, SINGING AND DANCING TO RAISE ENERGY, HEALING, CLAIRVOYANCE AND CREATIVE MYTHOLOGY.

Media and Execution

- Fine pencil and Photoshop.
- The figure was sketched out in pencil and scanned into Photoshop.
- The face was based on a photo (right).
- The two elements were put together in Photoshop and then painted using the Airbrush tool.

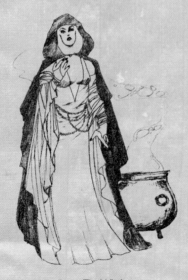

Development

- The symbol of the pentacle (above) is commonly associated with witchcraft; its roots lie in its association with the planet Venus and its feminine aspect.
- The use of the classic witch's hat and broomstick will always clearly define your character as a witch, so this will give you the freedom to experiment with her outfit – you can make her young and attractive.

FURTHER STUDY: Janet Farrar, The Witches Voice website, Hecate, Gerald Gardner

ART BY BOB HOBBS, MODEL DEANNA CAINE

Elves and faeries

ELVES ARE ONE OF THE MAIN PILLARS OF ALL FOLKLORE AND THEIR HISTORY IS SO CLOSELY RELATED TO FAERIES THAT THE TWO GET MIXED UP. THERE ARE TWO EASILY DEFINED BRANCHES OF FAERY AND ELF CULTURE, WHICH SHOW GREAT SIMILARITIES SO THEY CAN BE GROUPED TOGETHER. THE TUATHA DÉ DANAAN (SEE BELOW) WERE DIVIDED INTO TWO GROUPS BY WB YEATS: THERE WERE THE 'TROOPING FAERIES' WHO LIVED IN GROUPS AND WERE OF ARISTOCRATIC DESCENT AND THERE WERE THE SOLITARY FAERIES, WHICH INCLUDED CREATURES SUCH AS THE LEPRECHAUN. THE TROOPING FAERIES BECAME SPECIES SUCH AS THE 'SEELIE COURT' THE 'SIDHE' AND THE 'DANA O SHEE' AND WERE CLEARLY DESCENDED FROM THE TUATHA. ALL DARK OR EVIL CREATURES BECAME ASSOCIATED WITH THE 'UNSEELIE COURT' OR 'SLOAGH'. THE OTHER BRANCH OF FAERY CULTURE IS THE SCANDINAVIAN ELVES, WHICH CLOSELY RESEMBLE THE TUATHA – THEY ARE TALL, FAIR AND LIVE IN ORGANIZED SOCIETIES. THEIR ROYAL SEAT IS A PLACE CALLED ALFHEIM AND THEY FEATURE OCCASIONALLY IN NORSE MYTH.

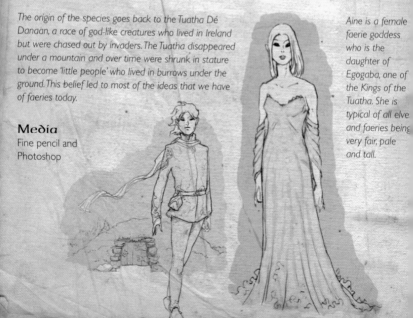

The origin of the species goes back to the Tuatha Dé Danaan, a race of god-like creatures who lived in Ireland but were chased out by invaders. The Tuatha disappeared under a mountain and over time were shrunk in stature to become 'little people' who lived in burrows under the ground. This belief led to most of the ideas that we have of faeries today.

Media

Fine pencil and Photoshop

Aine is a female faerie goddess who is the daughter of Egogaba, one of the Kings of the Tuatha. She is typical of all elves and faeries being very fair, pale and tall.

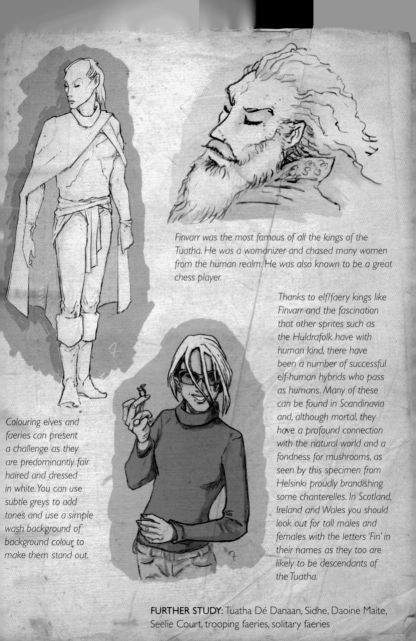

Finvarr was the most famous of all the kings of the Tuatha. He was a womanizer and chased many women from the human realm. He was also known to be a great chess player.

Thanks to elf/faery kings like Finvarr and the fascination that other sprites such as the Huldrafolk have with human kind, there have been a number of successful elf-human hybrids who pass as humans. Many of these can be found in Scandinavia and, although mortal, they have a profound connection with the natural world and a fondness for mushrooms, as seen by this specimen from Helsinki proudly brandishing some chanterelles. In Scotland, Ireland and Wales you should look out for tall males and females with the letters 'Fin' in their names as they too are likely to be descendants of the Tuatha.

Colouring elves and faeries can present a challenge as they are predominantly fair haired and dressed in white. You can use subtle greys to add tones and use a simple wash background of background colour to make them stand out.

FURTHER STUDY: Tuatha Dé Danaan, Sidhe, Daoine Maite, Seelie Court, trooping faeries, solitary faeries

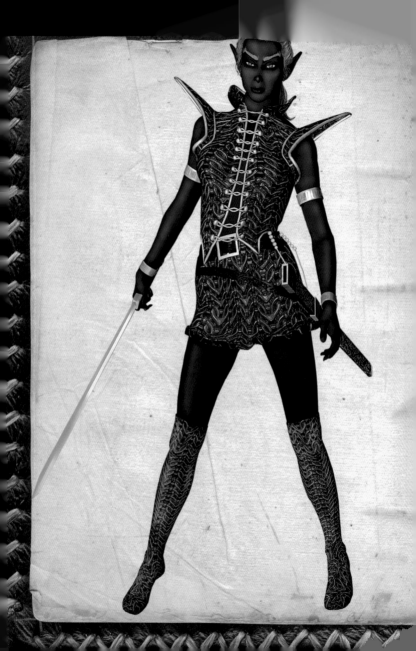

Dockalfar

A DOCKALFAR IS A DARK ELF; ITS APPEARANCE IN NORSE MEANS THAT ELVES ARE PART OF AN ORGANIZED MYTHOLOGY RATHER THAN FOLK TRADITION. THE DOCKALFAR HAVE ALSO BEEN LINKED TO TROWS, DROWS AND DU SITH, AND ARE USUALLY THE EVIL OR SINISTER COUNTERPARTS OF THE LIGHT ELVES (LJOSALFAR). THEIR ORIGIN MAY HAVE BEEN PRE-NORSE, AS THEY APPEAR IN ICELANDIC SKALDIC POETRY. ORIGINALLY, THE EXTENT OF THEIR EVIL WAS AMBIGUOUS, BUT MODERN INTERPRETATIONS MAKE A CLEAR DISTINCTION. THEIR LEADER WAS CALLED VOLUND, AND WIDER SCANDINAVIAN BELIEF HELD THAT A HUMAN COULD BE ELEVATED TO THE RANK OF DARK ELF AFTER DEATH.

Development

- Dark Elves have become a staple of fantasy fiction, particularly in the realm of games such as *Dungeons and Dragons*.
- They have largely replaced the tiny faery-like elves of British folklore, which were shrunk by centuries of folklore.
- Trows and Drows, along with Black Elves and Dark Elves, are often pictured as beautiful but dangerous.

Execution

- This figure began as a default Poser female figure from DAZ software, and the clothing was altered to make it look more like something a Dark Elf might wear.
- The texture was a chain mail texture from a texture map library.
- The skin texture map of the Poser figure was given a dark blue ambient colour.
- The image was rendered out and exported to Photoshop, where the hair and eyebrows were created using the Airbrush tool (right).

Media

Poser 3D software and Photoshop

FURTHER STUDY: Celtic and Norse mythology, Skaldic poetry, J R R Tolkien, *Everquest, Final Fantasy IV*

ART BY BOB HOBBS

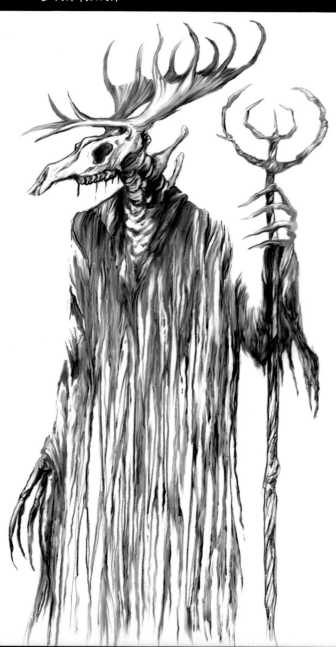

Svartálfar

FAERIES AND ELVES ARE OFTEN SYMBOLS OF AN ANIMISTIC BELIEF IN THE SPIRITS OF NATURE AND THE CYCLE OF LIFE, DEATH AND REBIRTH. I WAS INTERESTED IN INCORPORATING THIS QUALITY IN THE CHARACTER OF THE SVARTALFAR, THE DARK ELVES FROM NORSE TRADITION. WHILE VISITING THE FORESTS OF SMÅLAND IN SWEDEN I STAYED WITH JIMMY SODERHOLM, AN ARTIST WHO MAKES SCULPTURES FROM ELK BONES. THE ELK PLAYS AN IMPORTANT PART IN SCANDINAVIAN FOLKLORE AND IS CLOSELY LINKED TO THE EVERYDAY LIVES AND TRADITIONS OF THE PEOPLE. JIMMY TOLD ME HOW HE WOULD GO INTO THE FOREST, FIND ELK BONES AND PAINSTAKINGLY PIECE THEM BACK TOGETHER, PUZZLING OVER THE MYSTERIES OF THE CREATURE. JIMMY'S STORIES FIRED MY IMAGINATION AND THE IMAGE OF THE ELK SKULL BECAME THE PERFECT MODEL FOR MY INTERPRETATION OF THE SVARTALFAR.

Development

• The beauty of fantasy art is that the artist can draw on centuries of tradition but still be free to interpret the character from a personal viewpoint by adding modern elements or drawing on their immediate surroundings.
• This is not a typical interpretation of a Dark Elf but the use of a prominent creature in Scandinavian folk culture made logical sense.

Media and Execution

• Fine pencil and Photoshop.
• I made a few quick studies of elk skulls to get the feel of the creature – notice the 'nose' area extends well beyond the jaw.
• I used the lower jaw for my character, adjusting the antler shape to make them more iconic and give them symbolic strength.
• The final effect was achieved solely using the Smudge tool in Photoshop.

FURTHER STUDY: Svartalfar (Dark Elves) Loisalfar (Light Elves) Alfheim (elf throne) Snorri Sturrlson (Icelandic mythographer)

ART BY FINLAY

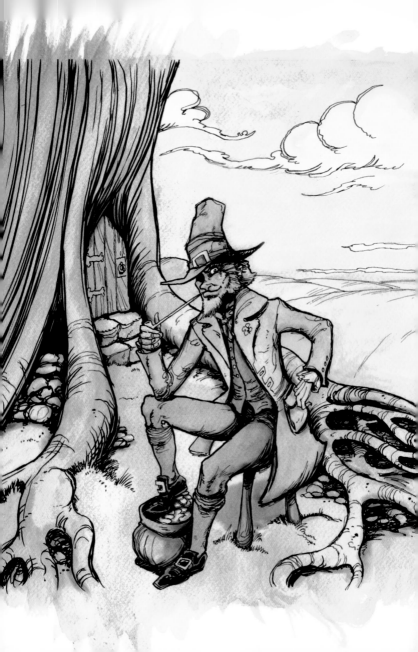

Leprechauns

LEPRECHAUNS ARE A SPECIES OF FAERIE FOLK WHO INHABIT IRELAND. ONE MEANING OF THE NAME IS *LEATH BHROGAN,* WHICH MEANS SHOEMAKER, AND THE LEPRECHAUN IS OFTEN PORTRAYED AS A COBBLER. LEPRECHAUNS ARE GENERALLY SAID TO BE HARMLESS AND TO ENJOY SOLITUDE. ONE OF THE MOST ENDURING MYTHS IS THAT THEY ARE EXTREMELY WEALTHY AND ALL HAVE A STORE OF GOLD; MANY STORIES TELL OF HUMAN ATTEMPTS TO OUTWIT THEM, NORMALLY ENDING IN FAILURE.

THIS IMAGE WAS INSPIRED BY THE WORK OF THE ENGLISH ARTIST ARTHUR RACKHAM, WHOSE STYLE HAS BECOME A TEMPLATE FOR THE DESIGN OF FAERIES, PIXIES AND WITCHES SINCE THE EARLY 1900S. RACKHAM TOOK HIS INSPIRATION FROM NATURE, AND HIS WILDER FIGURES ARE HEAVILY INFLUENCED BY THE TREES HE SAW AROUND HIM IN HIS NATIVE OXFORDSHIRE AND KENSINGTON.

Development

• The modern image of a leprechaun is of a character dressed in green, but older sources suggest they wore red.

• Try and imagine your character in context. What would he do? Where would he go? In the picture below left we see him chatting to a faery, as the two species would undoubtedly mingle.

• Highly stylized features, such as those of a leprechaun, can be developed by attempting the same drawing several times (below right).

Media and Execution

• Ink and watercolour.

• Watercolours are a quick medium to use, but can be difficult to control as they dry quickly.

• Ink was added with brushes and pens after the watercolours had dried completely.

FURTHER STUDY: Far Darrig, Cluricaun; Kallikantzaros, Menehune

ART BY FINLAY

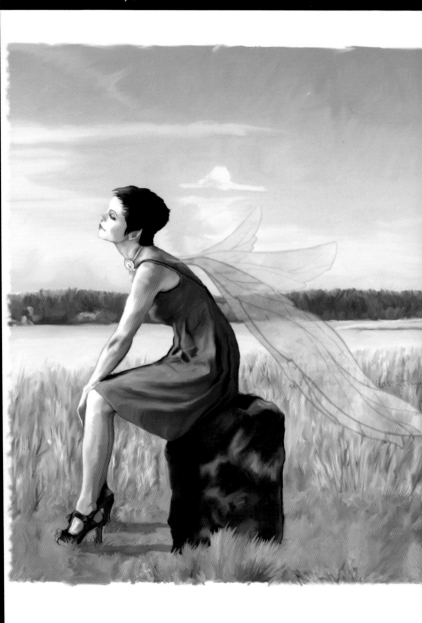

Pixie

THE IMAGE OF THE TINY WINGED FAERY IN THE MOULD OF TINKERBELL FROM J M BARRIE'S *PETER PAN* IS A PARTICULARLY ENGLISH TRADITION THAT BECAME A SOLID ARCHETYPE IN VICTORIAN TIMES. UP UNTIL THEN THE TERM 'FAERIES' WAS USED TO DESCRIBE A WIDE VARIETY OF CREATURES, AND BOTH FAERIES AND ELVES WERE OFTEN CONSIDERED TO BE OF HUMAN SIZE. ALTHOUGH IT IS FAIR TO DEFINE THE TINY MAGICAL CREATURES WITH WINGS AT THE BOTTOM OF OUR GARDENS AS FAERIES, THE TERM 'PIXIE' IS MORE SUITABLE FOR THESE DELICATE LITTLE WOODLAND CREATURES.

ONE MYTH SUGGESTS THEY WERE DRUIDS WHO REFUSED CHRISTIANITY AND WERE CONDEMNED BY GOD TO GROW SMALLER, WHILE ANOTHER LEGEND SUGGESTS THEY ARE DESCENDED FROM A SCOTTISH TRIBE CALLED THE PICTS.

ART BY FINLAY; MODEL MINNA

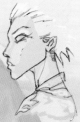

Media and Execution

• Fine pencil and Photoshop.
• This image was based on a photograph of a real life pixie singer. A photo of her was taken in London and overlaid on a photo taken at the Rudolf Steiner School near Stockholm.
• A drawing of her was blended with the photo and a Photoshop Smudge tool was used to change the image into a painting.
• Although the techniques are relatively simple, this look can't be created at the push of a button — all the best digital art techniques require the same level of craft and manual dexterity as traditional drawing and painting.

Development

• Try using different colour schemes for your characters. The colours of the hair and skin are in the same colour range (see above right).
• Note how all these creatures have very fine features — high cheekbones, small, turned-up noses and pointy chins (above centre).

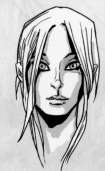

• This pixie (right) has typical humanoid colouring and was originally designed as a character for a proposed graphic novel in which she appears as a Huldra, so you can expect to see her turn up again in one disguise or another.

FURTHER STUDY: pixie, sprite, piskie

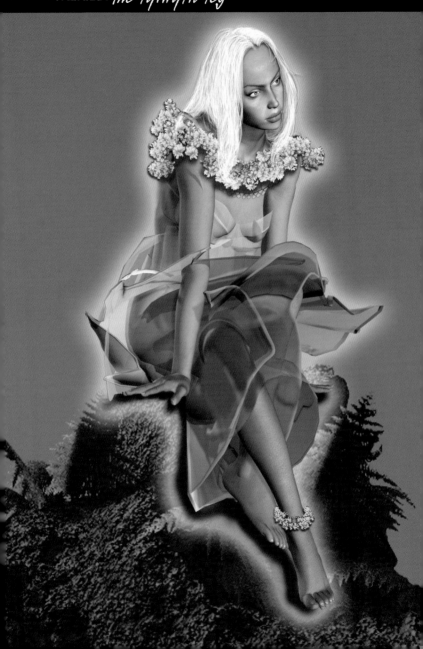

The tylwyth teg

THIS IS A GENERAL NAME FOR THE FAERIES IN WALES; IT MEANS 'THE FAIR FOLK' AND THE FLATTERING NAME WAS THOUGHT TO APPEASE THEM. IN APPEARANCE THE TYLWYTH TEG ARE BEAUTIFUL, FAIR-HAIRED, DRESSED IN WHITE AND SMALL IN STATURE. THEY WERE THOUGHT TO LIVE UNDER HOLLOW HILLS AND COULD BE SEEN AROUND ANCIENT PLACES SUCH AS BARROWS OR CROMLECHS. TO AN UNEDUCATED PEASANTRY, A BARROW WOULD HAVE AN AIR OF MYSTERY, SO IT WAS NATURAL TO BELIEVE THAT SUPERNATURAL BEINGS MIGHT FREQUENT THE AREA.

LIKE MANY TYPES OF FAERY FOLK, THE TYLWYTH TEG WOULD INTERACT WITH HUMANKIND, AND IT WAS HIGHLY DESIRABLE TO HAVE A FAERY WIFE, EVEN THOUGH THEY ALWAYS LONGED TO RETURN TO THEIR OWN PEOPLE. IT WAS SAID TIME IN THEIR REALM PASSED MUCH SLOWER THAN IN OURS - A DAY IN THEIR REALM COULD BE 100 HUMAN YEARS.

Development

• There are a great many 'breeds' of faery to be found throughout the world, and you can find widely varying descriptions of each type.
• Use this diversity to provide a wealth of detail that can lend a kind of accuracy to your creations – or create new breeds of your own.

Media and Execution
• Poser 3D software, Vue d'Esprit and Photoshop.
• This image began as a Poser figure, clothed and posed the way the artist wanted.
• The moss-covered rocks were created in the 3D landscaping program Vue d'Esprit.
• The gorse flower wreath was made using a photo of real gorse flowers copied, cut and pasted.
• The hair was done by hand in Photoshop with a Wacom graphics tablet and pen. The final touch was the magical glow.

FURTHER STUDY: faeries, fae, Welsh folklore, trooping faeries

ART BY BOB HOBBS

DWARVES

DWARVES STAND OUT IN FOLKLORE BECAUSE THEY HAVE A SPECIFIC DEFINITION AND CANNOT BE EASILY MISTAKEN FOR OTHER FIGURES. THEY ARE UNIQUE IN THE SENSE THAT THEY HAVE A HIGHLY ORGANIZED CULTURE AND ARE CLOSELY RELATED TO THE INDUSTRY OF METALWORK. IT HAS BEEN SUGGESTED THAT, DURING THE BRONZE AGE, STOCKY SOUTHERN EUROPEAN MINERS MIGRATED TO NORTHERN EUROPE AND WERE IDENTIFIED AS SUPERNATURAL BEINGS BY THE NORTHERN EUROPEANS WHO HAD YET TO DEVELOP METALWORKING SKILLS, WHICH MUST HAVE SEEMED ALMOST MAGICAL TO THEM. DWARVES ARE VERY COMMON IN GERMANIC AND NORSE MYTHOLOGIES AND THEIR DEFINITION HAS REMAINED RELATIVELY UNCHANGED THROUGH ITS EVOLUTION INTO MODERN FANTASY FICTION.

Media
Fine pencil and Photoshop

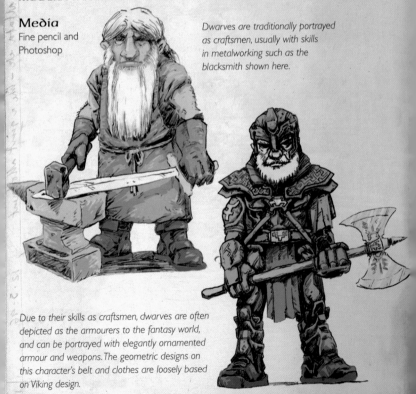

Dwarves are traditionally portrayed as craftsmen, usually with skills in metalworking such as the blacksmith shown here.

Due to their skills as craftsmen, dwarves are often depicted as the armourers to the fantasy world, and can be portrayed with elegantly ornamented armour and weapons. The geometric designs on this character's belt and clothes are loosely based on Viking design.

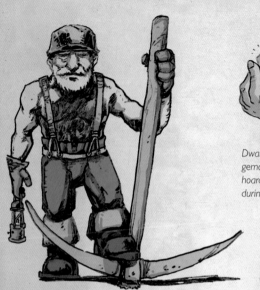

Dwarves are said to be renowned gemologists and often acquire huge hoards of precious stones extracted during their mining activities.

Kobolds are German dwarves specifically associated with mining and are said to hide the tools of human miners, although this kind of behaviour is not generally associated with dwarf culture. The lamp that he carries is based on the one left to me by my grandfather who was a miner in Scotland.

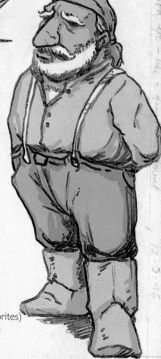

The Kallikantzaroi is said to be a kind of Greek dwarf although on further study it seems to be a far more powerful supernatural figure than its Northern European counterparts. It did however give me the idea of doing a Greek variant on the classic dwarf image.

FURTHER STUDY: Pygmies, Knockers (Cornish mining sprites) Hackers (Sweden) Bes (Egypt) Harmandle (Switzerland) Kröpel (Germany) Alvis (Norway) Trauco (Chile)

ART BY FINLAY

GNOMES

GNOMES ARE VERY POPULAR FIGURES WHO HAVE THEIR ROOTS IN SCANDINAVIA WHERE THEY ARE THE EQUIVALENT OF BROWNIES - HOUSE AND GARDEN SPRITES THAT WILL PROTECT THE FAMILY, BUT CAN ALSO BE MISCHIEVOUS. IN RECENT YEARS THEY HAVE BEEN RE-CAST AS ENVIRONMENTALLY AWARE GUARDIANS OF NATURE.

IT'S GREAT FUN TO RESEARCH ALL THE DIFFERENT TYPES OF A CHARACTER FROM AROUND THE WORLD AND TRY TO IMAGINE HOW EACH WOULD LOOK. THERE ARE VERY FEW IMAGES OF MANY OF THESE - SO USE ARTISTIC LICENSE.

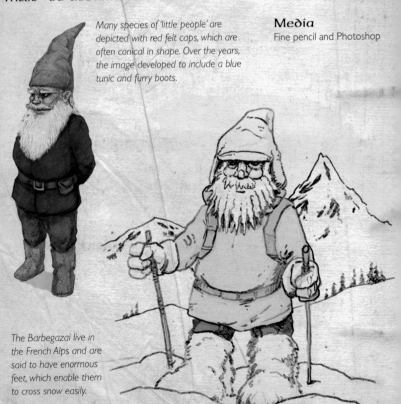

Many species of 'little people' are depicted with red felt caps, which are often conical in shape. Over the years, the image developed to include a blue tunic and furry boots.

Media
Fine pencil and Photoshop

The Barbegazai live in the French Alps and are said to have enormous feet, which enable them to cross snow easily.

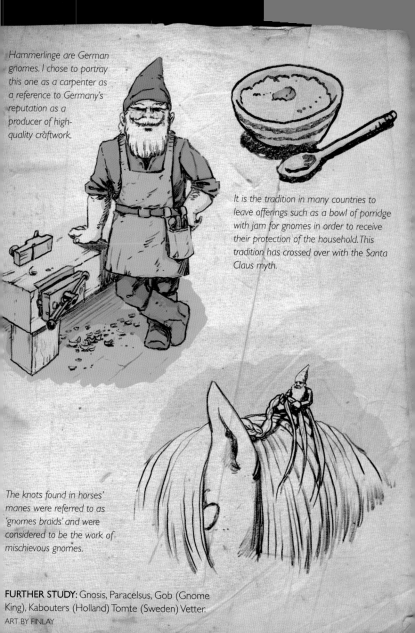

Hammerlinge are German gnomes. I chose to portray this one as a carpenter as a reference to Germany's reputation as a producer of high-quality craftwork.

It is the tradition in many countries to leave offerings such as a bowl of porridge with jam for gnomes in order to receive their protection of the household. This tradition has crossed over with the Santa Claus myth.

The knots found in horses' manes were referred to as 'gnomes braids' and were considered to be the work of mischievous gnomes.

FURTHER STUDY: Gnosis, Paracelsus, Gob (Gnome King), Kabouters (Holland) Tomte (Sweden) Vetter.

ART BY FINLAY

BROWNIES

HOUSE SPRITES ARE COMMON FAERY CREATURES, WITH THOUSANDS OF DIFFERENT VARIATIONS ALL OVER THE WORLD. THE BROWNIES, OR URUISG, OF THE BRITISH ISLES ARE SAID TO INHABIT HOUSES AND HELP OUT IN EXCHANGE FOR OFFERINGS OF FOOD AND DRINK. THESE CREATURES ARE RARELY MALICIOUS, BUT THEY ARE EASILY OFFENDED BY THE WRONG GIFTS. IN OLD MANOR HOUSES IT IS STILL POSSIBLE TO FIND SPECIAL SEATS BY THE FIRE THAT WERE ALWAYS LEFT FREE FOR THE HOUSE BROWNIE.

Media
Pencil and Photoshop

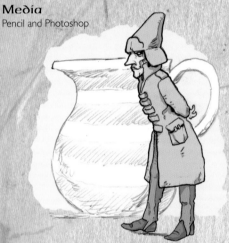

The image of the Brownie varies enormously from culture to culture. In some countries they appear more like a demon or monster, in others they appear as an old man.

The Dolya is a female sprite that appears in Slavic and Russian folklore. She lived behind the stove and could also be kept happy with offerings. When she was happy she would bring good luck, but when displeased she changed into her incarnation of Nedolya, an ugly hag who brought misfortune. She generally appeared as an elderly woman and oversaw the birth of children in the house.

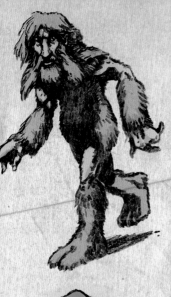

The Domovoi is a house sprite from Slavic folklore, known as Stopan in Bulgaria and Djadek in Slovakia. Many families treated the Domovoi as a member of the family, even though it was never seen. It lived under the threshold of the house or under the stove, and would reward the household with its protection if the house was well looked after. It was said to be able to foretell danger, and would moan and howl to warn the family.

A Domovik is a Russian fire sprite who lives at the hearth, traditionally the centre of the household and the focus of all family life – the place where everybody gathered, spent most of the winter and shared stories and knowledge. As a result a fire sprite was considered quite important, and offerings of corn and drink were made to keep it happy. It was said that if a Domovik was offended in some way, it might burn the house down.

The Igosha is another Russian house sprite, this time a legless, armless creature. It is said to be the soul of a new baby who died before being christened – religious belief dictating that the soul couldn't go to heaven unless the child was so blessed. Although Igoshas were mischievous, it was possible to placate them with an offering of a spoon and a loaf of bread, or a hat and mittens for the winter.

FURTHER STUDY:
house sprites, Lutin,
Jack o' the Bowl,
Bwbachod
ART BY FINLAY

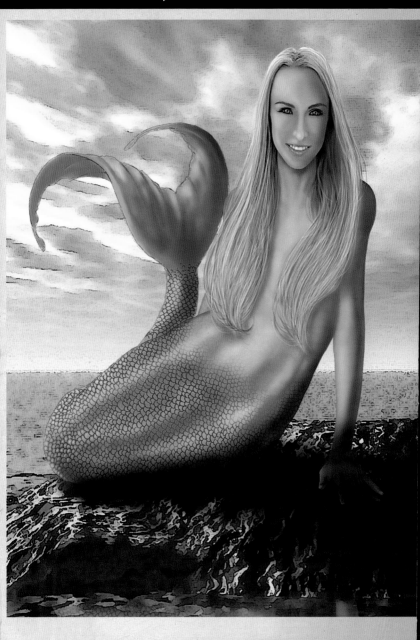

Mermaid 1

MERMAIDS (FROM THE MIDDLE ENGLISH *MERE*, MEANING 'SEA') APPEAR THROUGHOUT THE WORLD'S CULTURES IN MANY DIFFERENT FORMS. THEY ARE GENERALLY DESCRIBED AS HAVING THE HEAD AND TORSO OF A HUMAN FEMALE AND THE TAIL OF A FISH, ALTHOUGH THERE IS A MALE VERSION, WHICH IS CALLED A MERMAN.

THE MOST COMMON STORY OF MERMAIDS IS THAT, LIKE THE SIRENS, THEY LURE SAILORS TO THEIR DEATHS BY SINGING TO THEM AND GUIDING THEIR SHIPS ON TO ROCKS, OR SEDUCING THEM WITH THEIR SONGS SO THAT THE HAPLESS MARINERS DIVE INTO THE WATER TO TRY AND RETRIEVE THEM AND ARE NEVER SEEN AGAIN.

Development

- Similar creatures, such as the Rusalka and Scottish Selkie, are to be found throughout European and Slavic folklore.
- The mermaid myth may be connected with the early Greek goddess Aphrodite, who was depicted emerging from the sea.

Execution

- Pen and ink, Vue d'Esprit and Photoshop.
- An ink drawing of the fish and tail sections with all the little scales (above) was scanned into Photoshop.
- The face was based on a photo and the body was created from scratch. Everything was blended together in layers and worked on with the Airbrush tool.
- The background scene was created in Vue d'Esprit, rendered out and imported into Photoshop. A Smart Blur and Watercolor filter was applied.
- Finishing touches included shiny highlights, shadows and a slight mist in the lower third of the picture.

ART BY BOB HOBBS, MODEL KRISTEN PEOTTER

FURTHER STUDY: Junar the Sea Born, *The Little Mermaid*, J W Waterhouse, Vodyanov's daughters

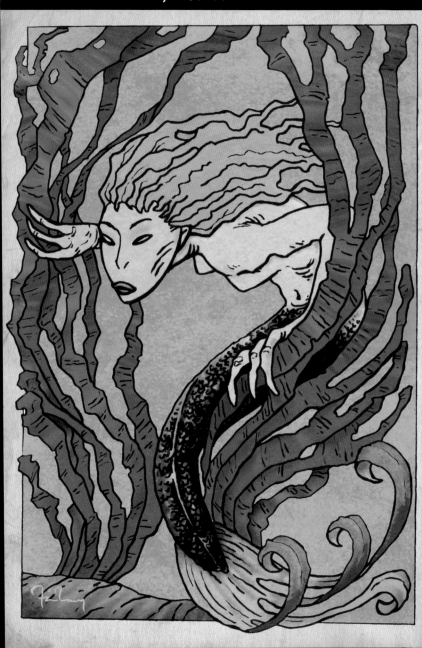

Mermaid 2

THE MYTH OF THE MERMAID MAY HAVE EVOLVED FROM SAILORS HEARING THE HAUNTING MELODIES OF WHALE SONGS IN THE FOG OR CAPTURING SEALS, WHICH CAN HAVE ALMOST HUMAN CHARACTERISTICS, ESPECIALLY IF YOU'VE BEEN AT SEA FOR MONTHS. AS THE MYTH OF MERMAIDS PASSED INTO FICTION THEY BECAME INCREASINGLY ROMANTICIZED AS BEAUTIFUL BEINGS THAT PERSONIFIED THE DESIRE OF THE UNATTAINABLE. RECENTLY, ARTISTS HAVE PORTRAYED MERMAIDS AS DARKER, MORE MALEVOLENT CREATURES AND GIVEN THEM A FISHY APPEARANCE.

Development

• Sea witches, common in British folklore, were said to be in control of the fate of sailors and were capable of conjuring up the storms that wrecked ships.
• The Blue Men of Minch (above right) were fallen angels who lived in the waters between Long Island and the Shiant Islands, and were capable of creating thunderstorms.
• The Tangie (below right) was native to the Orkney Islands near Scotland. It was covered in seaweed and could also appear as a seahorse but was one of the few sea sprites not to be harmful.
• Use obscure characters from folklore like these for creating your own fantasy characters and storylines.

Media and Execution

• Fine pencil and Photoshop.
• This was drawn with a thick black pencil line, which was colorized in Photoshop.
• Each area was coloured with flat colour using the Magic Wand and Paint Bucket tools.
• Highlights and shadows were added with Dodge and Burn tools set to a low percentage pressure.

FURTHER STUDY: Selkie (Scottish), Vodnik (Russian), Dracs (French), Fees (Breton), Glaistig (Irish)

ART BY FINLAY

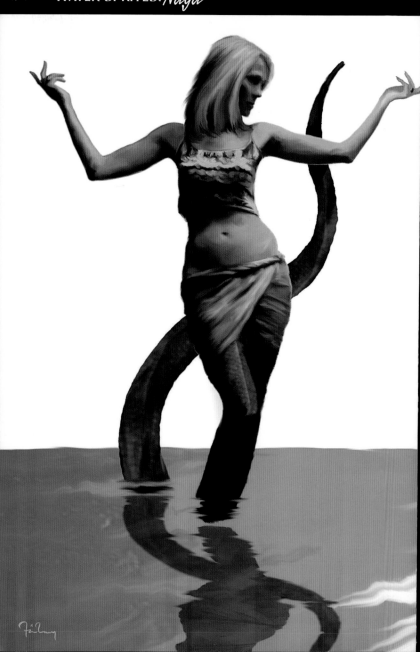

NAGA

THE PROFUSION OF MYTHS SURROUNDING WATER MAY BE DUE TO ITS NECESSITY TO HUMANS, WHILE AT THE SAME TIME BEING A SIGNIFICANT TAKER OF LIVES. MANY OF THESE MYTHS WERE CAUTIONARY TALES TO PROTECT YOUNGSTERS, WHILE OTHERS TELL OF BEAUTIFUL FEMALES WHO LURE MEN TO THEIR DOOMS IN FOREST POOLS AND MOUNTAIN LAKES. OTHER WATER SPRITES ARE LESS MALICIOUS. THESE BEAUTIFUL CREATURES ARE FASCINATED BY HUMANS AND OFTEN LEAVE THEIR WATERY WOODLAND HIDEAWAYS TO MARRY MORTAL MEN. ALTHOUGH IT WAS CONSIDERED DESIRABLE TO HAVE A 'FAERY WIFE' THE CREATURES WOULD ALWAYS PINE FOR THEIR OWN KIND AND WOULD SOONER OR LATER SLIP AWAY BACK INTO THE SHADOW REALM. NAGAS ARE INDIAN WATER NYMPHS SIMILAR TO GREEK NAIADS, SAID TO BE ABLE TO TRANSFORM INTO SNAKES.

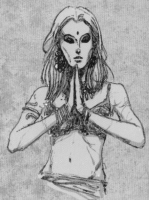

Media and Execution

• Pencil and Photoshop.
• The image was a based on a photograph taken of a friend, with the snake's tail added afterwards.
• I wanted to use colours that would reflect the character's watery origins so I opted to use watery tones for her clothes and body but gave her fiery red hair, which resulted in a stunning contrast with the palette of greens.
• The addition of blood red water suggests either a darker side to the figure or reflects the rich colour palette of an Indian sunset.

Development

• Life sketches like this one are invaluable in the development of any artist. Multiple studies not only develop essential skills but also help artists immerse themselves in the development of their fictional character and the process helps to trigger ideas for the final image.
• It is important to try different colour schemes to see how they affect the impression a character gives.

FURTHER STUDY: naiads, nymphs, sirens, Melusine

ART BY FINLAY, MODEL VEERA RONKKÖ

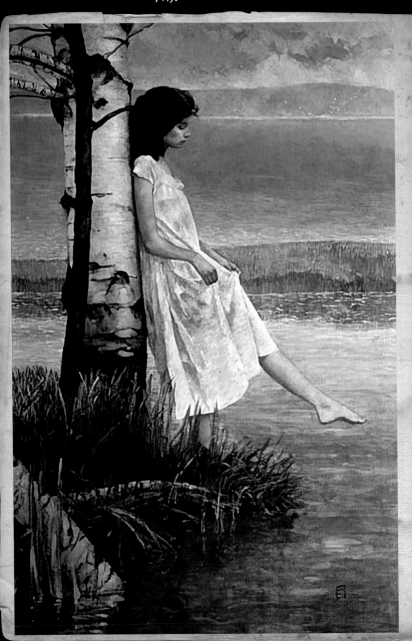

Nix

THE WORLD OF FAERIES IS HIGHLY POPULATED WITH WATER SPRITES, MOST OF WHICH ARE FEMALE AND MALICIOUS. SCANDINAVIA HAS A GREAT MANY OF THESE CREATURES IN ITS VAST FORESTS PEPPERED WITH THOUSANDS OF LAKES. SOME OF THE CREATURES ARE BENIGN AS WELL AS DEADLY, AND ARE A REFLECTION OF THE STILLNESS AND MAJESTY OF THE LANDSCAPE ITSELF. THE UNDERSTATED IMAGERY OF THIS IMAGE IS A GREAT EXAMPLE OF HOW INTERPRETATION CAN LEAD THE VIEWER TO TELL THEIR OWN STORY ABOUT AN IMAGE.

MANY ARTISTS SPEAK ABOUT HOW THEY ARE OFTEN FOLLOWING THEIR INSTINCTS IN THE CREATION OF AN ARTWORK AND HOW THEY DO NOT NECESSARILY KNOW WHAT THE FINAL OUTCOME WILL BE. THEY ARE PERHAPS BEING LED BY THEIR SUBCONSCIOUS IN THE RE-CREATION OF POWERFUL MYTHICAL IMAGES THAT RESONATE ACROSS THE CENTURIES.

Development

• A Nix, or Nixe, has origins in German folklore and is a freshwater equivalent of the mermaid or siren. Although they have the tail of a fish in their natural environment, Nixes can take the shape of humans and snakes.

• The images by artist Jeff Jones on these pages are not specifically water sprites but bear all the classic hallmarks of the archetype, many artists prefer to leave a little mystery around their work, choosing instead, to let the power of paintings speak for themselves.

• A Corrigan, or Korrigan, (below) is a water sprite from Breton folklore that haunts fountains and wells. She is said to have red flashing eyes and sings like a mermaid or siren.

Media and Execution

• Oil or acrylic paints are generally considered to produce a greater depth of colour, light and tone than any other medium.

• With technique and practice iridescent lighting effects can be produced, as seen here.

MAIN PAGE ART AND IMAGE ABOVE BY JEFF JONES, REPRODUCED COURTESY OF UNDERWOOD BOOKS, NEVADA CITY, USA,

OTHER ART BY FINLAY

FURTHER STUDY: Asrai, Glaistig, Gwragedd Annwn, El Trauco, Lamia

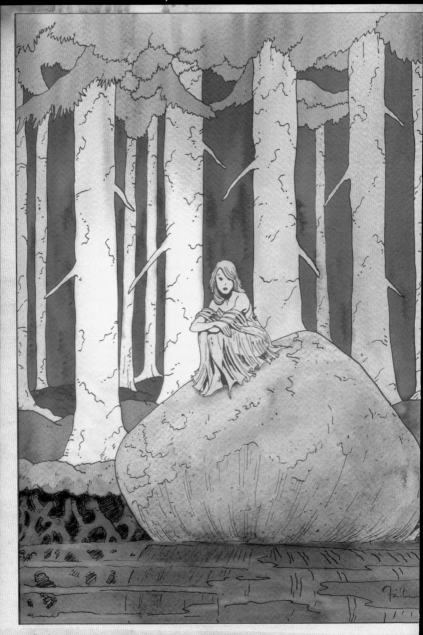

Ylva

WATER SPRITES APPEAR IN FOLKLORE OF ALL CULTURES, PROBABLY BECAUSE IN EARLY TIMES PEOPLE HAD TO CROSS RIVERS WITHOUT BRIDGES, AND WATER WAS RESPONSIBLE FOR MANY PREMATURE DEATHS.

THE YLVA IS INTERESTING BECAUSE SHE'S EXTRAORDINARILY RARE. SHE IS NOT A SPECIES: THERE IS ONLY ONE YLVA WHO INHABITS A FOREST IN SWEDEN CLOSE TO LAKE VATTEN IN THE SMÅLAND REGION. SHE IS NOT A WARNING OR A DANGER TO TRAVELLERS BUT SIGNIFIES CHANGING SEASONS. SHE EMERGES FROM THE WATER ON THE DAY OF THE FIRST THAW OF SPRING, AND CAN BE SEEN COMBING HER HAIR AND ENJOYING THE SUNSHINE AFTER SPENDING THE LONG WINTER DEEP IN A FREEZING POOL. SHE IS SAID TO BE WISE AND BEAUTIFUL AND A GOOD OMEN, A SIGN OF HOPE FOR THE WARM DAYS OF SUMMER THAT LIE AHEAD.

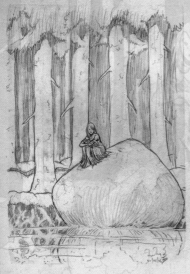

Development

• Studies like these can be the first step towards the development of a powerful symbolic image. Sometimes several different variations of an image need to be sketched out before the right composition is found.

• The Nakken (below) is a beautiful naked male figure that shows up in Swedish streams playing a violin and luring women to their deaths with his good looks and enchanting music.

Media and Execution

• Pencil and watercolour.
• A fine line pencil drawing was made over the initial sketch on a lightbox.
• A separate watercolour image was also made on the lightbox.
• The two were then laid over one another in Photoshop and tidied up so the colour layer matched the pencil layer.

FURTHER STUDY: nagas, Rusalka, sirens, nymphs, Gwragedd Annwn (Wales)

ART BY FINLAY,
MODEL YLVA FRIDELL

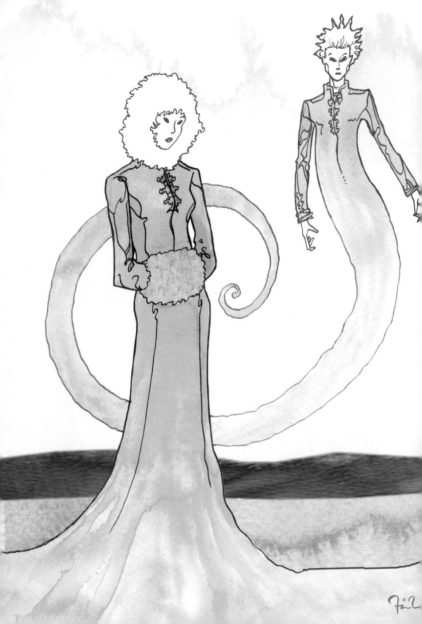

JACK AND JILL FROST

THERE ARE SPRITES FOR EVERY TYPE OF NATURAL ELEMENT: WATER,
FIRE, EARTH AND AIR. SNOW SPRITES ARE LESS COMMON BUT THE
MOST FAMOUS ARE JACK AND JILL FROST. THEY REPRESENT THE FIRST
FROSTS OF WINTER AND THE PATTERNED ICE ON WINDOWPANES
IS SAID TO BE THEIR ARTWORK. JACK FROST IS SAID TO HAVE
ORIGINATED IN NORSE MYTH AS JOKUL OR FROSTI. IN RUSSIA HE
APPEARS AS A METAL SMITH WHO BINDS THE ELEMENTS OF EARTH
AND WATER TOGETHER WITH CHAINS. IN ENGLISH FOLKLORE THE
WINTER IS REPRESENTED BY THE APPEARANCE OF THE HAG, AND IN
GERMAN TRADITION IT IS AN OLD WOMAN WHO CAUSES SNOW BY
SHAKING OUT HER BED OF FEATHERS.

Development
• The style of this illustration is based on the simple,
elegant depictions of women from the covers of
Vogue magazine during the 1920s.
• The figures are also inspired by images from the
Russian ballet.
• Sky women are said to be an incarnation of
the Rusalka who emerge from the waters at the
onset of winter. Women in Poland build snow
women at the first snow fall as an offering to them.
It is believed that springtime storms are caused
by sky women mating with thunder
gods, and spring festivals in Slavic
countries often include offerings
to them. This image (below)
is an irreverent modern
interpretation
of a sky woman
dressed in
contemporary
ski-fashion.

Media and Execution
• Technical ink pen and watercolour.
• The drawing style is flat with clean
lines and style favoured over
proportion.
• The composition
features Jill as static and
Jack as active creating a
dynamic tension between
the two figures.

ART BY FINLAY

FURTHER STUDY:
Sky women,
Rusalka, nix

Sylph

ONE OF THE MAIN FUNCTIONS OF FOLKLORE WAS TO MAKE SENSE OF THE NATURAL WORLD IN A TIME WHEN IT WAS HARD TO EXPLAIN NATURAL PHENOMENA. AS A RESULT BEINGS WERE CREATED FOR EVERY TYPE OF ELEMENTAL ACTIVITY AND THE SYLPH IS A FICTIONAL INVENTION MEANT TO REPRESENT THE ACTION OF THE WIND. IT WAS INVENTED BY PARACELSUS (WHO ALWAYS WROTE ABOUT MANDRAKES AND HOMUNCULI) AS A SPIRIT OF THE AIR. LATER ON, ALEXANDER POPE HUMOROUSLY SUGGESTED THAT SYLPHS WERE THE SPIRITS OF VAIN WOMEN WHOSE SOULS WERE UNABLE TO ASCEND TO HEAVEN. OVER TIME THE PHRASE BECAME USED FOR ANY FAERY THAT WAS ASSOCIATED WITH THE WIND.

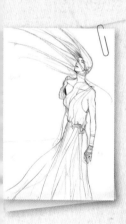

Development

• Here, the artist chose to break with tradition and depict the Sylph as a male.
• She gave the figure long hair so the powerful wind coming from behind the character would emphasize the presence and importance of air in the image.
• The figure is surrounded by a flurry of translucent white leaves. These conjure up an image of the power of the wind and its relationship to the character, who stands with his head back and eyes closed, seemingly drinking in the energy of the invisible elemental force.

Media and Execution

Pencils, Painter and Photoshop.
A rough sketch gave the artist the opportunity to make mistakes and revisions before a clean pencil drawing was produced.
This was then scanned and coloured in Photoshop.
The delicate strands of white hair were added in Painter.

FURTHER STUDY: *La Sylphide* (ballet), *A Midsummer Night's Dream* (Shakespeare)

ART BY SAYA URABE

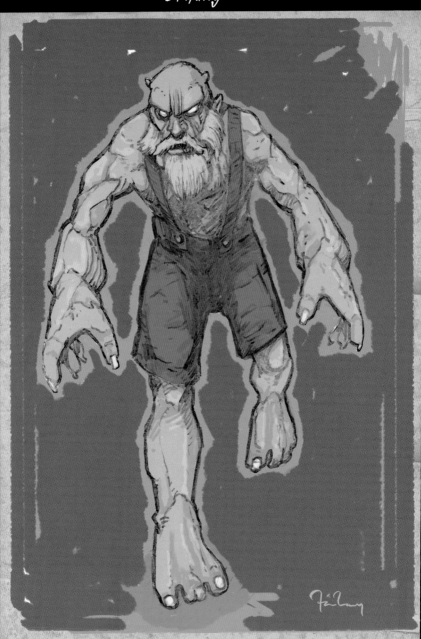

Erlking

AN ERLKING IS A MALEVOLENT SPRITE OF GERMAN ORIGIN, WHOSE AIM IS TO WHISK CHILDREN AWAY TO AN UNCERTAIN DOOM BY OFFERING THEM TREATS AND A VISIT TO HIS PALACE.

GOETHE'S POEM TELLS OF A FATHER CARRYING HIS SICK CHILD TO A DOCTOR ON HORSEBACK WHILE THE ERLKING CHASES THEM THROUGH THE NIGHT. IN OLDEN TIMES THE CHANCES OF LOSING A CHILD WAS VERY HIGH; THE SPECTRE OF THE ERLKING CAPTURES THIS DEEP-ROOTED FEAR VERY SUCCESSFULLY AND TOUCHES BEAUTIFULLY ON THE FEELINGS OF PROTECTION WE HAVE TOWARDS OUR CHILDREN.

Development
• Erlking translates as 'elf king'. How he came to be named thus is a mystery, as elves are generally considered to be good sorts.
• The Erlking is a powerful story tool, and modern versions have been expertly used by many filmmakers and writers.
• Stories of the Erlking always feature him as chasing his prey, so it is important to capture him in action.

Media and Execution
• Fine pencil and Photoshop.
• Initial sketches portrayed the Erlking as significantly demonic with a hint of intelligence.
• A colour scheme of greys and greens made him too much like a goblin. For the final image a tawny beige colour scheme was used.
• The beard and the *lederhosen*-style trousers are a nod of the head to his Germanic origins.

ART BY FINLAY

FURTHER STUDY: Schubert: *Lieder*, Goethe: *Der Erlkönig*

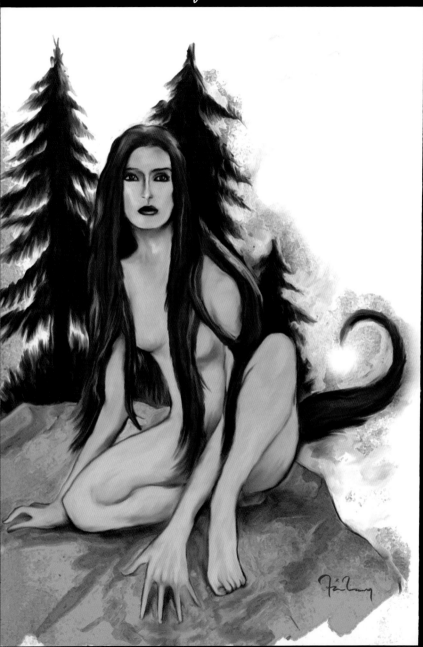

Skogsfru

THE VAST FORESTS OF SCANDINAVIA AND RUSSIA HAVE PRODUCED A VARIETY OF WOOD SPRITES, SUCH AS THE SWEDISH SKOGSFRU, WHICH MEANS 'ENCHANTED LADY OF THE FOREST'. THESE CREATURES TAKE THE FORM OF BEAUTIFUL GIRLS WHO LURE MEN INTO THE WOODS EITHER TO HELP THEM OR DRIVE THEM INSANE. THEY HAVE LONG AUBURN HAIR AND THE TAIL OF A COW OR A FOX AND APPEAR NORMAL FROM THE FRONT BUT ARE HOLLOWED OUT LIKE OLD TREE TRUNKS WHEN SEEN FROM BEHIND. THEY ARE PARTICULARLY FEARED AND ADMIRED BY HUNTERS AND OTHER LONE WORKERS IN THE FOREST. IF THEY ARE TREATED WELL THEY WILL ENSURE THAT WOODSMEN ARE SUCCESSFUL IN THEIR WORK.

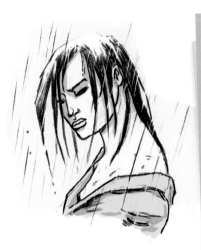

Development

• Try to capture an animal grace in the pose. Note how she seems to be in repose but has a primal, wild quality, like a coiled spring – ready to leap.
• Capturing the expression of such a creature in facial features and posture can be a challenge. Do some picture research for inspiration. Try a few sketches to see which works best.
• Szepassony (left) is a Hungarian wood spirit who comes out to dance when it rains. It is unlucky to step into a circle of short grass, as this may be where she has danced. She is known as the fair lady but I chose to depict her with dark hair.
• The Huldra (below) is a subspecies of the Rå, a name given to any type of forest spirit.

Media and Execution

• Fine pencil and Photoshop.
• The image was drawn in pencil and then scanned.
• The Photoshop filter 'fresco' was used on a duplicate layer to enhance the painted look of the image, then worked into with the Smudge tool.

FURTHER STUDY: Huldrafolk, nix, Yakishi, Askefreur, Wight

ART BY FINLAY, MODEL ALMA FRIDELL

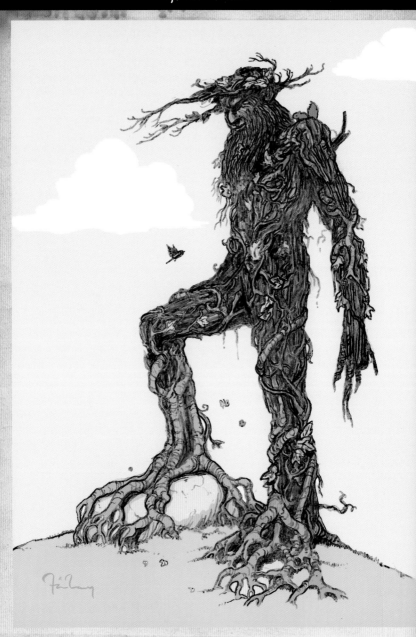

GREEN MAN

THE GREEN MAN IS ONE OF THE MOST ANCIENT AND PROMINENT FIGURES THROUGHOUT THE MYTHS AND LEGENDS OF ALL CULTURES. THE IMAGE IS SEEN IN INDIAN TEMPLES DEDICATED TO SHIVA, IN GOTHIC CATHEDRALS AND CAN BE FOUND IN THE ART OF EVERY CULTURE FROM ISLAM TO CHINA AND PRE-COLOMBIAN MEXICO.

HE REPRESENTS NATURE AND, IMPORTANTLY, THE RELATIONSHIP BETWEEN NATURE AND HUMANITY - AN ISSUE THAT IS JUST AS IMPORTANT TODAY AS IT WAS TO OUR ANCESTORS. HE REPRESENTS THE NEED TO BE IN HARMONY WITH NATURE AND IS CLOSELY CONNECTED WITH THE EARTH GODDESS - APPEARING EITHER AS HER SON, PARTNER OR GUARDIAN.

Development

• Fabian (right) is a Czech character who is the archetypal protector of the forest. He was a good knight who was turned into a forest spirit by his ex-wife who was a sorceress. He is said to scare off poachers and thieves with a fearsome yell.

• Nipal (below right) is the guardian of the Bayerishe Wald forest range. Legends tell that he kills poachers in the same way that they have killed an animal. He lives on Niklasberg hill and appears as a rich man when he is helping or as an ugly dwarf when he is punishing. There is another guardian named Tyllenberger and the two were said to have met.

Media and Execution

• Pencil and Photoshop.
• The original proportions of the figure were based on a human male.
• I exaggerated his limbs and features as I added the vegetaion to his basic structure.
• His crown of ivy is a reference to Pagan and Christian symbolism and adds a dynamic touch.

FURTHER STUDY: Hiisi (Finland) William Anderson (author) Pan (Greco Roman) Babi Jan, Hejkal, Tyllenberger.

ART BY FINLAY

Woodwife

PRIOR TO THE DEVELOPMENT OF AGRICULTURE, AND EVEN FOR MANY CENTURIES AFTER ITS ARRIVAL, FORESTS WERE THE PRINCIPAL SOURCE OF FOOD AND RAW MATERIALS. IN THIS SENSE THEY WERE BOUNTIFUL, BUT THEY WERE ALSO DARK AND MYSTERIOUS. CONSEQUENTLY, A SIGNIFICANT NUMBER OF FOLK CHARACTERS OF ALL CULTURES ARE ASSOCIATED WITH FORESTS, AND THE DIVERSE FAUNA OF WOODLAND LORE PROVIDES A WEALTH OF INSPIRATION AND RESOURCE FOR FANTASY ARTISTS AND WRITERS. THE TERM 'WOODWIFE' BECAME A TERM FOR A WHOLE HOST OF WOODLAND SPRITES THROUGHOUT CENTRAL EUROPE FOR MANY CENTURIES.

Development

• The Askefreuer (right) is a tree-dwelling sprite in German and Nordic folklore. Its name means 'ash-wife' after the ash tree.
• A Vadleany (centre) is a wood sprite from Hungary who seduces shepherds and makes the forest rustle.
• Dryads (bottom) are Celtic oak-dwelling spirits who were contacted by Druids for information.

FURTHER STUDY:
wood sprite,
weird women

Media and Execution

• The tones produced by using soft pencils can be used to your advantage.
• You can allow tonal areas to build up as you work, and either build on them with shadow or erase them away to create highlights.
• Her arms are crossed on her chest in an attitude of self-protection, which suggests she feels threatened: is she lost in the forest perhaps? But the small bird on her right has attracted her attention and brings a sense of safety and reassurance.

MAIN PAGE ART BY JEFF JONES, REPRODUCED COURTESY OF UNDERWOOD BOOKS, NEVADA CITY, USA, OTHER ART BY FINLAY

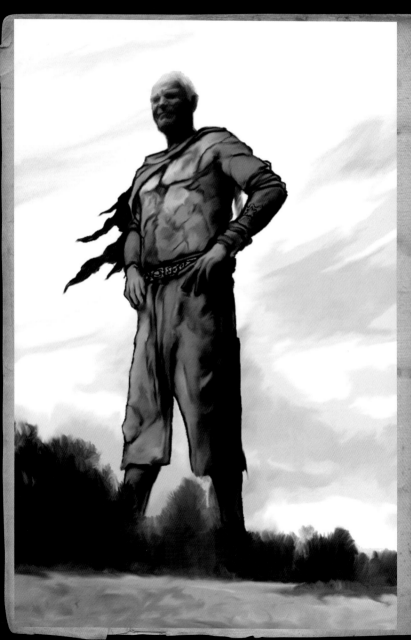

PELLE

GIANTS APPEAR THROUGHOUT FOLKLORE AND MYTH AS BEINGS OF HUMAN APPEARANCE BUT WITH IMMENSE SIZE AND STRENGTH WITH LIFE SPANS TO MATCH. THEY APPEAR IN THE OLD TESTAMENT. IN GREEK MYTHOLOGY A RACE OF GIANTS ENTERS A CONFLICT WITH THE GODS OF OLYMPUS WHICH IS ULTIMATELY SETTLED BY THE HERO HERACLES. GIANTS ARE CLOSELY RELATED TO OGRES AND TROLLS, AND MANY LOCAL STORIES OF GIANTS PORTRAY THEM AS KIND PROTECTORS OF NATURE.

Development

• It is widely believed that dolmens and stone circles (above) were erected by giants for use in an early form of the sport of bowling.
• Norse myth tells that humans were formed from the flesh of the Frost Giant Ymir (below).
• Burial mounds and ancient barrows were described as resting giants.

Media and Execution

• Pencil and Photoshop.
• A drawing was traced over a photo using a fine pencil.
• The drawing and the photo were merged together in Photoshop using the Smudge tool.

FURTHER STUDY: Atlas, Fomorians, Jotuns, Titans, Jentilak, Cerne Abbas

ART BY FINLAY, MODEL PELLE FRIDELL

Gog and Magog

THE DEFINITION OF THESE TWO FAMOUS GIANTS VARIES DEPENDING ON THE SOURCE: THEY CAN BE MEN, GIANTS OR DEMONS, NATIONAL GROUPS OR EVEN LANDS! GOG AND MAGOG APPEAR IN THE BIBLE AND THE QUR'AN, AND THROUGHOUT THE FOLKLORE AND MYTHOLOGY OF MANY CULTURES, FROM ANCIENT GREECE TO OUTER MONGOLIA.

ACCORDING TO ANCIENT ENGLISH HISTORY, THEY WERE THE SURVIVORS OF A RACE OF GIANTS. IN THE *RECUYELL DES HISTOIRES DE TROYE,* THE TROJAN SOLDIER BRUTUS AND HIS COMPANIONS FLED TROY AND INVADED ENGLAND. GOG AND MAGOG WERE TWO OF A RACE OF GIANTS THEY ENCOUNTERED AND DEFEATED, AFTER WHICH THEY WERE BROUGHT TO LONDON AND MADE TO WORK AS PORTERS AT THE ROYAL PALACE.

Development

• Effigies of Gog and Magog as giants are carried in a traditional procession by the Lord Mayor of the City of London.
• Think about the climate such giants would live in, and how this affects what they wear.
• Would they wear the hard-wearing clothes of a farmer, the robes of a wealthy merchant or the armour of soldiers?

Media and Execution

• Poser 3D software and Photoshop.
• The main character is the Poser figure called The Freak, which has giant proportions.
• The suits of armour and weapons are default items for The Freak. The textures for the axe, sword and chain mail came from a texture map library.
• Magog's horned helmet was created in Photoshop.
• The rubble background was taken from an old war photograph. Buildings were edited out, and part of the whole image was copied and placed in the far background, lit with a dull yellow light.
• The foreground rubble was lit differently, and shadows and wisps of smoke were airbrushed in.

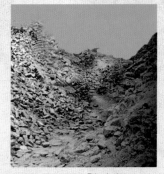

FURTHER STUDY: Diocletian, Corineus, Brobdingnagians, Patagons, Rumblebuffin

ART BY BOB HOBBS

GOLEM

IN JEWISH FOLKLORE THE GOLEM IS A FIGURE MADE FROM INANIMATE MATERIALS SUCH AS CLAY OR MUD AND BROUGHT TO LIFE BY RECITING MAGICAL VERSES IN HEBREW. TALES OF THE GOLEM DATE BACK TO BIBLICAL TIMES BUT THE MOST FAMOUS STORY IS SET IN THE 16TH CENTURY WHEN THE RABBI JUDAH LOEW CREATED ONE TO PROTECT THE GHETTO OF JOSEFOV FROM ANTI-SEMITIC ATTACKS. ONE STORY SAYS THAT THE BODY OF THE GOLEM LIES IN AN ATTIC IN PRAGUE AND THAT A NAZI OFFICER DISCOVERED IT DURING WORLD WAR II AND WAS KILLED BY IT.

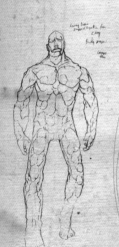

Development

• The anatomy of the creature was designed to be a mixture of musculature and mud, like a half-finished sculpture (above right).
• Golems have very low intelligence: a small cranium suggests a small brain (right).
• Experiment with extreme features – a creature hurriedly made from clay can have exaggerated physical deformities.
• The alchemist Paracelsus claimed the Homunculus (below), which grew from a mandrake root, was a mini golem standing only 12in (30.5cm) tall but had great strength.

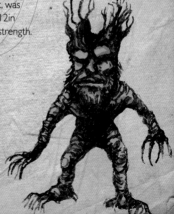

Media and Execution

• Fine pencil and Photoshop.
• The drawing was done in a loose pencil with strong lines and very little shade.
• The shade was added in Photoshop and then blended with the pencil lines to smooth out the image.

FURTHER STUDY: Gustav Meyrink (author), Paracelsus (alchemist), Raba (Rabbi), Zeira (Rabbi) ART BY FINLAY

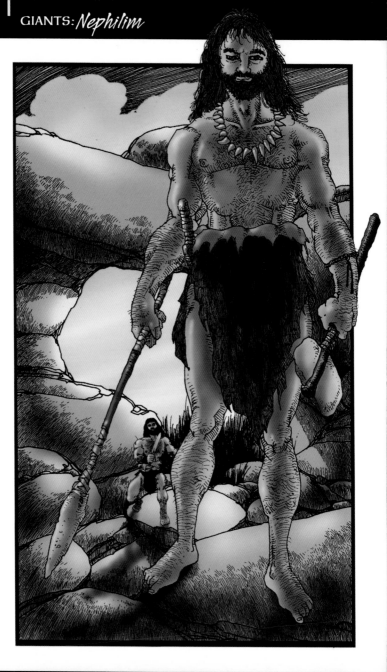

NEPHILIM

THE WORD *NEPHILIM* CAN BE SIMPLY TRANSLATED AS 'GIANT'. A HIGH-RANKING ANGEL NAMED SHEMHAZAI LED A REBELLIOUS GROUP OF ANGELS TO EARTH TO TEACH HUMANS THE PATH OF RIGHTEOUSNESS. SOME OF THE ANGELS EVENTUALLY TAUGHT THE WOMEN MAGIC AND EVENTUALLY HAD BABIES WITH THEM, WHICH PRODUCED AN ANGEL/HUMAN HYBRID RACE CALLED THE NEPHILIM.

THE NEPHILIM WERE GIANTS AND SOON USED UP ALL MANKIND'S FOOD AND BEGAN EATING HUMANS TOO. THE RESULT WAS MASSIVE DESTRUCTION ON EARTH, WITH THE HUMAN RACE ENSLAVED.

Development

• Some believe the Nephilim are immortal and still walk the earth today, but appear like normal humans.
• Figures like the Nephilim are normally portrayed with superb musculature.
• A great source for the study of anatomy like this is classical sculpture by artists such as Michelangelo and Thorvaldsen.

Media and Execution

• Pen and ink and Photoshop.
• The figure was created in pencil first, then all the details, including the clothing, weapons, hair and accoutrements, were inked in.
• The background was also created in pen and ink.
• Colour was added with the Airbrush tool in Photoshop.

FURTHER STUDY: The Book of Enoch, *Nephilim* games, *The Prophecy II* and *III*

ART BY BOB HOBBS

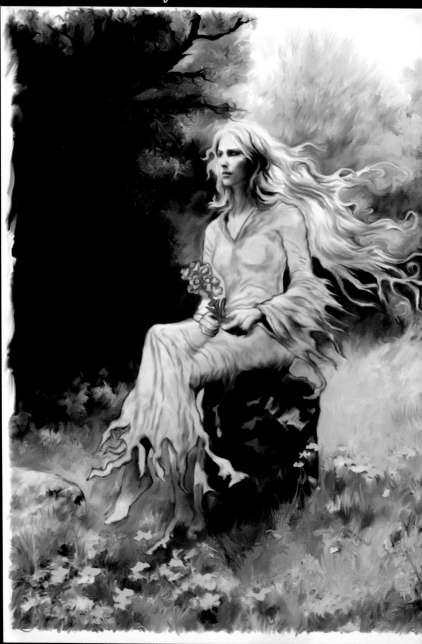

DEILDEGAST

IN NORWEGIAN FOLKLORE, DEILDEGASTS ARE GHOSTS WHO CANNOT PASS INTO THE AFTERLIFE BECAUSE THEY HAVE COMMITTED THE CRIME OF MOVING A BORDER STONE WHILE THEY WERE ALIVE IN ORDER TO STEAL LAND FROM A NEIGHBOUR. THIS INSPIRED THE STORY OF THE GIRL SHOWN HERE, WHO IS NOT STRICTLY A DEILDEGAST BECAUSE SHE IS THE VICTIM, NOT THE PERPETRATOR OF A BORDER DISPUTE. I IMAGINED THAT SHE HAD BEEN WAITING FOR HER LOVER AT THE BORDER STONE WHEN SHE WAS KILLED BY A JEALOUS NEIGHBOUR. NOW SHE WAITS FOR HIM IN ETERNITY, HER COLD, SAD EYES SEARCHING FOR A MAN WHO WILL NEVER COME.

Development

• A prop, such as flowers, can enhance the story behind an image – in this case, a poignant reminder of lost love.
• A real Deildegast would appear in traditional clothes like the ones worn here (below).

Media and Execution

• Fine pencil and Photoshop.
• A rough drawing was based on a photo of a friend.
• The drawing was scanned and different areas of the line were coloured in Photoshop.
• The Rubber stamp tool was used to clone colour and textures from photographs on to a new layer on the image.
• Colours were then carefully blended and manipulated using the Smudge tool.

FURTHER STUDY: Gjenganger, Mara, Wight

ART BY FINLAY

Shadow people

SHADOW PEOPLE ARE A SUPERNATURAL PHENOMENON IN WHICH OBSERVERS REPORT SEEING A DARK FORM AT THE EDGE OF THEIR FIELD OF VISION, WHICH DISINTEGRATES OR MOVES INTO A WALL WHEN NOTICED, USUALLY WITHIN A SPLIT SECOND.

REPORTS OF SHADOW PEOPLE ARE SIMILAR TO PURPORTED GHOST SIGHTINGS, BUT DIFFER IN THAT SHADOW PEOPLE DO NOT HAVE HUMAN FEATURES, WEAR CLOTHING, OR ATTEMPT TO COMMUNICATE. THEY ARE OFTEN DESCRIBED AS BEING DARK AND HAVING WISPY TENDRILS THAT EMERGE FROM THEM, SOMETIMES WITH GLOWING RED EYES AND EVEN A HOOD.

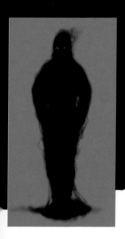

Development

• Although a fairly recent phenomenon, shadow people have been reported for many centuries.

• They may be linked to the deep need in the human psyche to make sense of what we see, to take shadows or clouds and turn them into recognizable objects.

• Just as the roots of a fallen tree at dusk probably gave rise to the myth of trolls, the movements we all see from the corner of our eyes has given rise to a new species of supernatural being.

Media and Execution

• 3D Studio MAX and Photoshop.

• Since shadow people often have no shape at all, the figure was created just using the Airbrush tool in Photoshop, setting the spray to wide for the large areas.

• The tool was then set to a finer pattern for the smaller wispy tendrils.

• The glowing yellow eyes were airbrushed in last.

• All of this was then placed on a background image of a carpeted hallway and door created in 3D Studio MAX.

FURTHER STUDY: *They*, mothman, wraith, ghost, poltergeist, paranormal

ART BY BOB HOBBS

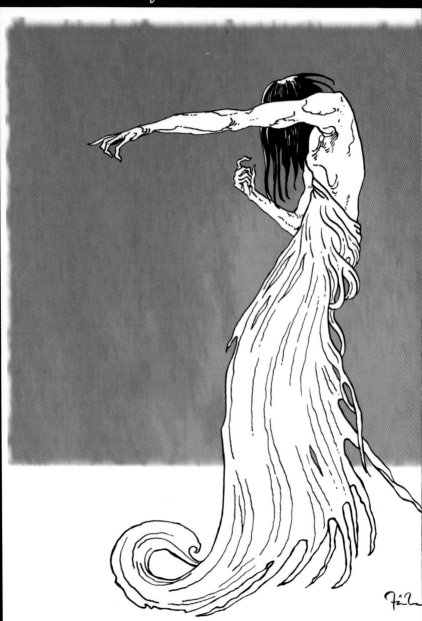

SLOAGH

THE SLOAGH ARE THE 'HOST OF THE UNFORGIVEN DEAD' FROM SCOTTISH FOLKLORE. THEY ARE THE 'UNSEELIE COURT', WHICH IS THE EVIL OPPOSITION TO THE 'SEELIE COURT' THE ARISTOCRATIC FAERIES OF THE TUATHA DÉ DANAAN. THE SLOAGH INCLUDE EVERY TYPE OF NASTY DEMON, GOBLIN AND GHOST IN CELTIC MYTH SO THEY CAN BE INTERPRETED IN ANY NUMBER OF WAYS.

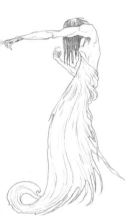

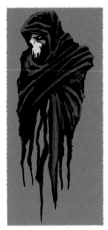

Development

• I based my drawing on the style of the artist Aubrey Beardsley. Note the image is very flat and has a strict composition.
• The Nicnivin (left) are spirits that haunt Scottish roads between dusk and dark and assault travellers.
• The Sloagh sometimes appear as unsanctified dead who fly through the night sky stealing the souls of mortals. An image of multiple beings in flight can be quite daunting but this version (below) shows how a simple solution can be found by mixing figures into each other with the use of smoky trails.

Media and Execution

• Fine pencil and Photoshop.
• The drawing was made with a very tight pencil line, which was then put on the lightbox and inked with a fountain pen, to give a more old-fashioned looking line.
• The image was scanned and a watercolour texture was sampled from another painting.

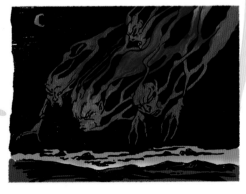

FURTHER STUDY: Seelie Court, Sloagh, Nicnivin, Red Cap

ART BY FINLAY

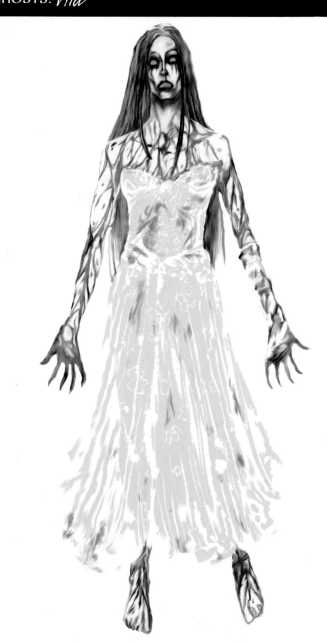

VILA

GHOSTS ARE SAID TO BE A VISUAL MANIFESTATION OF THE SOUL OF A PERSON WHO HAS DIED. THEY HAVE VARIOUS USES IN FANTASY FICTION - ACTING AS MESSENGERS AND GIVING VALUABLE INFORMATION TO HEROES AND HEROINES.

SOME GHOSTS, SUCH AS THE ONE IN SHAKESPEARE'S *MACBETH,* CAN ACT AS A CONSCIENCE, DRIVING THE HERO OR VILLAIN TO MAKE AMENDS... OR DIG THEMSELVES DEEPER INTO A HOLE. THE VILA IS A SLAVIC VERSION OF THE GREEK NYMPH AND HAS POWER OVER STORMS AND WATER.

Development

• To some people, there is nothing more beguiling than a dead lady in a bridal dress, especially when she is partially clothed in blood. A bridal dress is normally associated with a happy moment so, when it is used in this context it increases the pathos of the image and begs us to ask questions about who she is and how she came to be this way.

• It is good to root out some of the lesser-known characters from folklore and revive them for a new audience. The Wila (right) is a ghost who visited the families of the deceased. People would leave offerings of flowers and fruit at caves they believed she inhabited.

• An Acheri (below) is an Indian version of the Vila and Wila.

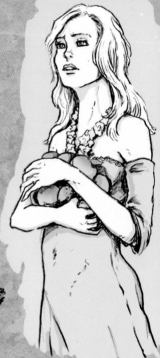

Media and Execution

• Self-propelling pencil and Photoshop.

• The figure was drawn first as a naked body. Clothes were added on top – this gives volume to the figure.

• An eraser was used to help create the translucent quality of the dress.

• Her outstretched hands give the impression that she is pleading for help so the character is both horrifying, while at the same time, begging for our sympathy.

FURTHER STUDY: poltergeist, doppelgänger, Wraith, Green Lady of Caerphilly ART BY FINLAY

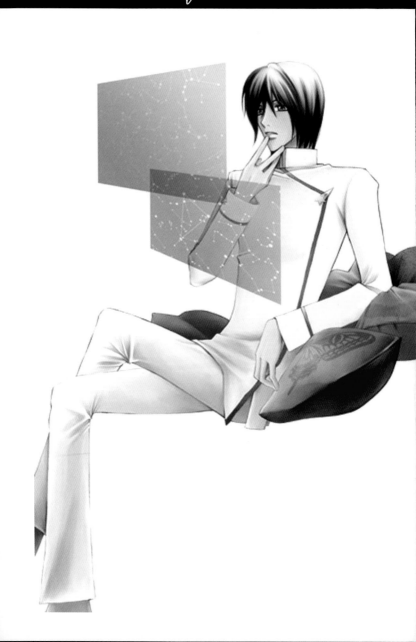

STARGAZER

ASTROLOGY IS A TRADITION OF BELIEFS THAT HAS BEEN CLOSELY LINKED TO MYTH AND FOLKLORE SINCE ANCIENT TIMES. IT IS BASED ON THE STUDY OF THE POSITIONS OF PLANETS AND CELESTIAL BODIES AND THE BELIEF THAT THEY HAVE AN EFFECT ON HUMAN BEINGS AND THEIR ACTIVITIES – PAST, PRESENT AND FUTURE. ASTROLOGY WAS CONSIDERED AN EXACT SCIENCE FOR MANY CENTURIES AND HAS REMAINED POPULAR INTO MODERN TIMES. THROUGHOUT HISTORY LEADERS, WARRIORS AND HEROES WOULD OFTEN BE GIVEN MESSAGES OR ADVICE BY ASTROLOGERS AND THE CHARACTER TYPE HAS BECOME COMMON IN FANTASY FICTION AS IT PROVIDES AN OPPORTUNITY TO LEND DIRECTION TO A STORYLINE.

Development

• When designing an astrologer you might normally think of the medieval type (below) – a scientist in a robe surrounded by archaic machinery and handwritten manuscripts – but in this case, the artist has opted for a futuristic look with the astrologer using holographic screens to study the heavens.

• The figure is dressed in clean white clothing, suggesting an antiseptic environment, and sits with his hand to his mouth in a state of ponderance as he attempts to analyse the mysteries of the stars.

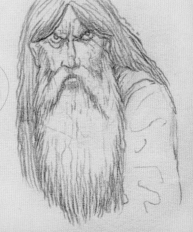

Media and Execution

• Fine pencil, Painter and Photoshop.

• The drawing was made with a fine technical pencil.

• It was then scanned and coloured in Photoshop and Painter.

FURTHER STUDY: horoscope, zodiac, Tycho Brahe, Guido Bonatti

ART BY SAYA URABE, SKETCH AT BOTTOM RIGHT BY FINLAY

Changelings

There is a great tradition throughout global folklore of creatures that kidnap children. The emergence of such creatures was obviously a ruse used by parents to ward their offspring away from danger. In Northern Europe there is a strong tradition of 'changelings' – the offspring of trolls and other creatures left behind with human families when their own children were kidnapped by the trolls. In earlier times a changeling child was a way of explaining a mentally or physically disabled or autistic child.

Media
Fine pencil and Photoshop

Changelings are generally depicted as oversized babies or children and are invariably ugly or grotesque in appearance. Despite their gruesome appearance I wanted to make this one still appear lovable.

Troll children left with humans were often treated badly but it is said that children taken by troll families were much loved and cared for by their kidnappers.

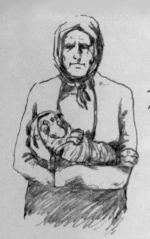

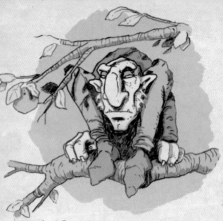

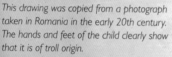

This drawing was copied from a photograph taken in Romania in the early 20th century. The hands and feet of the child clearly show that it is of troll origin.

Awd Goggie is a bogey that haunts forests and orchards and kidnaps children – he is the Scottish equivalent of the German Erlking.

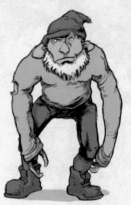

ART BY FINLAY

The Bogeyman is the most famous of all the creatures that are used to make children behave and has remained in popular folklore right up to the present day. In some cultures he can be quite friendly and I chose to picture him here in a less threatening light than usual.

A Bodach is another kind of bogey who slides down chimneys to kidnap children.

FURTHER STUDY: changeling, Erlking

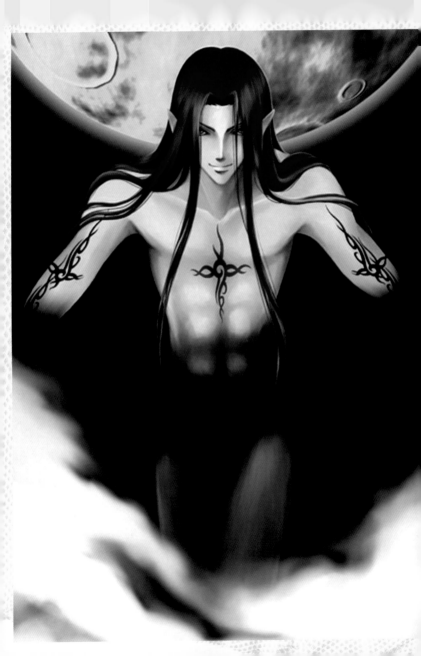

Alp

AN ALP IS A KIND OF SPIRIT FROM ANCIENT GERMAN FOLKLORE. IT IS OFTEN RELATED TO THE VAMPIRE MYTHS OF EASTERN EUROPE, BUT IS PROBABLY CLOSER TO AN INCUBUS OR SUCCUBUS IN ITS QUALITIES. IT IS A CREATURE THAT ATTACKS SLEEPING HUMANS AT NIGHT AND GIVES THEM TERRIBLE NIGHTMARES, AND IT IS ALSO SAID TO DRINK THE BLOOD OF ITS VICTIMS, HENCE ITS ASSOCIATION WITH VAMPIRES.

THE ALP IS GENERALLY CONSIDERED TO BE A KIND OF MALEVOLENT DEMON, BUT IT IS ALSO SAID TO BE ABLE TO TAKE AN ANIMAL FORM AND IS SOMETIMES ASSOCIATED WITH THE WEREWOLF. TO ADD TO THE CONFUSION IT IS SOMETIMES DESCRIBED AS A KIND OF ELF, BECAUSE THE GERMAN WORD FOR NIGHTMARE IS *ALBTRAUM*, MEANING ELF-DREAM.

ART BY SAYA URABE

Development

• Many spirits appear at night, but others can be described as 'daymares'.
• Mittagsfrau ('lady midday') appears in East German Lusatian folklore, and is known in Poland, Slovakia and Bulgaria as Poudnica. She is a noon demon, giving heatstroke and neckache to people working in fields.
• Roggenmuhme ('lady of the rye') (below) makes children disappear when they play in long grasses on hot summer days.

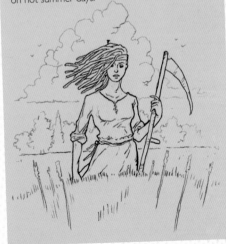

Media and Execution

• Fine pencil and Painter.
• The swirling mists give a dream-like quality and the figure is framed by the moon, suggesting a creature of the night.
• The symmetrical position of the figure gives compositional strength, and the low angle gives the impression it is looming up over us.
• Striking blue hair and elaborate, mystical tattoos lend individuality to the character.

FURTHER STUDY: Mara, succubus, incubus, Ephialtes, Gorska Makua, kornwief

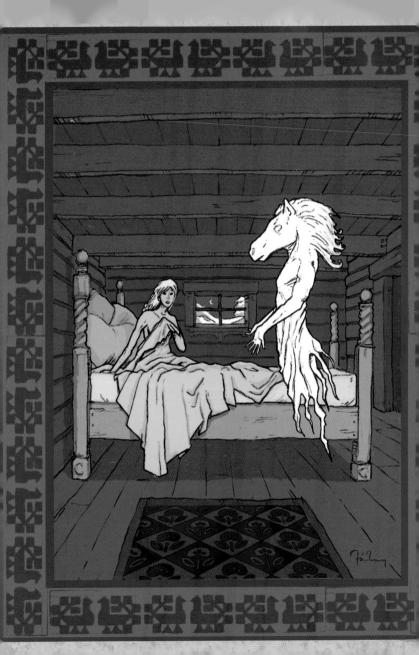

Etiänen

THE ETIÄNEN IS A GHOSTLY TYPE OF SPIRIT FROM FINNISH FOLKLORE. IT APPEARS AS A VISION OR HALLUCINATION, AND IT IS OFTEN SENT BY A SHAMAN TO BEAR SOME KIND OF IMPORTANT MESSAGE. THIS FIGURE CAN ALSO BE SENT FORWARD BY ANYBODY IN GREAT DISTRESS - AND THIS IS THE APPEAL THAT THE CHARACTER HAS FOR ME. IT IS REMINISCENT OF PEOPLE BEING VISITED BY SOMEONE WHO HAS JUST DIED, LONG BEFORE IT HAS BECOME KNOWN.

Development

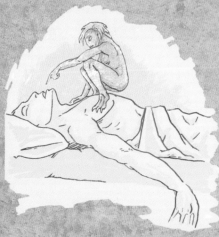

• The style of the main image is strongly inspired by Russian artist I Bilibin, who illustrated Pushkin's 'Swan Princess' poem in 1905.
• A Mara (right) is a creature from Norse myth, another night visitor who causes nightmares and can paralyse her victims.
• Giving the character a horse's head was a personal touch – my sign in the Chinese zodiac.
• A succubus (below) is the Islamic version of the Mara, a night visitor who brings dreams and nightmares.

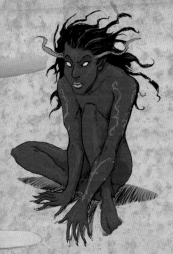

Media and Execution

• Fine pencil and Photoshop.
• Coloured inks can be used instead of Photoshop to produce areas of flat colour.
• Ink lines can be added afterwards in brush or pen when the colours have dried.
• The patterned carpet and border can be found in Russian textile designs.

FURTHER STUDY: Etiänen: Bilocation; Mara: Nocnitsa, Ephialtes, Albtraum ART BY FINLAY

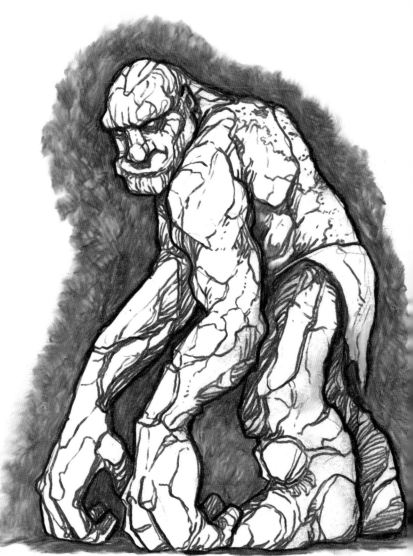

Rock troll

ROCK TROLLS APPEAR IN ITALIAN FOLKLORE AND ARE USUALLY MALEVOLENT BUT SOMETIMES HELPFUL. THE MYTH EMERGES FROM THE FOREBODING REGIONS OF THE APENNINE MOUNTAIN CHAIN, WHICH PILGRIMS HAD TO CROSS ON THEIR WAY TO ROME. ROCK TROLLS WERE BLAMED FOR THE LANDSLIDES THAT OFTEN PUT AN ABRUPT END TO THEIR RELIGIOUS ZEAL. THESE CREATURES WERE SAID TO SCREAM AT NIGHT, AN OCCURRENCE THAT COULD BE EXPLAINED BY THE LOUD CRACKING SOUNDS MADE BY THE FREEZE AND THAW ACTIVITY OF ICE IN THE ROCKS. ROCK TROLLS WERE MENTIONED BY HERODOTUS, A GREEK HISTORIAN, WHO TENDED TO BELIEVE EVERYTHING PEOPLE TOLD HIM.

Development

- Trolls are heavy-set creatures and never considered attractive.
- You could break with tradition and try other body shapes such as this spindly figure (right).
- Sketch out the basic shapes with a series of volumes that roughly follow basic muscle shapes but more angular.
- Don't be afraid to put a very thick line around the figure.

Media and Execution

- Fine pencil and Photoshop.
- Details were added by going over the drawing with lines following the shapes of the volumes. Rocky shapes and cracks are added this way.
- The pencil line was changed into colour using the Hue/Saturation tool in Photoshop.
- The layer was duplicated and the new layer was passed through the 'fresco' filter before being blended with the original drawing layer.
- The shadow around the outside of the figure was created using the Smudge tool.

FURTHER STUDY:
Phynoderree, Trows, Illes

ART BY FINLAY

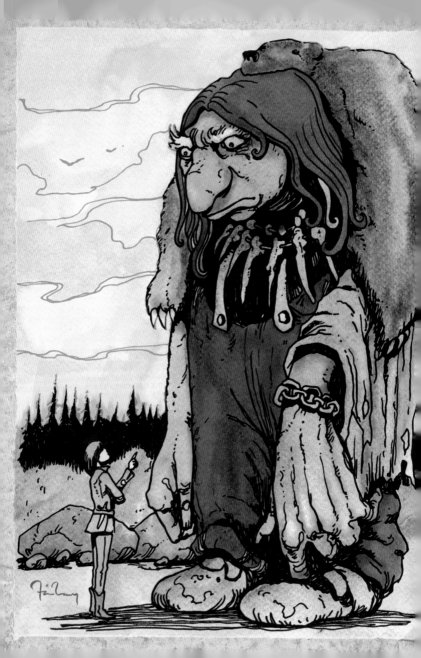

Swedish troll

TROLL CULTURE EMERGED FROM SCANDINAVIA, WHERE IT HAS BECOME AN ENTIRE INDUSTRY. TROLLS ARE GENERALLY SUPPOSED TO BE UGLY AND MALICIOUS TOWARDS MANKIND, ALTHOUGH THEY ARE USUALLY OUTWITTED BY HUMANS. IT IS EASY TO SEE HOW THE MYTH EMERGED; WOODSMEN RETURNING HOME AT DUSK MIGHT MISTAKE THE GNARLED ROOTS OF A TREE FOR A CREATURE AND, IN THE LONG DARK NIGHTS OF WINTER, MIGHT ENTERTAIN HIS CHILDREN WITH TALES CONJURED FROM HIS IMAGININGS.

JOHN BAUER CREATED THE ARCHETYPAL TROLL FROM HIS HOME DEEP IN THE FOREST OF THE SOUTHERN HIGHLANDS OF SWEDEN AND USED A MIXTURE OF WATERCOLOURS, OILS AND INKS TO CAPTURE THE TONE AND ATMOSPHERE OF THE COUNTRYSIDE.

Development
• Trolls can come in any shape and size; they live in family groups and behave much like humans.
• Try a variety of different hair and facial features — look at photos of very old men and women, and exaggerate certain aspects such as noses and eyebrows (right).

Media and Execution
• Pencil, watercolours and Photoshop.
• This picture was produced by painting with lighter watercolours first, then working with progressively darker hues.
• Colours were pushed around and blended by adding more water and dabbing with cloths and dry brushes.
• The definition was pulled together by adding an ink line.
• The colours were produced on a separate piece of paper using a lightbox then added to the ink lines in Photoshop.

FURTHER STUDY: John Bauer, Askeladden, Theodeor Kittelsen, Bergtroll, Hangtrold

ART BY FINLAY

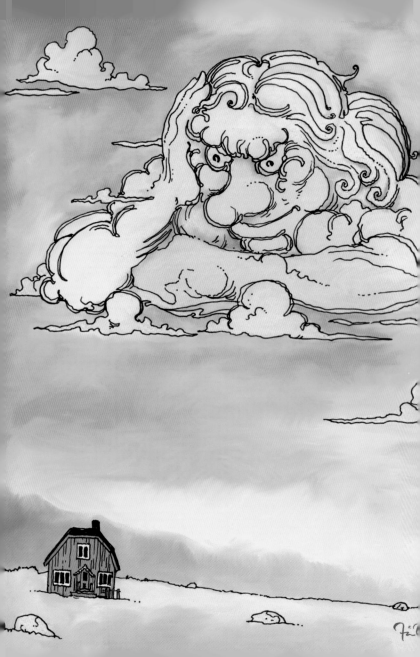

WIND TROLL

YSÄTTERS-KAJSA IS A WIND TROLL FROM THE SWEDISH REGION CALLED NÄRKE AND IS THE ONLY ONE OF HER KIND. NÄRKE IS VERY FLAT AND PRONE TO HIGH WINDS SO THE MYTH EVOLVED OF A PLAYFUL AND FRIENDLY TROLL WHO RODE THE WINDS AND DANCED IN THEIR CURRENTS. SHE WAS ALSO RESPONSIBLE FOR CREATING WINTER SNOWS AND SUMMER RAINS AND, DESPITE HER BENIGN CHARACTER, WAS SOMETHING OF A NUISANCE. HER STORY IS TOLD BY SELMA LAGERLÖF IN *THE WONDERFUL ADVENTURES OF NILS*.

Development

• Rubezahl (far right) is said to live in the Riesengebirge, the Giant Mountains. He is also known as Herr Johannes and is the ruler of the wind. I gave him a strong European profile and dressed him in the simple, rough clothes that might be worn by a mountain-dwelling farmer.

• The Bucca (centre) is a wind spirit from Cornwall in the UK and was supposed to be able to warn of shipwrecks on a coastline famous for marine disasters.

Media and Execution

• Fine pencil and watercolour.
• The drawing was made in pencil.
• Watercolours were made on a separate sheet of paper laid over the original on a lightbox.
• The pencil image and watercolour image were put together in Photoshop.

FURTHER STUDY:
El Nuberu (Spain)
Selma Lagerlöf
(Author) Folletti
(weather faeries)

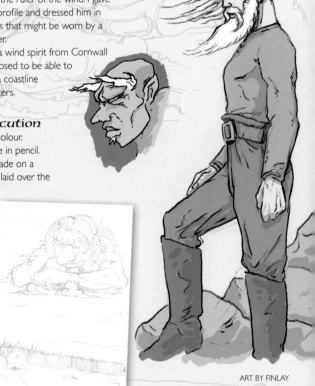

ART BY FINLAY

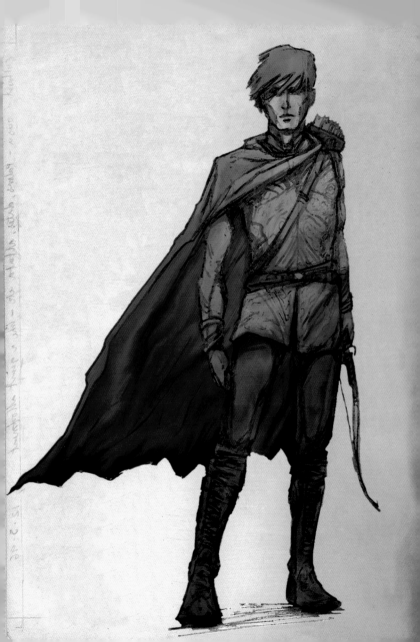

Archer

ARCHERY HAS BEEN ONE OF THE GREAT STAPLES OF WARFARE AND IT WOULD BE HARD TO CREATE A FANTASY WORLD WITHOUT THE INCLUSION OF ARCHERS. ARCHERY TOOLS VARY ENORMOUSLY THROUGHOUT HISTORY, FROM SHORT BOWS FOR CAVALRY TO LONG BOWS CAPABLE OF PIERCING ARMOUR.

THE PRECISION SKILL OF ARCHERY GIVES NUMEROUS OPPORTUNITIES FOR DRAMATIC STORY ELEMENTS, FROM THE WITHERING CASCADE OF A VOLLEY TO THE DEADLY ACCURACY OF SNIPER FIRE. THE PHRASE 'A PARTING SHOT' COMES FROM 'THE PARTHIAN SHOT' - PARTHIAN CAVALRY ARCHERS COULD TURN IN THE SADDLE AND FIRE THEIR ARROWS AS THEY RODE AWAY FROM THE ENEMY.

Development

- Legolas in *The Lord of the Rings* has become the archetypal archer in fantasy genres — tall and good looking with snug-fitting clothes to allow for extra mobility.
- Quivers are used for carrying spare arrows and come in a variety of shapes and sizes. This one (right) was made from highly ornamented leather with brass rings for attaching a strap.
- A sirra (below) is the piece at either end of a bow that holds the drawstring. These had to be strong and were made from hard wood or bone. In many cultures they were carved into animal figures.

Media and Execution

- Fine pencil and Photoshop.
- I made several sketches to define my character, none of which I was happy with. This sketch (left) was later rescued from my waste paper bin.
- The final image was put through the Watercolor filter in Photoshop then colour was added on separate layers, giving the opportunity to change it.

FURTHER STUDY: Arbalest, crossbow, horse archer, Macedonians, Greeks, Parthians, Chinese, Yeomen archers

ART BY FINLAY

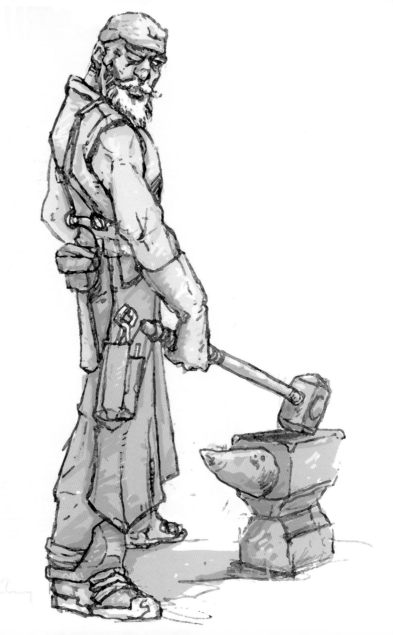

Armourer

THE ARMOURER IS A CHARACTER TYPE ESSENTIAL TO MOST FANTASY FICTION. THE IMAGES OF ORCS PREPARING FOR WAR IN *THE LORD OF THE RINGS* AND THE SCENES DEPICTING THE FORGING OF WEAPONS MAKE A POWERFUL LEAD UP TO THE BATTLE SCENES. THE CHARACTER PLAYED BY ORLANDO BLOOM IN RIDLEY SCOTT'S *KINGDOM OF HEAVEN* WAS AN ARMOURER WHOSE SIMPLE VOCATION LENT HIS CHARACTER HONESTY AND INTEGRITY. HAVING WORKED WITH MODERN-DAY ARMOURERS IN THE FILM INDUSTRY I CAN HONESTLY SAY THAT THEY HAVE CHANGED LITTLE SINCE MEDIEVAL TIMES... WHICH IS WHY THEY ARE KEPT LOCKED AWAY OUT OF SIGHT FROM EVERYONE ELSE!

Development

• Don't stick to the tried and tested clothing of leather aprons. This character (right) wears reinforced dungarees with a high waist to support the lumbar region of his back. Massive tool pockets are stitched to each side of the trouser legs.

• You can exaggerate the elements of the environment so they become more fantastic such as the creation of huge bellows for stoking fires.

• The tools of the armourer have remained unchanged for centuries (below). Factual details like these can balance out the purely fictional aspects of your fantasy world.

ART BY FINLAY

Media and Execution

• Fine pencil and Photoshop.

• This image was coloured in the style of the development art produced for feature films.

• This technique requires a rapid, quick-fire approach and, despite its sketchiness, gives a good indication of shape, form, detail, colour and even lighting.

FURTHER STUDY:
Kingdom of Heaven,
Hephaestus

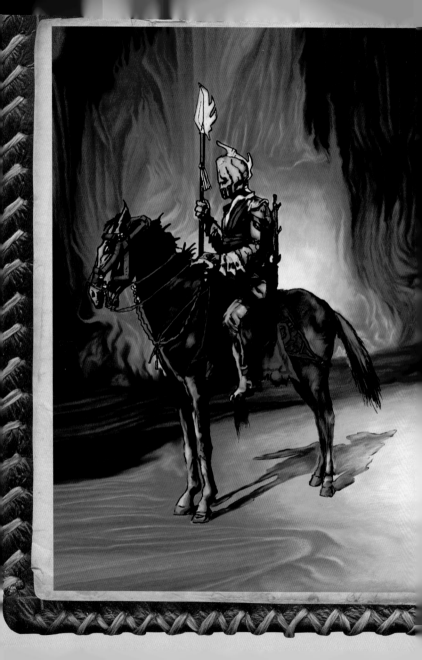

CAVALRY

CAVALRY IS ONE OF THE GLAMOUR OCCUPATIONS OF THE FANTASY WORLD, AND HISTORICALLY, THE USE OF CAVALRY GREATLY ENHANCED THE EFFECTIVENESS OF FIGHTING FORCES. CAVALRY CHARGES HAD THE DEVASTATING EFFECT OF A BATTERING RAM OF FORCE THAT WOULD PLOUGH ITS WAY INTO ENEMY FORCES, SCATTERING THEM IN ALL DIRECTIONS. MEDIEVAL AND ASIAN CAVALRIES ARE A GREAT SOURCE OF MATERIAL FOR FANTASY ARMIES, BUT IT'S ALSO WORTH REFRESHING YOUR THINKING BY LOOKING AT 18TH- AND 19TH-CENTURY CAVALRIES, SUCH AS HODSON'S HORSE AND SKINNER'S HORSE, WHICH WILL PROVIDE YOU WITH INTERESTING COSTUME IDEAS AS WELL AS BLOODCURDLING STORYLINES.

Media and Execution
- Fine pencil and Photoshop.
- Drawing figures on horseback requires careful study and attention to detail.
- This image was traced in pencil from an old photo.
- Significant changes were then made in Photoshop to turn the figure into an ominous fantasy character.

ART BY FINLAY COWAN

Development
- Military subjects are well documented, so there is plenty of material on which to base your fantasy art.
- This character (right) was taken from the background of an orientalist painting. The idea of a high belt around the chest containing a dagger makes perfect practical sense – a detail I might not have thought of working from memory.
- Don't settle for a normal horse: trace a photo of a real horse then add scales, feathers, horns, metallic plates, or anything to make it different.

FURTHER STUDY: Hodson's Horse (India, 19th century), Skinner's Horse (India, 19th century), Cuirassiers (heavy cavalry), Hussars (light cavalry), Lancers, Mongols, Cossacks

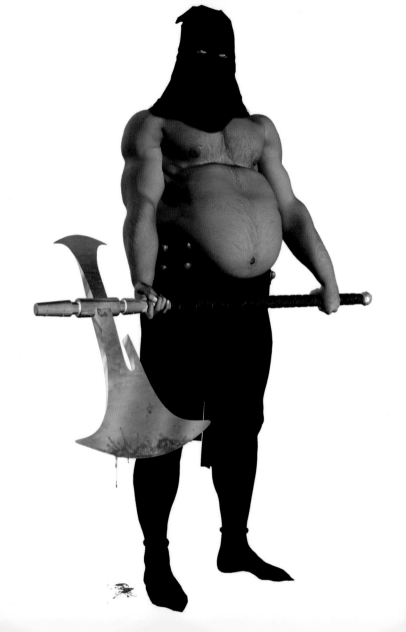

EXECUTIONER

THE IMAGE OF THE HOODED EXECUTIONER HAS BECOME A STAPLE OF FANTASY FICTION. FEW FANTASY SERIALS ARE COMPLETE WITHOUT A SCENE IN WHICH THE HERO SAVES HIS FRIEND FROM THE GALLOWS OR GUILLOTINE AT THE LAST MOMENT. THE WORD 'EXECUTIONER' COMES FROM THE LATIN *EXSEQUI*, 'TO EXECUTE' AND THE CHARACTER IS OFTEN BASED ON THE MEDIEVAL IMAGE OF A LARGE MAN IN A BLACK POINTED HOOD.

THE EXECUTIONER IS RARELY PORTRAYED AS A SYMPATHETIC CHARACTER, BUT AT THE SAME TIME, HE IS NOT REGARDED AS A VILLAIN, MERELY AS AN UNWITTING INSTRUMENT OF THE STATE. QUITE OFTEN WRITERS INVERT HIS IMAGE, AND HE CAN BE USED IN A COMEDIC ROLE SHOWING AN UNEXPECTED SENSITIVITY OR SENTIMENTALITY.

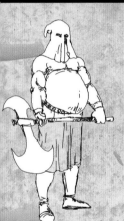

Development

• Traditionally, executioners were shunned by society, so the hood was used to conceal their identity.

• Don't think that 3D characters can easily be produced by using stock textures and figures, as here. You will always have to do a lot of manual work, retouching hair and skin by hand to make your figure convincing.

• Digital art relies on painstaking attention to detail just as much as the traditional mediums of drawing and painting, and you will need to use brush and pen tools in the same way as for these methods.

Media and Execution

• Poser 3D software and Photoshop.

• The executioner began as a Poser figure with the parameter dials set to turn him into a hulking, pot-bellied brute.

• The outfit was put together using elements available in Poser and DAZ software, including the axe.

• Basic textures were applied, then all rendered out to Photoshop.

• The hood was created using the Painting and Airbrush tools. Cut-outs were made for the eyes and shading was added.

FURTHER STUDY:
The Headsman,
Andre Obrecht,
The Witcher game

ART BY BOB HOBBS

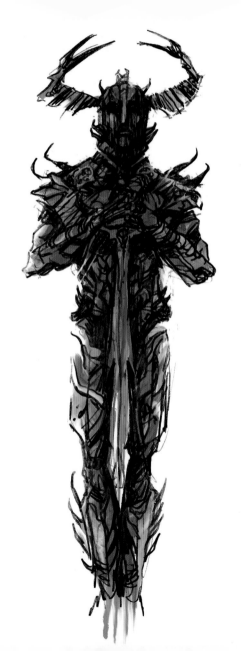

SOLOIER

FANTASY FICTION RELIES HEAVILY ON CONFLICT TO CREATE DRAMA AND THE MOST VISCERAL FORM OF CONFLICT IS WARFARE. FANTASY FICTION RARELY DEALS WITH THE UNPLEASANT REALITY OF WARFARE... AND IT SHOULDN'T HAVE TO, WARFARE IS USED IN FICTIONAL GENRES TO CREATE THRILLS AND EXCITEMENT - IT IS NOT MEANT TO BE REAL.

WHEN CREATING A FANTASY ARMY IT IS WORTH RESEARCHING THE ORGANIZATION OF HISTORICAL ARMIES AS THERE IS MUCH DIVERSITY INVOLVED IN THE MANAGEMENT OF A FIGHTING FORCE, WHICH MAY GIVE RISE TO INTERESTING IDEAS FOR YOUR OWN CREATIONS.

Development

• When designing armour. you can opt for a historically accurate look or invent your own, less practical versions. This one (right) was based on a bird's skull.
• Sword hilts and scabbards (below) can be highly decorative.
• Note how perspective lines were used in the construction of this dagger (far right) to give it a solid, realistic shape.

Media and Execution

• Fine pencil and Photoshop.
• I gave the knight a popular symbolic posture as seen on many Christian tombs.
• I decided to create a contrast by having him drenched in blood, which makes a paradoxical comment about the image of the virtuous knight and the reality of professional killer.

FURTHER STUDY: mercenaries, elite units, commando, guerilla, ART BY FINLAY

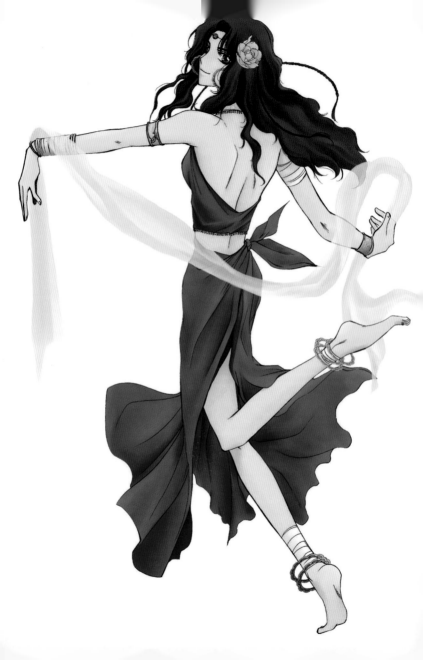

GYPSY

THE FICTIONAL IMAGE OF THE GYPSY HAS BECOME DIVORCED OVER TIME FROM THE REALITY. THE POPULAR IMAGE OF THE GYPSY GIRL IN A FLORAL DRESS, HEADSCARF AND BANGLES IS PROBABLY BASED ON MOORISH GYPSIES WHO ARRIVED IN SPAIN FROM AFRICA AND HAD A STRONG INFLUENCE ON WESTERN ART AND MUSIC. THE ROM ARE TRAVELLING PEOPLE ORIGINALLY FROM INDIA BUT NORMALLY ASSOCIATED WITH SOUTH-EASTERN EUROPE.

GYPSIES MAKE GOOD CHARACTERS BECAUSE THEY ARE OUTSIDERS AND THEIR FASCINATION WITH TAROT AND MYSTICISM GIVES THEM AN OTHERWORLDLY QUALITY. THEY ARE OFTEN USED IN FICTION AS SCAPEGOATS AND ARE RARELY PORTRAYED IN A NEGATIVE LIGHT. THEIR LOVE OF DANCING AND MUSIC MAKES THEM COLOURFUL, FLAMBOYANT CHARACTERS.

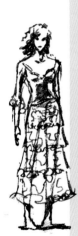

Development

• Gypsy archetypes like Esmerelda in *The Hunchback of Notre Dame* are vibrant, beautiful and unabashed. They are portrayed as being suspicious of authority and have a strong sense of their own cultural identity.
• In the main image the gypsy is shown in a classic posture – she is dancing with freedom and friendliness in her movements.
• In the sketch (right) the character is equally flamboyant but there is something slightly threatening about her posture suggesting she might be a sorceress.

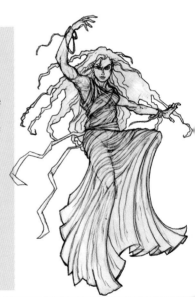

Media and Execution

• Fine pencil and Photoshop.
• The image was drawn with a fine technical pencil and inked with technical pens.
• It was then scanned and coloured in Photoshop with special effects added in Painter.

FURTHER STUDY: Rom, Romany, Moorish gypsies, nomads, Suyolak (gypsy wizard), Urmen (gypsy fata), Devel (supreme gypsy deity)

MAIN PAGE ART BY SAYA URABE, VARIANT ART AND SKETCH BY FINLAY

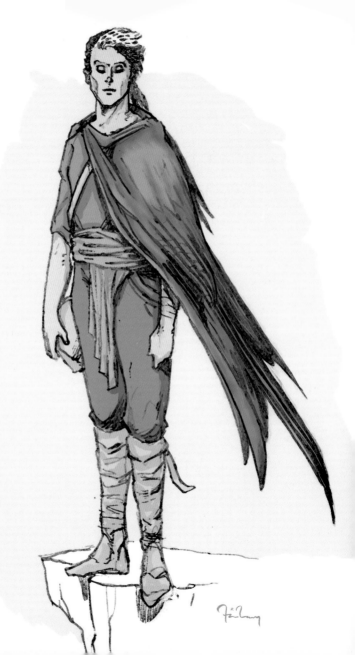

Mendicant

HISTORICALLY, THE TERM MENDICANT WAS GIVEN TO MEMBERS OF RELIGIOUS ORDERS THAT RELIED ON BEGGING TO SURVIVE, AS THEY HAD TAKEN A VOW OF POVERTY. THE TERM WAS ORIGINALLY APPLIED TO CHRISTIAN ORDERS, SUCH AS THE FRANCISCANS, BUT THE WORD IS ALSO USED FOR ANY PEOPLE WHO GAVE UP WORLDLY GOODS.

IN FICTION, THE IDEA OF THE INDEPENDENT LONER DEVOTED TO A SPIRITUAL PATH MAKES FOR AN INTERESTING AND SOMETIMES FUNNY CHARACTER. FRIAR TUCK IN THE ROBIN HOOD LEGEND BELONGS TO NO APPARENT ORDER, PREFERRING INSTEAD TO LIVE IN A FOREST WITH A GANG OF VIOLENT BRIGANDS - QUALITIES THAT MAKE SUCH A CHARACTER POTENTIALLY INTERESTING.

Development

• The young mendicant shown in the main picture was based on the image of the Fool from the tarot deck.
• A wandering holy man (right) could be a cantankerous old grouch, a scheming trickster or a brooding noble in search of the meaning of life.
• Give a mendicant in a cold climate (below) animal skin clothing and an enormous backpack containing items needed to survive in a hostile climate.

Execution

• Fine pencil and Photoshop.
• A photo of a tribesman from Central Asia was traced in pencil on a lightbox.
• The pencil image was scanned into Photoshop and coloured with three layers of colour. Each layer was set to 'multiply' so that it was semi-transparent.
• A similar technique can be applied using markers or even coloured pencils. A very limited tonal range of one dark, one medium and one light can be the quickest way to colour a figure.

ART BY FINLAY

FURTHER STUDY: bhikku, Friar Tuck, nomad, tarot, Adele Nozedar

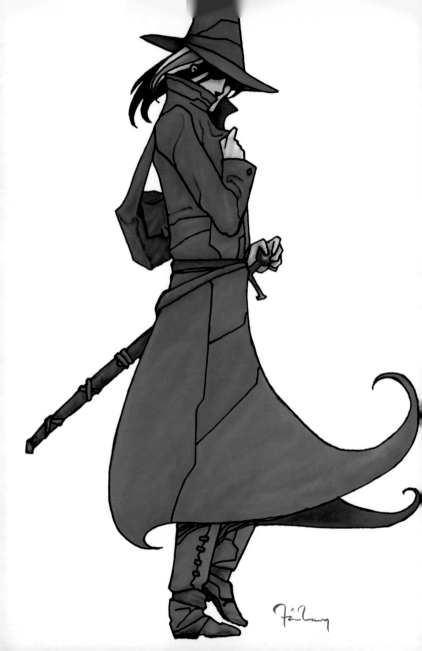

Ranger

EXPLORERS ARE REAL-LIFE FIGURES THAT CAN MAKE INTERESTING FANTASY CHARACTERS. THEY ARE ALWAYS MARCHING OFF ON MISGUIDED QUESTS AND CAN SURVIVE FOR LONG PERIODS OF TIME ON NOTHING BUT DRIED BISCUITS AND THE OCCASIONAL PASSING PENGUIN. A RANGER WOULD BE EXTREMELY INDEPENDENT AND CAPABLE OF ADAPTING TO CIRCUMSTANCES AS HE GOES ALONG. THESE QUALITIES, ALONG WITH THE ABILITY TO MAKE FRIENDS WHEREVER HE GOES, MAKE HIM A USEFUL ACCOMPLICE FOR A FANTASY HERO OR HEROINE.

Development

• Most explorers come covered in a thick layer of snow or dust, or both (right).
• Like most fantasy characters he is of 'no fixed abode', and carries his few worldly belongings in a rucksack (below).
• Sir Richard Francis Burton was one of the great explorers of the Victorian era. When he wasn't getting lost and blinded for months at a time in Africa he was learning to speak 25 languages! His life story provides plenty of inspiration and ideas for any artist or writer.

Media and Execution

• Fine pencil and Photoshop.
• The figure was first drawn in pencil, then inked with technical pens.
• Flat colours were added in Photoshop and tone added using the Dodge and Burn tools, which made areas of shadow and highlights.
• The changes in tone were then blended into the main areas of colour using the Smudge tool.

FURTHER STUDY: Aragorn, Sir Richard Francis Burton, Lewis and Clark, Wilfred Thesiger

ART BY FINLAY

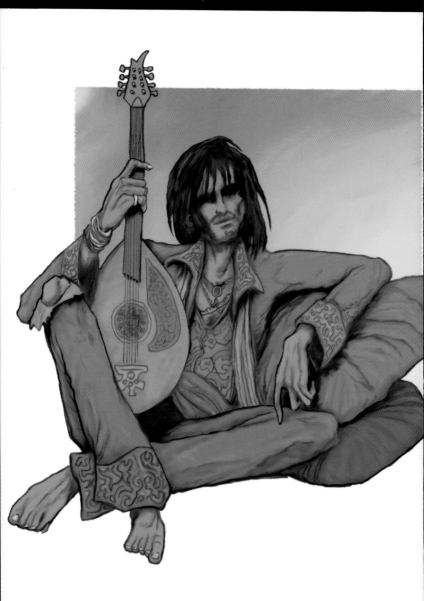

TROUBADOUR

A TROUBADOUR IS A WANDERING MUSICIAN OR MINSTREL WHO DRIFTS FROM TOWN TO TOWN MAKING HIS LIVING BY PERFORMING AT FESTIVALS OR WRITING SONGS AND POEMS TO ORDER. THESE CHARACTERS STRIKE A ROMANTIC CHORD IN OUR IMAGINATIONS AND THEIR APPEAL HAS BEEN SO GREAT THAT THE IDEA OF WANDERING THE WORLD SINGING SONGS AT FESTIVALS HAS BECOME A MULTI-MILLION DOLLAR GLOBAL BUSINESS AND IT'S ALL THANKS TO SOME POVERTY-STRICKEN LOSERS FROM THE MIDDLE AGES.

PART OF THE APPEAL OF THESE CHARACTERS IS THAT THEY STRIKE THE DANGEROUS POSE OF PIRATES AND OUTSIDERS BUT ARE, IN FACT, HARMLESS ARTISTS WHOSE SOLE AIM IN LIFE IS TO MAKE THEIR MUSIC AND FIND THEIR WAY INTO A SITUATION OF ABSOLUTE LUXURY AND COMFORT!

Development

• This musician (left) was inspired by a painting by Carl Haag who was an Orientalist painter working in the mid to late 1800s.

• The main immage aims to strike the balance between a character who is handsome and charming but also slightly dangerous, which is an enduring part of a troubadour's appeal.

• His clothes are elegant but frayed at the edges as he is always down at heel.

• Strange-looking instruments (below) can be found in museums, which you can use to add interesting details to your work.

Media and Execution

• Fine pencil and Photoshop.

• The original drawing was a loose sketch made with a soft pencil.

• Tone and shadow was added at the pencil stage.

• The colours were kept to a narrow range of warm autumnal tones.

FURTHER STUDY:
Belman (Swedish troubadour), wanderer, bard, Orientalist painters, Romantics

ART BY FINLAY

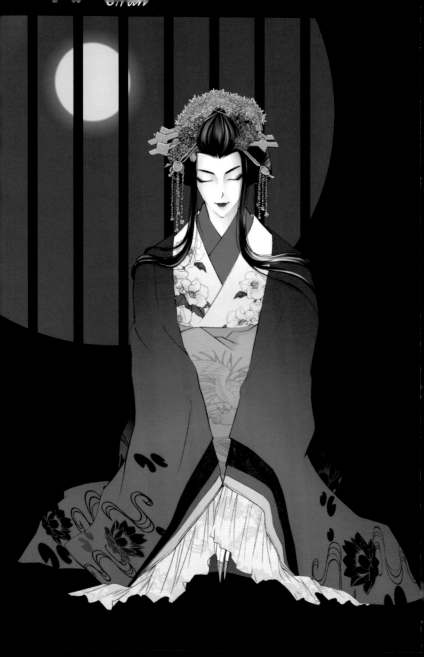

Oiran

THIS FIGURE FROM JAPANESE HISTORY CAME BEFORE THE GEISHA. THESE WOMEN WERE NOT ACTUALLY SLAVES - BUT WEREN'T FAR OFF. OIRANS WERE HIGHLY TRAINED ENTERTAINERS WHO LIVED TOGETHER IN A CLOSED HOUSE. THEY WERE SKILLED IN DANCING, MUSIC, POETRY AND WRITING, AND A COMPLEX AND STRICT HIERARCHY OF BEHAVIOUR AND MANNERS WAS DEVELOPED WITHIN THE HOUSES. A RANKING SYSTEM EVOLVED DEPENDING ON ABILITIES, BEAUTY AND EDUCATION; THE HIGHEST LEVEL BEING A TAYU. THESE REAL-LIFE FIGURES MAKE INTERESTING FICTIONAL CHARACTERS BECAUSE THEY BECAME SO DEVELOPED IN THEIR ABILITIES THAT THEY BECAME INCREASINGLY DETACHED FROM NORMAL LIFE.

Development
• Oiran costume was highly developed and varied according to rank.
• Study the history and culture of costumes from various cultures.
• In the main picture the figure has five pins in her hair. As time went by Oiran costume became more elaborate and the hair had up to eight combs or pins.

Media and Execution
• Fine pencil and Photoshop.
• This type of artwork requires a very clean version in hard pencil or ink before you scan it for colouring.
• Apply flat colour in Photoshop or Painter.
• Add subtleties of shadow and tone either as a separate colour layer or by using the Dodge and Burn tools.

FURTHER STUDY:
geisha, courtesan, Tayu

ART BY SAYA URABE

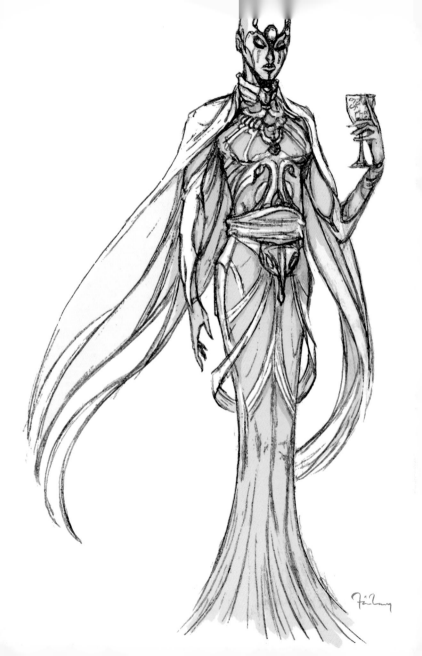

DRUIDESS

DRUIDISM IS AN ANCIENT SYSTEM OF SPIRITUAL BELIEFS BASED ON A DEEP UNDERSTANDING AND RESPECT FOR THE NATURAL WORLD. DRUIDISM EVOLVED TO CONSERVE VAST REPOSITORIES OF KNOWLEDGE THAT WERE CONSIGNED TO MEMORY AND PASSED ON ORALLY. THIS SYSTEM REQUIRED APPRENTICES TO LEARN ENORMOUS AMOUNTS OF INFORMATION BY HEART, AND DRUIDS WERE HIGHLY RESPECTED BY THEIR RULERS BECAUSE THEIR KNOWLEDGE REPRESENTED POWER – THEY WERE THE LIVING DATABASES OF SOCIETY.

THE WORD 'DRUID' COMES FROM AN ANCIENT WORD MEANING 'OAK' OR 'KNOWLEDGE' AND DRUIDS WERE A KIND OF PRIESTHOOD THAT CARRIED OUT WEDDING CEREMONIES AND DEATH RITES AS WELL AS PRACTISING FORMS OF MAGIC, LAW AND DIVINATION.

Development

• Female druids were quite rare but were known to exist. This image of a druidess is based on ideas for a tarot card, The Queen of Cups, which is The Goddess. I decided a swan might be a good bird to use so the character is wearing a kind of swan costume.
• Cups represent love, happiness, pleasure, deep feelings and humanity so I wanted to make the figure benign and sensitive looking. She also represents the moon and psychic powers so it was important that she should have a mystical quality too.

Media and Execution

• Fine pencil and Photoshop.
• This is a loose pencil sketch without any hard edges.
• Colour was added very sparingly in Photoshop to achieve the look of a film production visual.

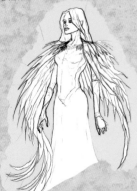

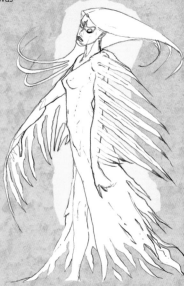

FURTHER STUDY: druids, bards, Corrigan, Neo Drudism, Vortigern, Mug Ruith, Ynis Mon, William Blake

ART BY FINLAY

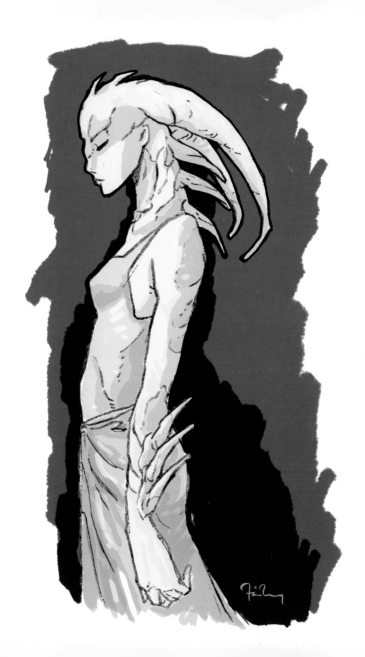

ORACLE

AN ORACLE IS A PERSON OR OBJECT THAT CAN BE USED TO FORETELL THE FUTURE AND MAKE PROPHECIES. HUMAN ORACLES ALSO ACTED AS WISE MEN OR WOMEN AND WERE CALLED UPON TO MAKE JUDGMENTS AND GIVE ADVICE. ORACLES APPEAR IN MOST ANCIENT CIVILIZATIONS AND WHEN THEY APPEARED IN HUMAN FORM IT WAS SAID THAT THE GODS WERE SPEAKING THROUGH THEM. IN THIS RESPECT THEY ARE SIMILAR TO SHAMANS WHO ENTER INTO A TRANCE-LIKE STATE TO DIVINE INFORMATION AND MAKE PROPHECIES.

Development

• Sibyl (left) was an oracle who operated from the temple of Apollo at Delphi and had a massive influence on Greek politics.
• Oracle bones (right) have been found in China dating from the Shang Dynasty (1600BCE–1046BCE).
• Various herbs and spices (below) were also used as aids for divination (below).

Media and Execution

• Fine pencil and Photoshop.
• This was executed as a rough pencil sketch.
• Strong, flat colours were added in Photoshop and a dark line was added around the figure to strengthen the image.
• Further layers of shadows and highlights were added to give the flat figure the impression of more form.

FURTHER STUDY: I-Ching (China), Sibyl (Greece), Dodona (Greece), Mima (Norway), Nechung Oracle (Tibet)

ART BY FINLAY

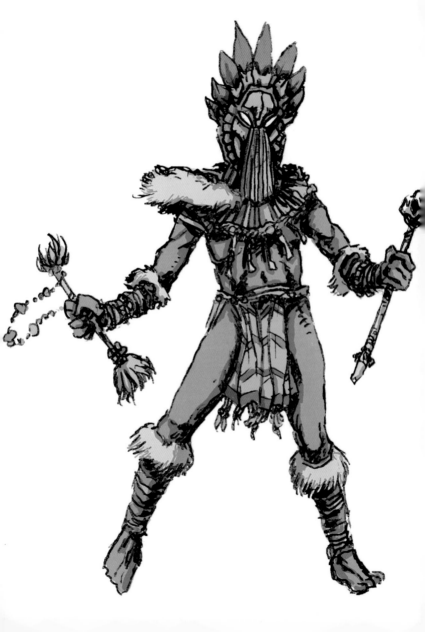

Shaman

SHAMANISM IS AN ANCIENT FORM OF SPIRITUAL BELIEF THAT IS SAID TO PRE-DATE ALL ORGANIZED RELIGIONS AND IS STILL PRACTISED IN MANY COUNTRIES. SHAMANS WERE WISE MEN OR WOMEN WHO WERE CALLED UPON TO DIAGNOSE PHYSICAL AND MENTAL AFFLICTIONS AND ALSO MAKE DIVINATIONS. SHAMANS ARE RARELY ORGANIZED INTO ANY FORM OF PRIESTHOOD LIKE THE DRUIDS BUT TENDED TO ACT ALONE OR WERE AUTHORIZED BY THE HEADMAN OF A VILLAGE. LIKE MANY ANCIENT BELIEF SYSTEMS, SHAMANISM IS BASED ON AN UNDERSTANDING AND RESPECT FOR MANKIND'S CONNECTION WITH THE NATURAL WORLD.

Development

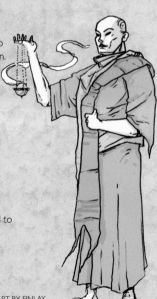

- In some cultures, such as the Mongols, shamans appeared as scary figures wearing death masks (right), which suggested their ability to communicate with spirits of their ancestors.
- It is possible that Shamanism evolved into organized religion is some societies. This could be the origin of Tibetan and Cambodian monks (below right).
- This image isn't based on any specific research into Shamanism but is put together from research at various natural history museums.
- This example is African in appearance and uses the techniques of dancing, music and animal imitation to enter into a trance through which he will be able to dispense information.
- Shamans would use various drinks and herbs (below) to help them make the transition into the state required for communication with the spirit world.

Media and Execution

- Fine pencil and Photoshop.
- This was one of a series of quick pencil sketches that aimed to capture the fluidity and movement of the character.
- A simple colour treatment was added in Photoshop using flat colour without blending or soft shading.

FURTHER STUDY: Big Tail (North America), Kia Pod (Tupari tribe of Brazil), Wishinu (Javari tribe of Ecuador)

ART BY FINLAY

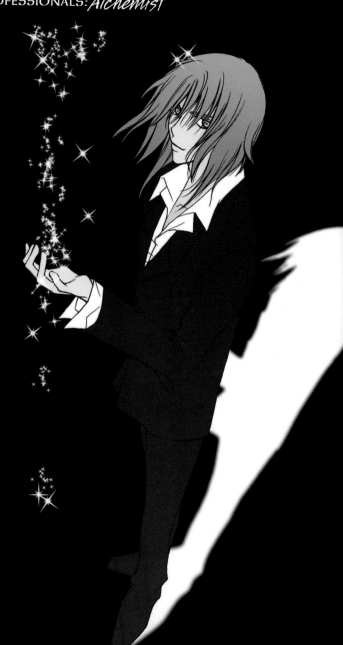

ALCHEMIST

ALCHEMY IS A TERM FOR A MIX OF EARLY SCIENCES, RANGING FROM CHEMISTRY AND METALLURGY TO PHILOSOPHY AND RELIGION. ITS BASIC AIMS WERE SIMPLE: ALCHEMISTS SOUGHT THE KNOWLEDGE TO TURN ANY METAL INTO GOLD OR SILVER, TO DISCOVER A UNIVERSAL REMEDY FOR ALL ILLNESSES AND PROLONG LIFE INDEFINITELY.

NEEDLESS TO SAY, MOST ALCHEMISTS WERE AMBITIOUS. IN GENERAL, THEY WERE TRYING TO UNDERSTAND THE FORCES OF NATURE AND MATERIALS AT A TIME WHEN THERE WAS VERY LIMITED KNOWLEDGE ON THE SUBJECT.

Development

• Chinese alchemists are said to have invented gunpowder.
• An alchemist can be any figure who seeks esoteric knowledge and has an ability to transform ideas or materials – a powerful figure in any story.
• Here the stardust that hovers around his hands suggests his alchemical power, and his white shadow helps to create an aura of magic in the image.

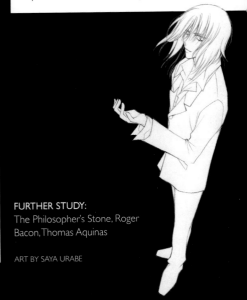

Media and Execution

• Fine pencil and Photoshop.
• Try working with several rough versions in soft pencil before doing a clean line version with a harder pencil; you can do this on a lightbox by tracing off one of your rougher versions.
• Scan the image and colour it in Photoshop, or use the lightbox to try different colour versions with pencils, coloured inks or watercolours.

FURTHER STUDY:
The Philosopher's Stone, Roger Bacon, Thomas Aquinas

ART BY SAYA URABE

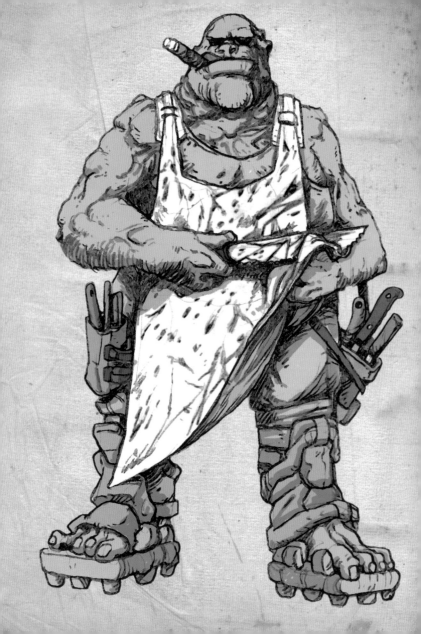

Cook

CHARACTERS IN FANTASY QUESTS OFTEN COVER VAST DISTANCES ON NOTHING BUT THE AIR THEY BREATHE. BUT WHEN FOOD ARRIVES, IT MAKES FOR A FASCINATING DIVERSION IN ANY EPIC. THE KITCHENS OF KINGS ARE OFTEN VAST AND PEOPLED WITH A COLOURFUL HOST OF SLAVES TOILING AWAY OVER HUGE STEAMING CAULDRONS AND BLAZING GRILLS.

COOKS ARE NORMALLY DEPICTED IN TWO WAYS. THE FIRST IS THE GREAT ARTIST, USUALLY WITH A FRENCH ACCENT, WHO CONDESCENDS TO CREATE CULINARY MASTERPIECES FOR AN UNDESERVING CLIENTELE. THE SECOND IS THE GREASY 'ARMY CHEF' TYPE, WHO DOLES OUT VAST QUANTITIES OF WATERY SLOP TO A GRIM-FACED LEGION.

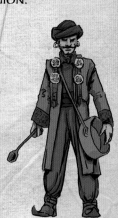

Development

• More a butcher than a cook, this character carries a plethora of razor-sharp instruments. His shoes are designed to cope with a kitchen floor awash with slop, bile and blood.

• The Khavcesbasi (right) was the sultan's chief coffee cook for the 18th-century Janissaries, who would not march into battle without coffee.

• Portunes (below) were medieval faeries that were said to work on farms by day and feast on frogs at night – a rare insight into the eating habits of faeries.

Media and Execution

• Fine pencil and Photoshop.

• Use a lightbox or tracing paper to do a clean line version in either pencil or ink.

• Scan and colour this version in Photoshop, or use the lightbox again to do colour versions in any medium.

• Vary the colours slightly on all details, so each knife handle is a slightly different tone.

FURTHER STUDY: Portunes, Khavcesbasi, Janissaries, *Gormenghast* trilogy (Mervyn Peake)

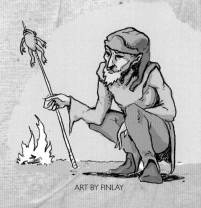

ART BY FINLAY

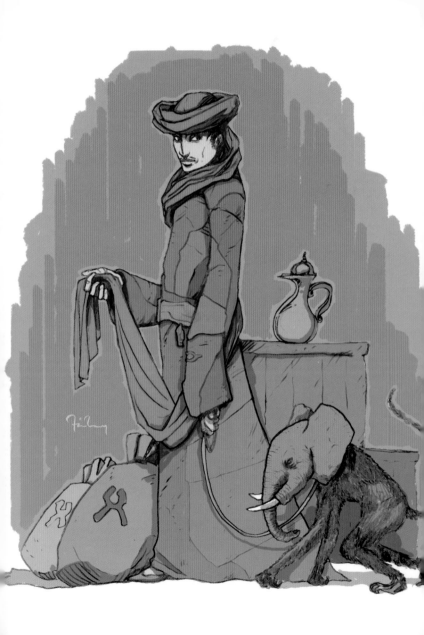

Merchant

IT IS THE SALESPEOPLE OF HISTORY THAT ARE THE OIL THAT LUBRICATES THE WHEELS OF CIVILIZATIONS AND EMPIRES. THEY SET OUT INTO THE UNKNOWN AND OPEN UP THE WORLD TO NEW MARKETS, ESTABLISHING TOWNS WHEN THE SOLDIERS HAVE GONE. IT'S INTERESTING TO NOTE THAT THE LARGEST STANDING ARMY OF THE LARGEST EMPIRE IN HISTORY WAS CREATED AND RUN BY A PRIVATE TRADING COMPANY CALLED THE EAST INDIA COMPANY.

TRADERS MAKE GOOD FICTIONAL CHARACTERS AND ARE OFTEN PORTRAYED HELPING THE HERO. THEIR NETWORKS OF CONTACTS AND TRAVEL EXPERIENCE ENABLE THEM TO HELP THE HERO ESCAPE VILLAINOUS PURSUERS OR ACHIEVE THEIR GOALS BY OTHER MEANS.

Development

• Paintings from the Renaissance period provide a rich source of costume detail (right).
• The use of 'worry beads' display religious piety at the same time as serving as a rudimentary calculator.
• The great bazaars of Tunis and Cairo can still be visited today. The image of the turbaned merchant whiling away the afternoon playing backgammon, a glass of mint tea and an abacus at his side has remained unchanged for centuries.

Media and Execution

• Fine pencil and Photoshop.
• The fantasy element here came with the addition of a green monkey with an elephant's head.
• A tight pencil drawing was scanned and coloured in Photoshop.
• Flat colours with strong shadows were used for a more graphic look rather than soft painterly blends.

FURTHER STUDY: Khan El Khalili (great bazaar in Cairo – highly recommended), Eugene Delacroix, Jean Leon Gerome, David Roberts ART BY FINLAY

Finlay Cowan

When he isn't writing fantasy art books Finlay has a secret double life working as a consultant with his company Endless Design Ltd. When he isn't doing that he has a secret triple life designing interiors. When he isn't doing that he has a secret quadruple life playing in his group Night Porter. And when he isn't doing that he has a secret quintuple life with his wife and child in Italy. But his biggest secret of all is the can of worms that is his series of graphic novels…
www.finlaycowan.com • www.subwayslim.com
art@the1001nights.com • Photo by Lou Smith

Finlay's thanks

My thanks go to Freya Dangerfield and all at D&C for their vision and hard work. Bob Hobbs has been a stalwart ally throughout and it is also thanks to him that this book features the work of the legendary Jeffrey Catherine Jones, who was an inspiration to me when I was a child, so it is a great honour to have her work featured. Saya Urabe has been another great friend and supporter – my warmest thanks to her. My very special thanks go to Janette Swift for being a constant source of inspiration throughout my career, and special thanks also to friends and mentors Bill Bachle of Solutions by Design, Adele Nozedar and Adam Fuest at Twin Peaks, and screenwriter John Watts.

Saya Urabe

Sawako Urabe was born in Japan and studied graphic design in London. She is currently working as a freelance cartoonist and illustrator. Her series of graphic novels *Central City* has been published in Europe and the US
www.005.upp.so-net.ne.jp/diva/

Saya's thanks

Everyone who has helped me…

Bob Hobbs

Bob Hobbs' credits include *L. Ron Hubbard's Writers of the Future* Vol. 8, *The Star Trek Concordance* by Bjo Trimble, *Healing Magick* by Levanah Shell Bdolak, *New Sun* by Steve Jackson Games, *Amazing Stories* magazine, *Drawing and Painting Fantasy Figures* by Finlay Cowan, *Drawing and Painting Fantasy Worlds* by Finlay Cowan, *Wizards of the Coast* and many others. His work has graced the short stories of over 120 writers, including Ursula K. Le Guin, Larry Niven and Yves Maynard. Bob's work has been on display at the Atrium on Park Avenue in NYC, DragonCon, The Naval War College Museum, the RISD Museum and the US House of Representatives.
www.moordragon.com

Bob's thanks

Bob would like to thank the fine people at DAZ 3D, Renderosity, E-On, e-frontier, and Adobe for their wonderful software. Thanks to Finlay for inviting me on the journey. And thanks to the master… Jeff Jones.

Jeff Jones

Jeff Jones' work can be found on http://www.ulster.net/~jonesart/

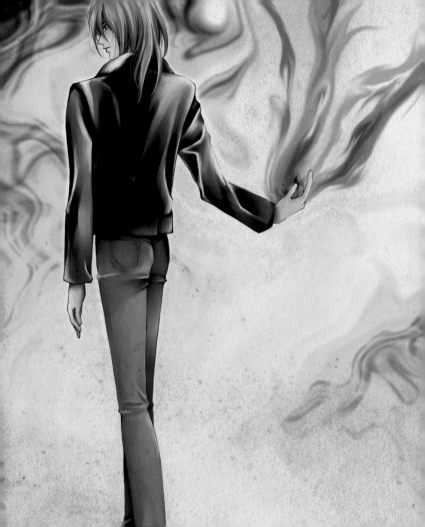